the magic of
digital landscape photography

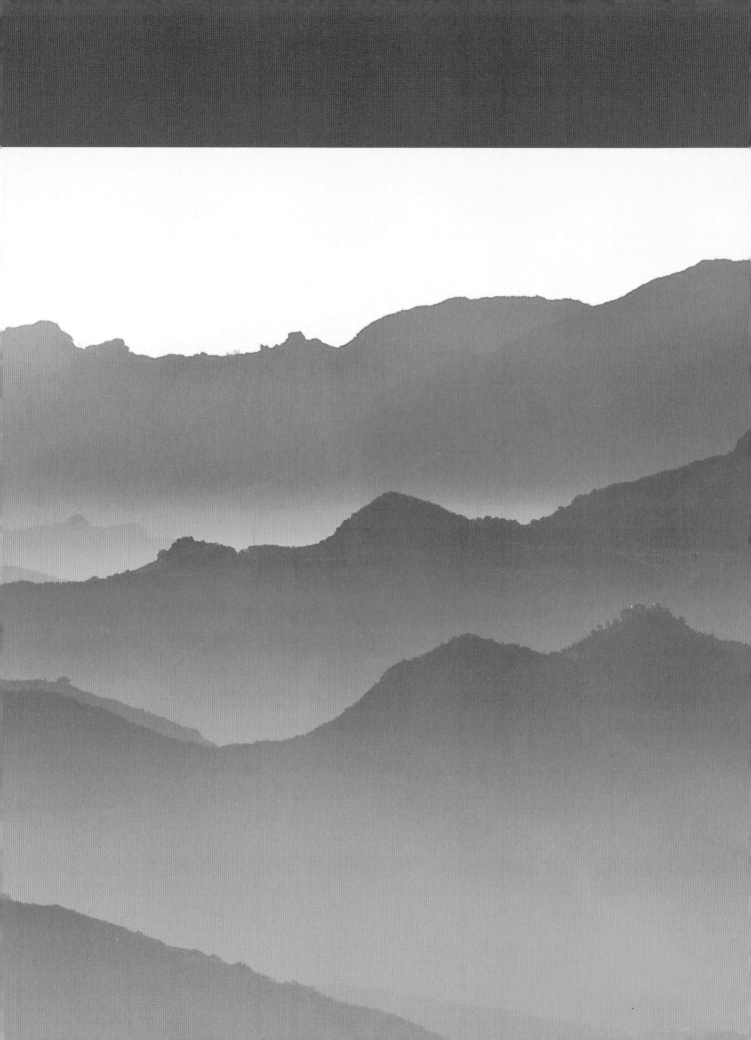

the magic of
digital landscape photography

Rob Sheppard

LARK
PHOTOGRAPHY
BOOKS

A Division of Sterling Publishing Co., Inc.
New York / London

Art Director: Tom Metcalf
Cover Designer: Thom Gaines
Production Coordinator: Lance Wille

Library of Congress Cataloging-in-Publication Data

Sheppard, Rob.
 The magic of digital landscape photography / Rob Sheppard. — 1st ed.
 p. cm.
 Includes index.
 ISBN 978-1-60059-516-5 (pb-pbk. : alk. paper)
 1. Landscape photography. 2. Photography—Digital techniques. I. Title.
 TR660.S478 2010
 778.9'36—dc22

 2009028592

10 9 8 7 6 5 4 3 2 1
First Edition

Published by Lark Books, A Division of
Sterling Publishing Co., Inc.
387 Park Avenue South, New York, N.Y. 10016

Distributed in Canada by Sterling Publishing,
c/o Canadian Manda Group, 165 Dufferin Street
Toronto, Ontario, Canada M6K 3H6

Distributed in the United Kingdom by GMC Distribution Services,
Castle Place, 166 High Street, Lewes, East Sussex, England BN7 1XU

Distributed in Australia by Capricorn Link (Australia) Pty Ltd.,
P.O. Box 704, Windsor, NSW 2756 Australia

If you have questions or comments about this book, please contact:
Lark Books
67 Broadway
Asheville, NC 28801
(828) 253-0467

Manufactured in China

ISBN 13: 978-1-60059-516-5
For information about custom editions, special sales, premium and corporate purchases, please contact Sterling Special Sales Department at 800-805-5489 or specialsales@sterlingpub.com.

Merced River, Yosemite National Park, California (right).

Santa Monica Mountains National Recreation Area, California (previous page).

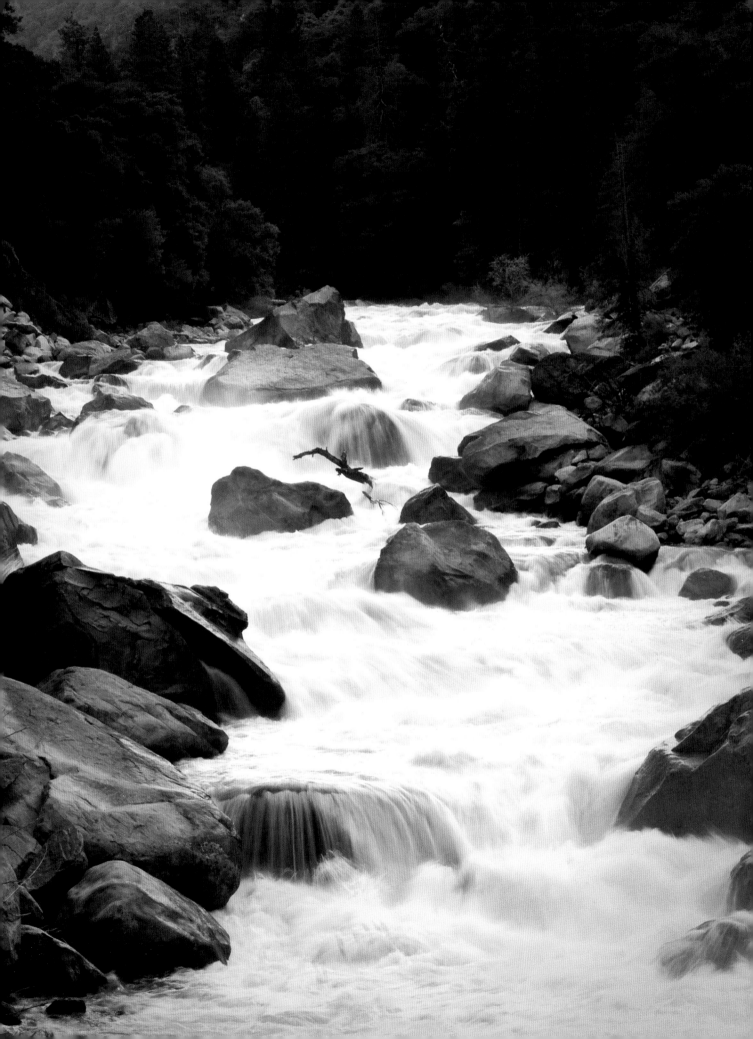

contents

INTRODUCTION8

THE PROPER GEAR12

Megapixel, Sensor Size, and Image Quality12

Types of Cameras20

 The Digital Single-Lens Reflex (D-SLR)20

 EVF (Electronic Viewfinder) with

 Interchangeable Lenses22

 Advanced Compact Digital22

 Pocket Digital23

Lens Factors24

 Focal Length26

 Lens Features35

Tripods36

Filters for Landscape Photography37

 The Polarizer37

 The Graduated Filter38

Memory Cards39

SETTING YOUR CAMERA42

Recording Format42

 JPEG42

 RAW45

 RAW + JPEG46

The LCD46

 Highlight Warnings48

Exposure Modes48

In-Camera Processing51

Reduce Camera Movement52

Leveling the Camera54

Photographer Profile: Ian Shive56

LIGHT58

Different Types of Light60

 Dramatic Light62

 Subtle Light63

 Backlight64

 Flare67

Measuring Light68

 Multi-Segment Metering68

 Spot Metering69

 Center-Weighted Metering69

ISO69

The Histogram70

Exposure Compensation71

White Balance72

COMPOSITION76

The "Nature-Is-Perfect" Trap76

Using Composition78

 The Rule-of-Thirds80

 Dominant Visual Elements82

 Small and Large Relationships82

 Use of Space83

 Foreground84

 Background85

 Distractions85

 Composition to Communicate85

 Framing the Scene88

 Connections—Edges89

Finding Photos in the Landscape90

SKY & WATER94

Skies Are Important94
 The Challenges of Skies98
 Clouds100
 Connections—Clouds102
 Sky Is Not Just Sky103
Water in the Landscape104
 Water Is About Reflections105
 Water Has Many Moods108
 Water Movement109

THE LANDSCAPE & MAN110

Including Man in the Landscape112
Show the Good and the Bad115
Connections—Fire117
Photographer Profile: Peter Essick118

SPECIAL TECHNIQUES120

Black-and-White Photography122
 Shooting in Black-and-White124
 Creating Digital Black and White125
 How to Translate Color into Black & White ...127
 Grayscale vs. RGB Color for Black & White ...130
Infrared Photography130
Panoramic Photos132
 Shooting Panoramas133
 Stitching the Images133
Photographer Profile: George Lepp136
HDR138

THEMES142

Mountains144
Connections—Geology151
Forests152
Deserts160
Oceans168
Photographer Profile: Richard Hamilton Smith174
Flower Landscapes176
Wetscapes182
Prairies188
Connections—Microclimate195
Small Scale Landscapes196
Photographer Profile: Bill Fortney202
Natural Icons204
Winter210
How Landscape Photos
Can Change the World by Miriam Stein216

INDEX222

introduction

Canyonlands National Park, Utah.

Landscape has long been one of the most popular types of photography, probably because beautiful scenery within the United States and around the world just begs to be photographed. Landscapes are perfect subjects for still photographs—they don't move or change positions while you press the shutter release. And people like these types of photos; just look around and count all the landscape calendars you notice on desks and walls.

A landscape is old, yet always new. By that I mean that most were formed over a very long time period, yet every day each will look different due to changing light and weather conditions. That makes landscapes great subjects for photos. You can count on a landscape being available, yet you can also be confident it will have a fresh look every day. (I almost said you can count on a landscape being there, but sadly, that is not always true due to shortsighted and poorly planned natural development policies in some localities.)

A Great Historical Tradition

Some of the earliest photographic experiments included landscapes, making this genre among the oldest types in the photographic field. William Henry Fox Talbot, especially, worked with landscapes. The early light-sensitive materials used by him and other photography pioneers were quite primitive compared to today's camera sensors, and could take hours to register an exposure—therefore landscapes were an appealing subject because they did not move.

Though the early photographers soon discovered better materials and chemistry, it was still common in the middle of the 19th century for exposures to take many seconds, even in bright sunshine. Photography was not well suited to any type of changing subject, so scenes tended to be static portraits or landscapes. Sports or wildlife action photos were simply not possible.

But this new medium of photography started to grow in popularity, and both photographers and the public loved it. Photographers began to travel to photograph fresh scenes, bringing home landscapes from near and far. In that day and age, most people had seen little more than their own corner of the world, so almost every photograph looked new and exciting. Photographers were not competing with thousands of others for the same common subjects.

These are the reasons that landscape photography has developed a rich tradition and powerful heritage. For example, William Henry Jackson was a 19th century photographer who set a high standard for this genre. Working in what is now Yellowstone National Park after the Civil War, he made photographs that astounded Congress and the public alike with their strange scenery, stimulating the politicians to set aside that land for the first national park. Now that's a heck of a legacy for this field of landscape photography! I find it exciting that we have such a tradition that can enrich our photographic experience today and challenge all of us to new heights.

Focus on the Landscape

Obviously a book called *The Magic of Digital Landscape Photography* is about shooting landscapes. In addition to photographic technique, we will focus on how to deal with the landscape as our subject. This book will help direct your creative efforts to record the best photographs you can of the particular landscapes that lie in front of your lens.

First, we are going to take a look at the gear. A camera and lens are clearly basic, but there are many choices out there. We'll consider the key features you need in a camera, how megapixels might affect your photography, what focal lengths are best for different aspects of landscape photography, and the ways in which important accessories can enhance your photos.

Next, you'll learn how to set your digital camera for optimum landscape work, since the default settings may not be appropriate for you. I hope to shed light on the numerous choices and options for settings, and why you might want to select them in given situations.

Looking east from Valley of Fire State Park, Nevada

Then, you'll find a few chapters that analyze the factors that constitute a good landscape photograph. Implicit throughout is the fundamentally important concept to think photographically: You want to do more than merely document a scene because it is there. A critical attitude is essential for photographers to convert a scene in nature into an expressive photo. You'll learn how to use light and composition to make better landscape images. Composition is particularly crucial in landscape photography simply because your scene is not moving, so you have time to think about the way you want it to look.

The chapter on sky and water looks at these two frequent elements of landscape scenes. While it certainly is possible to photograph a landscape without sky, it is often the sky itself (whether deep blue, threatening to storm, or with puffy white clouds streaming on the horizon) that lends interest (or not) to the picture. And water is always fascinating, whether it is moving, still, reflecting, or with its own color.

After that is a chapter on man and the landscape. This is a departure from most nature and landscape photography books, but just look around and you will notice that mankind is a part of most landscapes in one way or another. We are deeply connected to the land, not separate from it, so why not acknowledge that in our photographs? Whether good or bad, our relationship with the natural landscape is strong and deserves photographic attention.

Special techniques round out the first part of the book. Digital has opened many possibilities for photographers to optimize their cameras and photographs, which we will consider in this section.

Following the special techniques section is a series of short chapters that detail a number of specific landscape themes and tips on photographing them. While most of the general landscape techniques from the book's first section apply to all landscape photographs, there are definite methods and approaches that can be used to get the best from particular types of landscapes.

Finally, there is a chapter that asks if landscape photographs can have a practical impact. Jackson's photography had a huge effect in the United States, but that was in the 19th century. With photography such a common part of our world (so common that much of it becomes mere background noise), how much of a difference can our photos make today? You can probably guess that I believe photos can effect change. But we will explore what that might mean.

> **Note: For additional information, visit
> www.robsheppardphoto.com for digital how-to lessons and
> information on workshops. Also, check out my blogs at
> www.photodigitary.com and www.SeeingCreation.com.**

1 the proper gear

The type of equipment you use will definitely have an effect on your photography. I'm talking about features, not brand names. And although it's great fun to kid other photographers about the particular camera they use, it is often their lenses, tripods, and filters that are more important for landscape photography. We'll look at equipment in this chapter with a very specific focus—how it can help with landscape photography.

Megapixels, Sensor Size, and Image Quality

Before we examine different types of cameras, let's consider a couple of issues that have been at the forefront of debates in the photographic world since digital cameras started becoming popular over the past decade: Megapixels (MP) and sensor size.

What are megapixels all about? Is it worth getting a high megapixel camera with a full 35mm-frame sensor? (I use the term "full 35mm-frame" rather than simply "full-frame" because that is what we are really talking about. The format of 35mm is not actually "full-frame"—in fact, you could call it a cropped frame compared to medium format or 4 x 5. It is simply a format choice that measures 36 x 24 mm.)

The answers to these questions are not simple. They are certainly not so simple as thinking that more megapixels or full 35mm-frame sensors are the surest avenues to improving your landscape photography. In reality, rather than guaranteeing better image quality, the desires for more megapixels or a 35mm-sized sensor are more closely related to the question, "How much do you want to spend?"

Pacific Ocean, Palos Verdes, California.

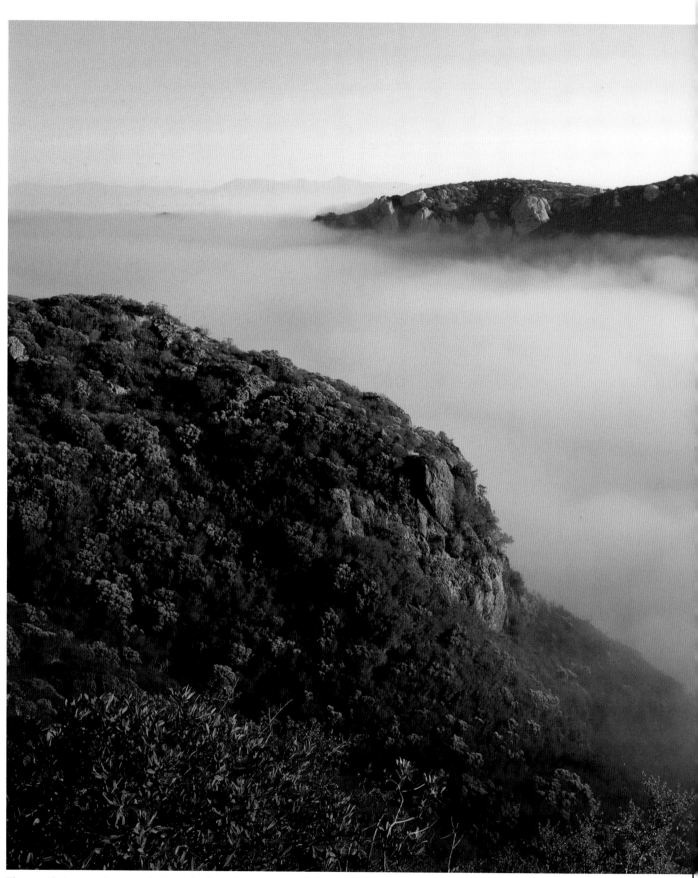

The way that you make your photograph—including camera technique, careful use of light, and interesting composition—has a more important effect on image quality than shooting with a high-megapixel, full 35mm-frame digital camera. Santa Monica Mountains Recreation Area, California.

I want photographers to get the best results for their needs at a cost that enables them to enjoy their photography. As a pro, I am clearly concerned about image quality, but none of the landscape photos I shot for this book was taken with a full 35mm-frame digital camera, nor recorded with more than 15 megapixels (most were 10 megapixels or less). Just having the largest sensor or the highest pixel count available does not mean the best possible image quality. Yet, many photographers want a high-megapixel, full 35mm-frame digital SLR (D-SLR). Those features seem to be some sort of Holy Grail, but I think this may be a mistake for many. The money might well be better spent on lenses and a high quality carbon-fiber tripod with a lightweight magnesium head.

That being said, there are some general advantages to bigger sensors and more pixels. So, what results can you expect when using a high-megapixel, full 35mm-frame format camera?

• Excellent performance at high ISO settings. Sensors with formats smaller than full 35mm-frame, such as APS-C or Four Thirds, deliver fine image quality at ISO settings of 400 or less. At higher ISO settings, the larger format sensor does better. But how often is an outdoor scene recorded at an ISO higher than 400?

• Better use of fast wide-angle lenses, such as a 24mm f/2.8. As we will see a bit later in the text, this type of lens does not give a truly wide angle of view when used with a sensor that is smaller than a full 35-mm frame. So you really need the bigger sensor to use such a lens as it is intended. However, such fast wide-angle lenses are rarely needed for landscape photography.

• A different look from telephoto lenses. This is not intuitive or quickly explained, but you need more millimeters in lens focal length when using a full 35mm-frame sensor for the same magnification effect that you get when using a smaller-format camera. With that

Landscape photography involves being outside, usually during daylight, which means most photos can be shot using the camera's lowest ISO setting. Rarely will you require the high-ISO advantage offered by a full 35mm-frame sensor (e.g. low noise at ISO 400-1600). For example, even though in deep shade, I only had to raise my ISO setting to 250 for this photo. Acadia National Park, Maine.

change in focal length, you therefore see a change in perspective and depth of field. While this can be a creative opportunity, it is not critical for landscapes.

• The ability to make big prints. However, a 10-megapixel sensor in either APS-C (approximately 25 x 17 mm) or Four Thirds format (18 x 13.5 mm) can easily make 16 x 20 or 16 x 24-inch prints that equal the image quality of those from a full 35mm-frame sensor. So, you would have to make prints even bigger than that in order to capitalize on the full 35mm-frame advantage.

• The ability to do significant cropping of the image and retain high image quality. This can be important for sports or wildlife photography, but it is not such a vital factor for landscape imaging.

• A high price tag.

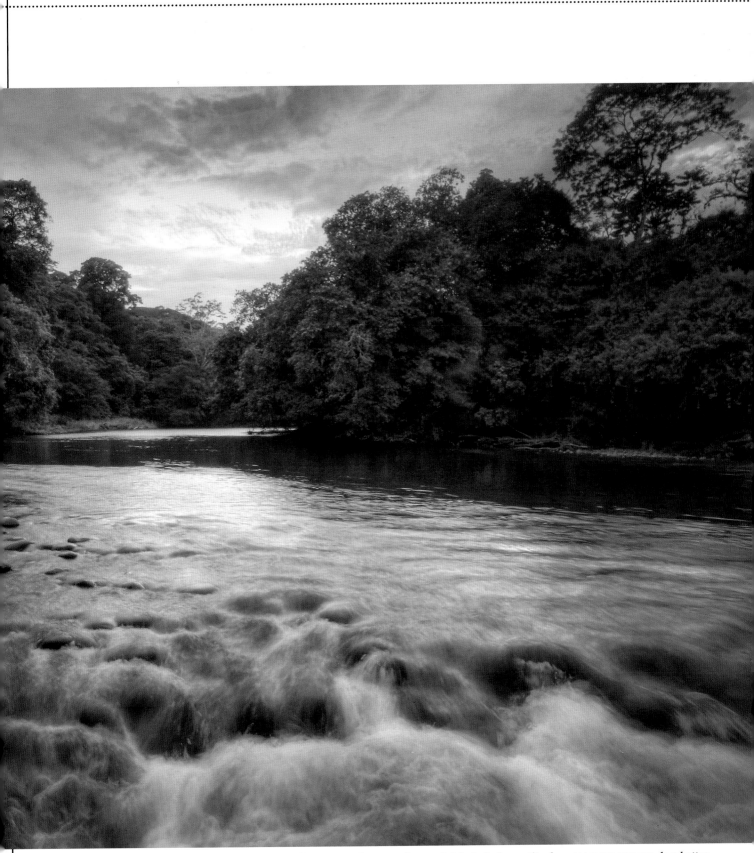

More megapixels may allow more latitude to crop an image or make a very large print, but pixel quantity does not mean you can do a better job of recording detail in high-contrast scenes. Here I relied on an HDR (high dynamic range, see page 138) to insure that both highlights and shadows were properly exposed. Sarapique River, Selva Verde, Costa Rica.

Many people equate more megapixels or full 35mm-frame sensor size with better photos, but as I've explained, a number of different factors contribute to image quality.

In addition, consider the following with regard to the issue of sensor size:

• Because of a technical factor that I call "relative magnification" (see page 26), a small format sensor allows you to use a smaller focal-length lens than a larger sensor while providing the same results in terms of subject size in the image frame. That usually means the lens is significantly smaller and lighter, as well as less costly. For example, at the same maximum aperture, a 70–200mm lens on an APS-C format camera will equal the range (for half the cost) of a 105–300mm on a full 35mm-frame camera, plus offer similar quality, more versatility, and much less weight and size. Or with a Four Thirds camera, that same focal length zoom would give the equivalent of a 140–400mm lens with less than half the size and about a fifth of the price.

• Not only are the lenses smaller, but because the sensor takes less space in terms of camera design, the camera itself is smaller and lighter than those that utilize a full 35mm-frame sensor. This can enhance portability.

• The price you pay for a full 35mm-frame sensor is not going to assure a camera with more quality, features, or options. You are putting most of that money into the big sensor.

• It is true that most of the highest-level pro cameras are full 35mm-frame cameras. They are built to be much more durable than most amateur photographers will ever need. But if you're a sports photographer shooting in all sorts of conditions, or a wildlife photographer going to difficult locations, such a camera can fill a critical need. Remember, though, that these cameras are almost always heavier and more expensive than those with smaller sensors.

I have heard photographers talking about their purchase of a high-priced, high-megapixel camera, and then I continue to listen as they say that a high quality, carbon-fiber tripod and a good, lightweight head is too expensive! We'll talk about tripods for the landscape photographer later in this chapter, but I can guarantee that a good tripod will ensure visibly higher image-quality for landscape work than a camera with more and more megapixels.

A sturdy tripod is a necessity if you plan to record high-quality landscape photos, perhaps even a better investment than an expensive lens or camera body. Pacific Ocean, Palos Verdes, California.

The point of this discussion is not to discourage you from buying a camera with a full 35mm-frame sensor; it is to help you understand what you are really buying in terms of cost effectiveness. You don't have to pay the high price and carry the weight of a full 35mm-frame camera if you don't need its capabilities. Other factors may have just as much, or more, bearing on image quality—if that is your biggest concern—than a large sensor.

At present there are three basic types of cameras to choose for landscape photography: the digital single-lens reflex (D-SLR), the electronic viewfinder (EVF), and the advanced compact digital. It is difficult to shoot landscapes with a true point-and-shoot camera, meaning one that has limited controls other than automatic mode, because its operations are so restricted. Let's look a little more closely at these various types of cameras:

The Digital Single-Lens Reflex (D-SLR)

This is a good choice for landscape work. All digital SLRs available today have plenty of megapixels (enough resolution) to record high-quality photos equal to or better than what was possible with 35mm film. The single lens reflex design is classic. It uses a mirror inside the camera body and a pentaprism (of varied designs) to bend the light coming through the lens into the viewfinder. You see the optical image that is coming through the lens (instead of an electronic video version). D-SLRs have interchangeable lenses, offering a great range of focal lengths, which is an important feature for the landscape photographer. They also offer complete control over exposure and include a variety of metering, exposure mode, ISO, choices of recording format, and much more.

D-SLRs are manufactured for photographers at different levels of photographic skill and interest. These basically break down as professional, advanced amateur, and entry-level cameras.

Types of Cameras

I often get asked, "What camera should I get?" Well, that is a loaded question because it implies that there is such a thing as the "perfect camera" that will fit everyone's needs. Unfortunately, I don't have a quick answer because I don't believe there is a single, arbitrarily perfect camera, even though I have owned and shot with many from every major brand.

People buy different camera models for a variety of reasons. Camera manufacturers have to supply this wide demand or they will lose sales. What makes a camera good for one individual is not necessarily the reason another photographer should choose it. The important thing is to find a camera that meets your needs as a photographer, which include price, shape, size, weight, features, assortment of available accessories and lenses, as well as the skill and artistic levels of photography you want to achieve.

Professional: A professional-level camera is usually the top (and therefore most expensive) model in the manufacturer's line of D-SLRs. But being top-of-the-line doesn't necessarily mean pro cameras always produce the best photos, because image quality is dependent on a number of factors, including the lens used and the user's photographic ability. However, this type does offer the most rugged construction, along with seals designed for the demands of daily shooting in field conditions by on-the-go photojournalists. Pro D-SLRs are big and heavy. They have a number of capabilities, many of which, however, are not really needed by the landscape photographer. These cameras also often have full 35mm-frame sensors, although the top Olympus E-series model has many of these features in the Four Thirds format size.

Advanced: Camera's in this category offer many of the features of professional-level cameras, yet are usually smaller. They do have rugged construction, but are not sealed to the very highest standards against water and dust. They are popular with traveling pros because of their smaller size and weight, and take all of the accessories that their pro siblings do. Most of these cameras use the APS-C or Four Thirds format size sensors, but a few are full 35mm-frame.

Entry: These D-SLRs are not the stripped-down models that were their introductory counterparts in film days. These are often quite sophisticated cameras with a number of useful features. Designed for amateur photographers, they are less robust and often include features that are more automated than those on higher-end cameras, such as a multitude of specific program modes for autoexposure. Some of these cameras are small for a digital SLR, and for that reason may be used by pros when they need to travel light. These cameras use the APS-C size or Four Thirds size sensor.

EVF (Electronic Viewfinder) with Interchangeable Lenses

This is a new camera category. These are small cameras, in some cases very small, that act like a D-SLR with the ability to change lenses, but the viewfinder is not a direct optical view through the lens of the camera. The EVF camera uses an electronic viewfinder, which is a miniature LCD that presents a video display of the signal coming from your sensor. You see what the sensor sees through the lens, but you are not looking through the lens directly and there is no mirror box. In addition, the view can be displayed on the LCD just like Live View capabilities of other cameras. These cameras are hard to beat in terms of portability. So far, they are using a variant of the Four Thirds format called Micro Four Thirds, with some manufacturers planning different formats for release to the market.

Advanced Compact Digital

This type can be categorized into the three styles described below. They are smaller than D-SLRs and have fixed (non-interchangeable) zoom lenses, making them more portable, yet they have most, if not all, of the autofocus and exposure controls found on D-SLRs.

High-Zoom Range: This kind of advanced compact has no comparable film-type model. The lenses for these cameras typically have zoom range factors of 10–24x, definitely long enough for sports and wildlife. This type is fine for landscapes as long as you don't need a wide-angle view shorter than a focal length of about 25mm. Generally, these cameras use an electronic viewfinder (EVF) along with the back LCD for viewing. They have no true optical viewfinder, which allows this design to be more compact.

Small-Zoom Range: This group is similar in capabilities to the previous one except that the lenses have less zoom range, usually 3–7x. Because the lens is smaller, the camera is also more compact. These cameras may or may not have an optical viewfinder, as well as the back LCD for electronic viewing. If no viewfinder, they display an electronic image in the LCD. They often have the means to add accessory lenses that screw on in front of the fixed lens to add additional focal length or close-up capabilities. However, the relatively narrow range of focal lengths is a limitation, and camera controls may be limited as well.

Rotating LCD: In this variation, the scene is live on the LCD, which can move out from the body and either rotate/twist or tilt. This permits you to see the LCD at different angles, so you can easily shoot overhead or down low, plus it makes macro shooting easier. This is becoming an important feature of digital SLRs, too.

Pocket Digital

Full-featured pocket digitals are small cameras that often offer seemingly impossible features for their tiny size. You can carry such cameras at nearly all times, and they include many of the exposure and focus characteristics found in D-SLRs. Many pros tuck one of these into their camera bag so they have a little camera to shoot for fun, but also when shooting in situations where a larger camera is not appropriate. One National Geographic photographer I know uses such a camera to photograph in an unobtrusive, almost invisible way (people don't think he is "serious") that gets him shots in certain locations that a larger camera would not. However, pocket cameras are not really suited for standard landscape photography, and discussion in this book usually does not take these into account.

Lens Factors

Probably the biggest issue that most people have with lenses and landscape photography is whether or not to use a wide-angle focal length, and further, how wide it should be. Wide-angle lenses can be useful for landscape photography, and if you are serious about landscape work, you will want a wide-angle lens sooner or later. However, as with cameras, there is no perfect lens that will create magical results for everyone.

Lens choice is a personal decision and will vary considerably from photographer to photographer. The basics are simple. The lens on your camera controls what the sensor sees: how much of the scene, what is or isn't sharp, perspective, and so on. It is a critical part of any camera, regardless if you can change the lens or not.

To help choose lenses that work for you, it is important to determine in what ways you feel limited by the focal lengths you already have. If your lenses give you a view that is nearly wide enough, but you want just a little more, then there's probably little need to get an ultra wide-angle lens. If, on the other hand, you are unhappy with perceived limitations at the widest focal length in your collection, then you probably want to consider more extreme wide-angle focal lengths.

The same ideas apply to telephoto lenses. Where do you feel restricted when trying to isolate specific aspects of a scene? If you are satisfied with the landscape details you are able to record, then don't bother buying a longer telephoto lens. If you find that you want a certain type of picture and cannot get it, then look at how much of a change in focal length you might really need.

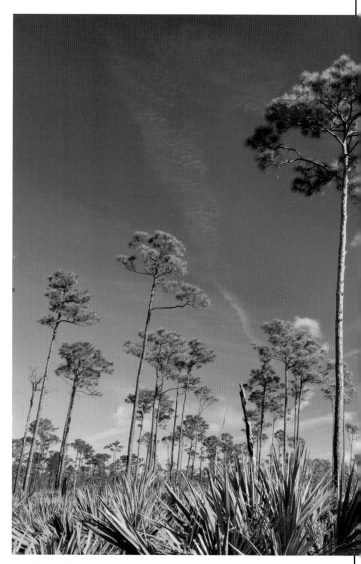

A wide-angle lens can give your landscape a feeling of openness and space, as well as allowing you to include a lot of the scene and the sky. Jonathan Dickinson State Park, Florida.

The most common type of lens used today is the zoom—a lens that can change focal length to "zoom in" and "zoom out" on a subject. Years ago, zooms were inferior in quality compared to prime (single-focal length) lenses. You may still hear that said, but these days it is no longer true. Quality lenses, whether zoom or prime, capture excellent sharpness and detail, and no one is going to pick out photos made with one type compared to the other.

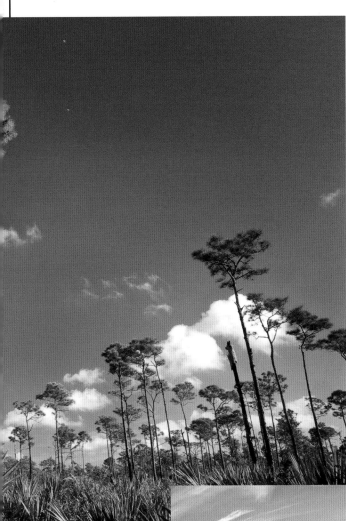

Additionally, I have shot with lenses that range from budget offerings to elite pro models. Sure, the budget lenses do not have the image capabilities of the pro lenses, but less expensive lenses can yield excellent results these days. Computer design and modern manufacturing techniques have allowed companies to build very good lenses quite economically. If you can't afford a pro lens, you can still get outstanding images from low-priced optics. Where you will find big differences are in the finishing—high-end lenses are built to tougher standards so they keep working even if pros happen to abuse them in day-to-day shooting.

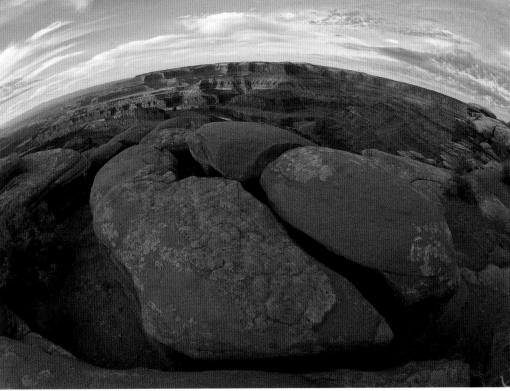

Interchangeable lenses offer you many opportunities for changing the look of your landscape photograph. This image, for example, was shot with a full-frame fisheye to capture an expansive feeling of depth in the canyon lands of Utah. Dead Horse Point, Utah.

Focal Length

The focal length of a lens is a critical element for landscape photography. It can change what a scene looks like and how it is portrayed, and this is much more than simply a wider or narrower view of the landscape. Focal length can affect perspective, depth of field, color relationships, and much more.

Angle of View (Relative Magnification): Focal lengths are typically described as wide-angle, mid-range (including normal), and telephoto. When using 35mm SLRs, these classifications were considered to be approximately 14–35mm, 36–59mm (with the normal range running from 45–55mm), and higher than 60mm, respectively. The reason most landscape photographers buy new lenses is to get different angles of view than those present in their existing sets of lenses. Wider-angled lenses become useful to see more of a landscape. A telephoto, with its narrow angle of view, will bring attention to details in the scene or to distant subjects, such as wildlife.

However, in the digital age, different camera models are built with a variety of sensor sizes, so these traditional descriptions of lenses and focal lengths are no longer sufficient. Without knowing the size of a camera's sensor, it is impossible to know the exact angle of view (what is "seen" by the sensor); you may not even know whether a given focal length acts, in general, as wide-angle, mid-range, or telephoto.

For example, how should we classify a lens with a focal length of 30mm? It is a wide angle when used on a full 35mm-frame camera, but acts as a normal lens with an APS-C sensor, and as a very short telephoto on cameras with a Four Thirds sensor. If you could mount that lens on a pocket digital camera, it would act as a longer telephoto, approximating the angle of view seen when using a 200mm lens or longer on a full 35mm-frame sensor.

Note: This change in angle of view is not new with digital photography. A focal length of 90mm will be a wide angle for a large-format (4 x 5 inches) film camera, a mid-range lens for medium-format (such as 6 x 6 cm or 6 x 7 cm), and a short telephoto on a 35mm SLR.

This relative magnification occurs because the angle of view changes based on both the focal length and the sensor size. A small sensor yields a proportionally small angle of view, which gives more of a telephoto effect. Larger sensors give a larger angle of view, or more of a wide angle. Consequently, you need a smaller focal length when using a small sensor than you do when shooting with a larger sensor to see an angle of view that is equal on both sensors (e.g. a focal length of 50mm used with an APS-C sensor offers the equivalent angle of view that is seen when a 75mm lens is used on a full 35mm-frame camera).

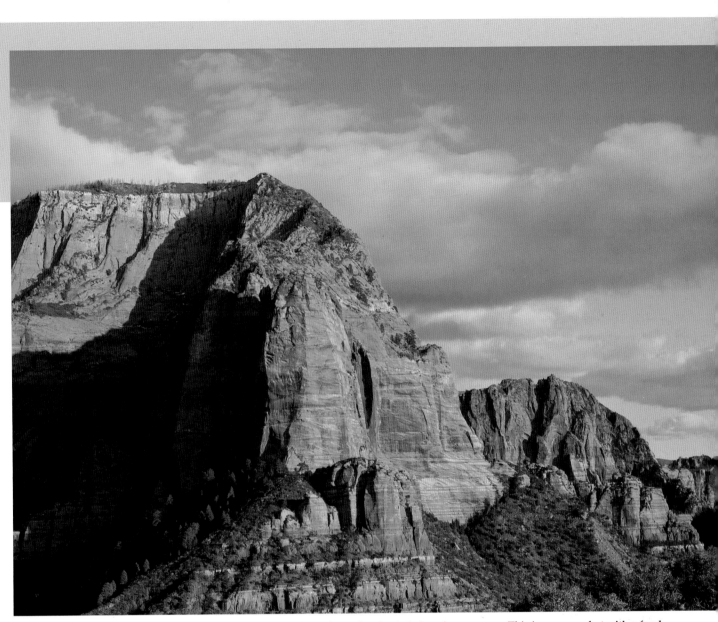

What your camera and sensor see from a given focal length depends on the physical size of your sensor. This image was shot with a focal length of 32 millimeters, which acts like a short telephoto with the Four Thirds sensor used. Shuntavi Butte, Zion National Park, Utah.

Though the subject is relatively larger within the condensed image area of a small sensor compared to a larger sensor, the actual size of the subject remains constant. In essence, a smaller format sees a cropped version of what a larger format sees, whether the sensor is the size of a 35mm frame compared to 4 x 5 inches, or APS-C compared to 35mm.

These factors have created confusion and misinformation about focal lengths and digital sensors. A common misconception is that, for example, a 100mm lens used with a full 35mm-frame sensor becomes a 150mm lens with an APS-C sensor or a 200mm lens with a Four Thirds sensor. That is impossible. Focal length is built into the optics of the lens and cannot change—it is the angle of view, not the focal length, that changes.

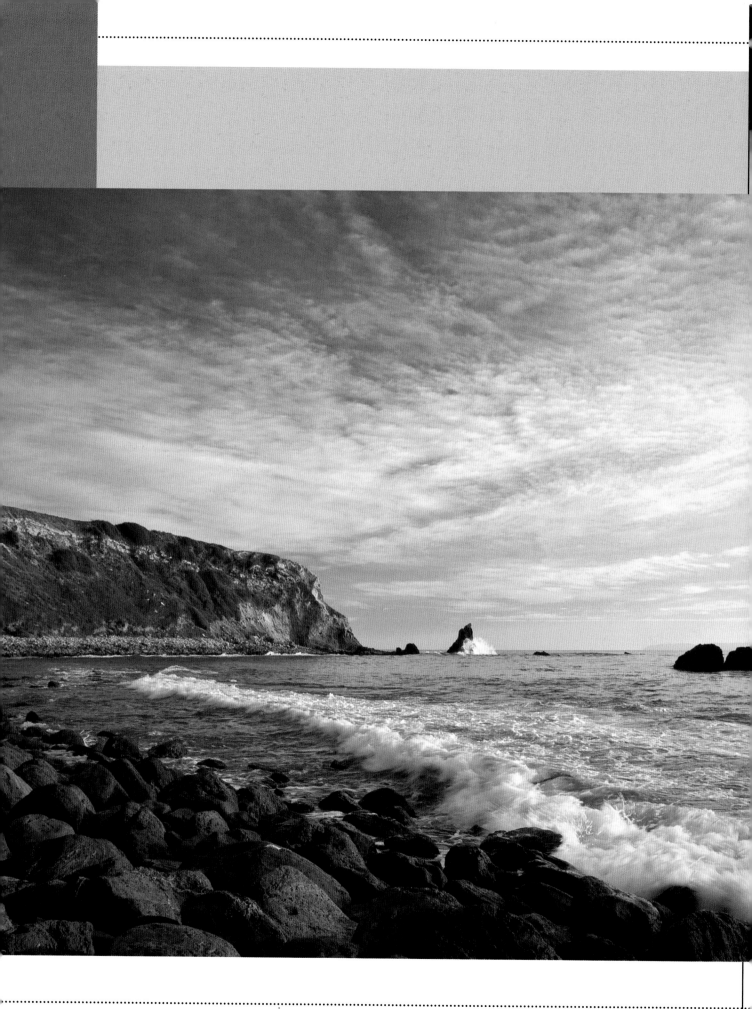

Consequently, since smaller formats, when compared to larger ones, appear to magnify the subject in the image area, you will see a "crop" or "magnification" factor listed with various cameras. That is why a 100mm lens on a camera with a 1.5x factor acts as a 150mm lens would on a camera with a full 35mm-frame sensor. However, this also means that a 28mm lens on the same 1.5x camera will act like a 42mm lens on a full 35mm-frame sensor—decreasing your opportunity to capture wide angles.

So, keep the principle of relative magnification in mind when separating lenses into categories of wide-angle, mid-range, and telephoto, remembering that a lens might be considered wide-angle when used with one sensor format, but not so with a smaller format. Still, we do need to talk generally about the way lenses work in terms of wide-angle, mid-range, and telephoto.

Wide Angle: Wide angle means that more of the subject and its surroundings are increasingly seen as the focal length gets shorter (occasionally you will hear wide-angle lenses referred to as short lenses). One result is a decreased subject size in the viewfinder.

Several things about short focal lengths become important to remember for landscape photographers. First, a wide-angle focal length allows you to see more of the landscape when you are standing at a single location and cannot move farther back. Second, a shorter focal length will pick up more foreground than a longer one if the camera is pointed down, or more sky if the camera is pointed up. In 35mm photography, a wide angle is typically considered as any focal length of 35mm or less, although for landscape work this usually becomes 28mm or less. Consequently, it requires a focal length of 18mm or less to record a wide-angle landscape using a camera with an APS-C sensor, while the focal length would be 14mm or less for a wide-angle landscape using a Four Thirds system camera.

With a wide-angle lens, you can capture more of the subject and its surroundings. This allows you to show setting and space. Pacific Ocean, Palos Verdes, California.

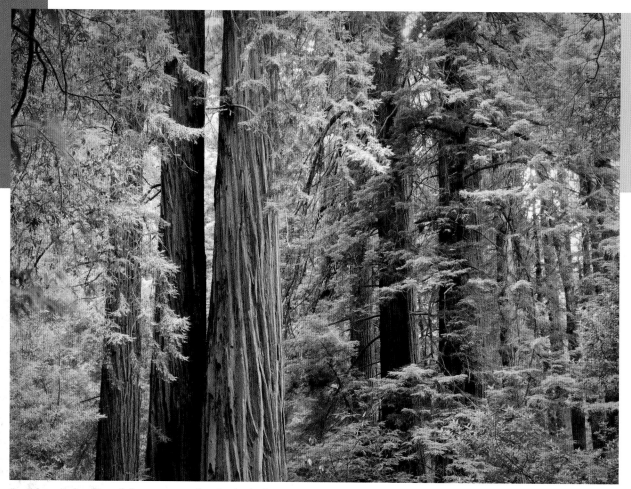

A mid-range focal length has a perspective that is similar to what we see with our eyes. It lets you focus on tight relationships within the landscape, like these groups of giant redwood trees. Muir Woods, California.

Mid-Range: Mid-range focal lengths see the world in a moderate way, neither too wide nor too narrow (telephoto). This category includes "normal" focal lengths.

Naturally, normal varies from format to format, but in general it refers to lenses that see the world in a perspective similar to how we see a scene with our unaided eyes. In 35mm film format, this is typically from 45–55mm. Using an APS-C sensor, normal focal length is 30–37mm, and is about 22–28mm for Four Thirds. Meanwhile, the full class of mid-range lenses includes somewhat shorter and longer focal lengths on either side of the normal range.

Telephoto: Telephoto refers to any lens that is longer in focal length than a mid-range lens. Telephotos see an increasingly narrower portion of the scene as the focal length gets longer (you will often hear telephotos

referred to as long lenses), and the subject becomes progressively magnified. The telephoto range itself is usually divided into short (50–90mm on a camera using an APS-C sensor), medium (90–140mm with an APS-C sensor), and long (200–350mm).

Perspective: In addition to angle of view, perspective is another important visual effect that is altered by your choice of focal length. The term refers to the way objects in a scene change in size as they are seen closer or farther from the camera. That relationship between size and distance is very important. You can easily change the size of an object in your photograph by zooming, but you have not changed your distance to that object, so perspective does not change.

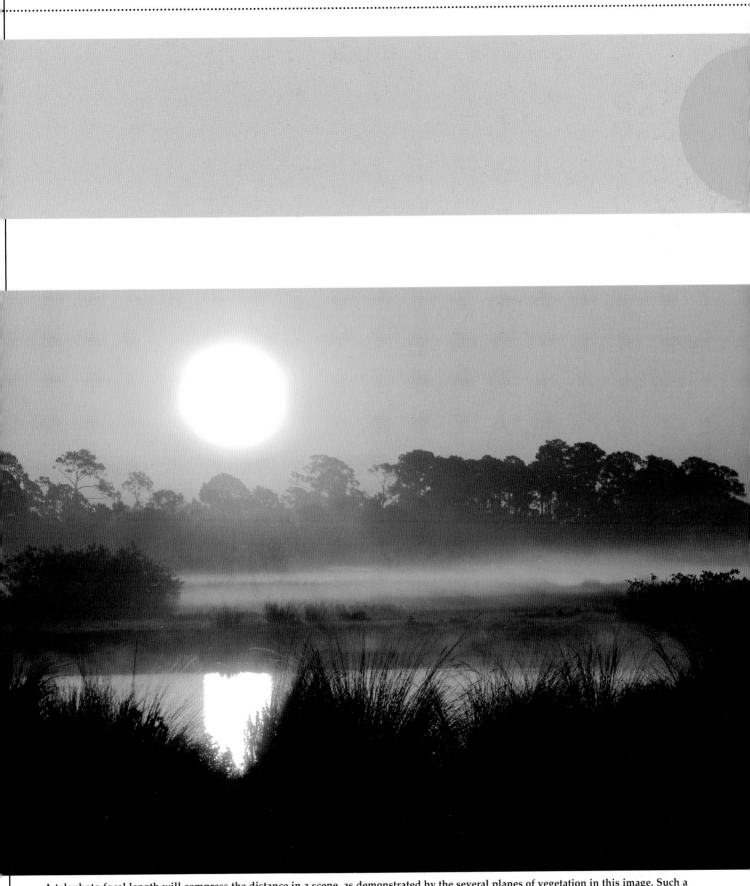

A telephoto focal length will compress the distance in a scene, as demonstrated by the several planes of vegetation in this image. Such a focal length will also allow you to record a large sun if that is an object in your landscape picture. However, be very careful of staring into the sun with a telephoto lens. Merritt Island National Wildlife Refuge, Florida.

For example, imagine that you pick up two rocks of the same size from the landscape in front of you. If you hold one close to your eyes and keep the other at arm's length, the one closer looks bigger—that's perspective. If you hold them at the same distance, they are the same size. A painter will create the appearance of perspective or depth in a painting by changing this relationship—when the artist puts these rocks onto a plain background, he or she can make them look the same size or radically different sizes, changing how you see the distance between them. Perspective is all about this relationship of size and how we perceive distance.

By changing focal length at the same time you change your distance to a subject, you can alter how perspective looks in a photograph. This is so important that I need to repeat it: Change both your distance to the subject and the focal length you are using to control perspective in a composition.

You can quickly see this if you put a zoom lens on your digital camera. Find or place a subject that is a little distance in front of a distinctive background and set the widest focal length on your zoom. Get close enough so that the subject fills your viewfinder from top to bottom, and take the picture. Next, zoom in to the longest telephoto setting and back away from your subject until it once again fills the picture from the top to bottom (you are keeping the subject the same size in the photo).

You will immediately see a change in the background when you compare the two photos. Even though you know the distance between the subject and background did not change, it will look like it did! The wide-angle shot will have a background that looks much farther away from the subject than the telephoto image. The wide-angle image therefore has a deeper perspective, while the telephoto has a flatter perspective.

This is a valuable concept to understand for landscape photography. If you have a subject, such as a group of flowers, surrounded by other objects behind that may be visually distracting, you might choose a wide-angle and get close to the flowers. This makes the background objects smaller because perspective has been stretched.

On the other hand, if you want to make the subject look like it is close to a stand of trees or group of mountains in the background, you can use a telephoto to compress the distance between them. With extra long telephoto lenses, this can make objects look like they are right on top of each other when, in reality, they are not. This is an old Hollywood trick used, for example, to make a movie hero look as though he or she is about to be run over by a truck when the vehicle is still a safe distance away.

Use perspective control for creative effect or to simply make a livelier and more interesting photo. A sun setting over the mountains may look fine with a mid-range focal length, but when you put a strong telephoto lens on the camera, mountain ridges will become compressed and look closer together, making a more dramatic scene against a larger sun. Or, with a really wide-angle lens, you can get close to a subject so it dominates the image.

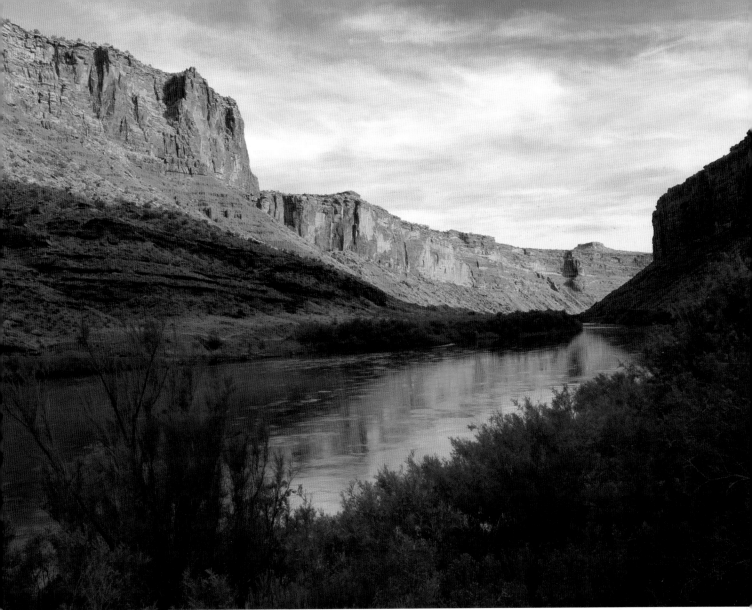

A wide angle and a small aperture help increase depth of field, recording a sharp scene from front to back. Colorado River near Moab, Utah.

Depth of Field: Depth of field is the amount of sharpness from foreground to background within a photograph, which is important because we usually want to control how much of the scene from front to back is in focus when shooting landscape photos. Four things affect depth of field:

1. Focal length
2. Aperture (f/stop)
3. Focusing distance
4. Size of a displayed image

The shorter the focal length of a lens, the greater the apparent depth of field. Conversely, as the focal length increases, apparent depth of field decreases. This is a significant principle for landscape photographers. If you want your background to be more clearly seen behind your subject, you might change to a wider-angle focal length to increase depth of field. If you want that background to be less dominant and somewhat out-of-focus, you could change to a longer focal length.

A shallow depth of field can either focus on the foreground and blur the background (above), or focus on objects farther away while blurring those that are close. Sullivan's Island, South Carolina. © Kevin Kopp.

Landscape photographers often shoot with a wide-angle lens to gain a feeling of depth (from perspective) and sharpness (from more depth of field). Photographers who like to record people, on the other hand, will typically do just the opposite—shoot with a telephoto lens to produce a shallow depth of field and make the subject stand out from the background.

Aperture also affects depth of field. A small aperture (large f/number such as f/11 or f/16) creates deep depth of field, while a wide aperture (small f/number such as f/4 or f/2.8) reduces it. Both are creative controls in photography. An extensive depth of field can be important for showing detail in a landscape, from the flowers in the foreground to the mountains in back, but can make an image confusing if you are trying to focus the viewer's attention on the flowers. In such a situation, you often want much less depth of field so that the background is not as sharp as the flowers, making it much easier to show the flowers as the subject of the shot.

The distance between the camera and the subject also modifies depth of field as you focus closer or farther away. A close focus-distance will make depth of field shallower; farther away will increase depth of field. This is why close-up or macro photography can be challenging for sharpness—depth of field gets very shallow no matter what settings you may try. On the other hand, you can focus on a mountain or some other subject in the distance and not worry much about depth of field. The distant subject will pretty much be sharp no matter what camera settings you make, as long it is in focus.

All of these factors (focal length, f/stop, and subject distance) work together. Your most shallow depth of field comes from a wide aperture used on a telephoto lens at a close distance. The most depth of field results with a small aperture used on a wide-angle lens when the subject is far away.

The fourth factor, display size, only comes into action when you display a photo. A small print, for example, will appear to have more depth of field than a large print.

There are many things to consider when choosing a lens: focal length, f/stops, special lens elements, and more. How a lens handles on your camera, in addition to its size and weight, can also be a factor to think about.

Lens Features

As you consider lenses to use with your digital camera, you will find a number of features that can qualify how well a lens will work for your specific needs. Not all features are available in all lens types and focal lengths, nor are they needed for all photographers. However, when you do need them, they are worth considering.

Maximum and Minimum f/stops: Both maximum and minimum f/stops have a strong influence on how a lens can be used. The maximum f/stop is the widest aperture possible with a lens, for example, f/2.8 or f/4. It helps determine how bright things are in your viewfinder, and how well you can photograph in low light.

The minimum f/stop is the smallest aperture that can be set on a lens, for example f/16 or f/22. The opening for the minimum f-stop can get so small that the image will be degraded by diffraction of the light coming through the opening. Indeed, at the smallest apertures (high f/numbers), the lens opening can become so small that the lens becomes less sharp from the optical effects of diffraction.

Special Lens Elements: Uncorrected lenses have aberrations that lead to problems. For this reason, all camera lenses are highly corrected to deal with these defects that can cause color fringing (false colors appearing along the edges of dark objects near the outer borders of the image) and softness (decreased sharpness due, in this case, to blurring of highlights). There used to be a big gap in lens quality from the budget lenses to the most expensive pro models, but that is much less true today. Still, more expensive lenses, and even newer lower priced lenses, will often have special lens elements to give even better lens correction. These include apochromatic (APO), low-dispersion glass, diffractive optics (DO), and aspherical lens elements.

IF (Internal Focus): Internal Focus is a relatively recent development in lens design. Originally, all lenses focused by moving part of the lens closer or farther from the focal plane in the camera. But as lenses became physically larger, the form and balance started to change and the lens often became unwieldy. Internal Focus uses optical mechanisms inside the lens to allow focusing to occur with no change in the outer dimensions of the lens. In addition, this allows the lens to

focus without rotating the front element, making certain filters (such as polarizing filters) easier to use, which can be a big deal for landscape photography.

Image Stabilization: During the mid-1990's, Canon introduced a type of lens to still photography called an IS (Image Stabilization) lens that had an internal mechanism to shift lens elements to compensate for camera/lens movement during exposure. This allowed for sharper images at slower shutter speeds. Other manufacturers followed the Canon lead and now offer a similar function in their line; some include vibrating sensor technology within the camera's body to compensate for camera movement. While these features generally work well to help photographers handhold lenses at slower shutter speeds than normal, a tripod is still the best method for stabilizing your camera during landscape photography.

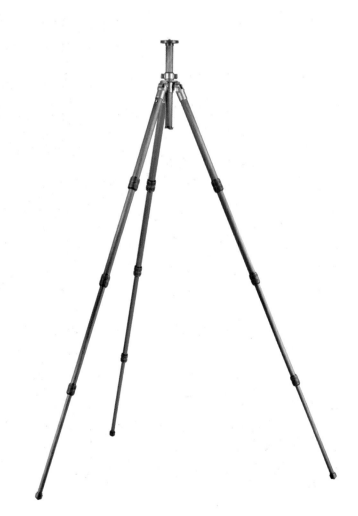

Tripods

I often hear photographers debating the merits of different cameras, sensor formats, quantity of megapixels, and so forth. I rarely hear them talking about tripods. Yet, investing in a good tripod can make a huge difference in the quality of your images. An inexpensive lens will outperform any pro lens in landscape photography if it is mounted on a camera that is supported by a tripod while the high-end lens is not.

I made an investment (and I definitely consider it an investment) in a high-quality carbon fiber tripod and a sturdy, lightweight magnesium ball head. I consider this one of the best photographic investments I have ever made. This is a very lightweight tripod and head combination, so I never have a problem of taking these items with me on any type of photo shoot.

Participants in workshops will sometimes complain about their heavy tripods. I ask them to try holding mine. Expecting a lot more weight, they grab it and will often say, "Wow! That's light." But when I tell them the tripod and head cost over $600, they think that is too much to spend, even though they will talk about buying a new lens for twice that price! However, I guarantee that purchasing a good tripod will produce better, consistently sharper photographs than buying any lens on the market.

Look for a tripod that is sturdy when set up to its maximum height. Also, look for the ability to set legs at varying angles and lengths so you can more easily place a tripod on uneven ground. I highly recommend carbon fiber tripods with a solid, yet lightweight, head. Most landscape photographers like ball heads for their tripods; however, a good pan-and-tilt head can be just as good, and will often work better for photographers who like to have very precise control over their camera movement.

A tripod gives you a stable platform for your camera so that you can shoot slow shutter speeds and still get

These two photos (right, top and bottom) are of the same location and framing. Notice how different they look, due to the use of a polarizing filter for the bottom picture. The polarizer strongly affects contrast in the image, as well as the richness of the color in water and the sky. Pacific Ocean, Palos Verdes, California.

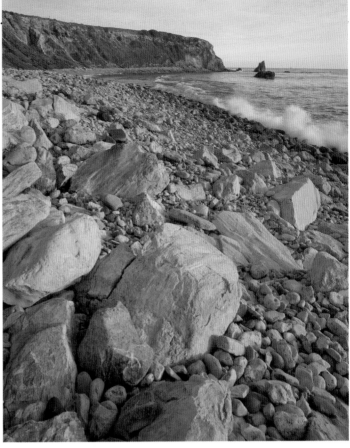

optimally sharp landscapes. In addition, a tripod is helpful because it allows you to set up your shot, take a picture, check that photo in your LCD, and decide if you want to make any changes to the composition. Since your camera is on a tripod, such changes are easy.

Filters for Landscape Photography

There is a large variety of photographic filters available, but there are two that all landscape photographers should own, even if they have no others. These are the polarizing filter and the graduated filter (or split ND—neutral density).

The Polarizer

The polarizing filter, or polarizer as it is often called, changes the way light hits the sensor. You use it by rotating it in front of your lens—the rotation changes the effect. It can do four key things for your photography:

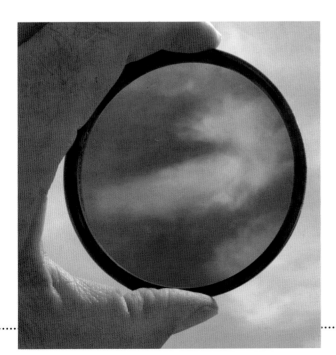

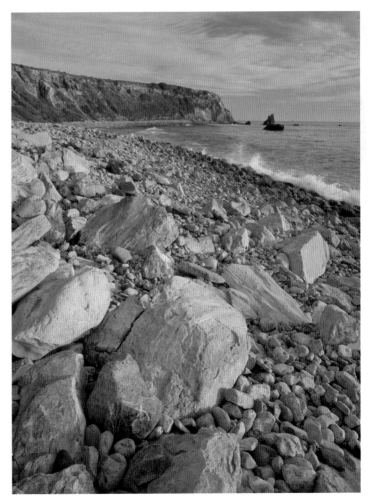

1. A polarizing filter will make blue skies darker and create contrast with clouds, but the effect depends on the angle to the sun at which the camera is pointed. The maximum effect occurs when the sun comes from the side (90° angle) as you are photographing—that's not a bad direction for landscape photography. The minimum polarizing effect (and sometimes none) occurs when you photograph directly toward or away from the sun. This changing effect can pose a problem when using a polarizer on a wide-angle focal length to record an expansive landscape, since the sky is not likely to be uniform in tone. Also, you may find that skies at high altitude, or during the winter, become too dark from a polarizer. In some cases they become almost black, which can be used as an effect if you want drama, but it can make a scene look rather harsh.

2. It will reduce or remove unwanted reflections on water. You may find, however, that the effect is too strong if the water disappears, making the photo look odd (a good thing to watch for in the LCD playback). You can then rotate the filter so some of the reflections return.

3. A polarizer will greatly lessen glare from shiny objects, causing them to look enriched by allowing their underlying colors to come through. This can create a dramatic effect in landscape photography by removing the glare from leaves in your scene—the greens will really pop—which can be as important as dark skies when recording landscapes.

4. Additionally, polarizing filters diminish the effect of light haze and make the image look more contrasty. However, polarizers cannot perform miracles by removing haze altogether, nor do they have an effect on heavy haze or foggy conditions.

To test the effect of a circular polarizer, hold it up to your eye in the field and rotate it. Decide then if it is worth using or not. It is not a good idea to leave the polarizer on all the time because it can affect autofocus, significantly reduce exposure, and with a digital SLR, make the viewfinder much darker and difficult to see through. When you place a polarizer in front of the lens and rotate for best effect, check the image results immediately on your LCD. You might even want to compare images with and without the filter.

The Graduated Filter

This filter is so named because half of it is clear while the other half is dark, with a graduated (blended) tone across the middle. When the dark half is a neutral tone, it is also called a split ND filter for split neutral density. (You can get these filters in sky blue colors to enhance skies or sunset colors to enrich sunrise or sunsets.) These are often simply called grads, as well.

Graduated NDs help balance the light in a scene. They are commonly used by landscape photographers to help moderate extremes in tonalities between bright skies and dark ground. By rotating a circular filter screwed into the front of the lens (or sliding it in its holder if it is rectangular type), the dark part of the filter can go against the sky while the clear portion is across the ground. In this way the bright sky is reduced in tone, yet there is no effect on the ground.

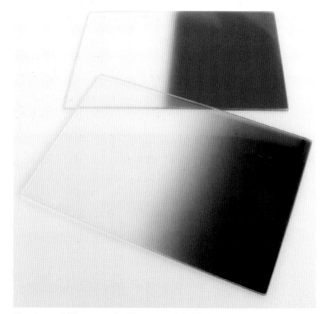

Graduated filters are half gray and half clear. They come in different strengths and in different blends through the middle of the filter.

Graduated filters come with different blends across the middle. The most common is a soft edge that blends the dark and light parts of the filter quite gently. These are quite easy to use. Just put one over the lens, position so the scene looks right, and take the picture. Check the exposure on the LCD if you aren't sure of your results. If it isn't quite right because the filter is not positioned properly or the lighting conditions are exceptionally difficult, make an exposure adjustment and try again.

Another common grad is the hard-edged split. This has a sharp edge across the middle boundary between light and dark and can be used when there is a distinct edge between light and dark areas in the image. You do have to be careful that a hard-edged split does not show up in an image shot with a lot of depth of field, because that can awkwardly make the edge noticeable.

Memory Cards

Memory cards are a critical part of your digital camera. They are where the recorded digital images are stored as you shoot. They come in several different types, the most common being CompactFlash (CF) cards (often in larger cameras) and SD cards (typical of small cameras).

The storage capacity and speed of memory cards has increased dramatically over the past several years, while prices have correspondingly dropped. You can take many more pictures using a card than you could ever get from a roll of film. They affect camera design, but they don't offer photographic features independent of cameras, so they should never affect a choice of a camera.

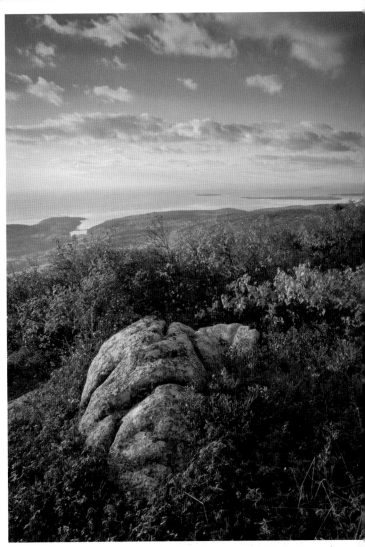

A graduated filter darkens the sky in this photo, while the bottom of the picture stays bright through the clear part of the filter. Cadillac Mountain, Acadia National Park, Maine.

Some key features include:

• Capacity determines how many photos a card can hold. More gigabytes, more photos.

• Memory cards are relatively cheap now. Buy more than you need in order to guarantee that you never run out of memory while shooting photos.

• The speed of the memory card does not affect camera speed. How fast a camera can shoot is totally dependent on the internal file handling capabilities built

Some cameras now have the ability to use more than one memory card for added recording capacity.

into that model. Card speed, meanwhile, will affect how fast the camera buffer is downloaded to the card, and to a degree, how fast images can be downloaded to the computer.

- Memory cards are usually quite durable. Most are solid pieces of plastic with the electronics imbedded in them. CF cards are nearly indestructible, even dropping them or getting them wet rarely causes any damage. SD and xD cards are also very tough. However, smaller and less substantial than CF, they could be cracked or deformed more easily (though still not without some effort). One type that can have durability problems is Microdrive, a memory card sized like a CompactFlash card, but with a tiny hard drive inside. They are relatively low-priced, but dropping or getting them wet easily damages them.

There are a few common misunderstandings about memory cards. To set the record straight, know that you cannot wear out a memory card. And you cannot hurt a memory card by erasing images from it, although it can get corrupted (sort of like becoming "confused") if you erase too much without formatting the card. Most problems with memory cards come from not for-matting them regularly, a procedure that is usually found as a selection in the menu system.

You should also check a brand-new card immediately to be sure that it works properly. If a card is going to fail, it will often fail within the first several uses, and you don't want this to happen on a special photo trip. Shoot some images with a new card and format it right away to be sure that it all works properly.

Be sure to test some shots with your memory cards before taking them into the field. You don't want to hike into a great location and then find that one of your cards has failed. North Shore, Lake Superior, Minnesota.

Recording Format

Most digital cameras, except for the basic pocket point-and-shoot style, offer the choice to select JPEG, RAW, or, in many cases, the RAW+JPEG image formats. This selection affects how the image is recorded to your memory card. Both RAW and JPEG are capable of producing images of excellent quality.

JPEG

JPEG is a compressed format that reduces the size of the image file and allows you to store more photographs on a memory card than you can when recording the larger RAW files. This was important several years ago when most memory cards had relatively small capacities, but is less so today with the abundance of high-capacity cards.

JPEG is a finished file in many ways because the camera processes the raw data coming from your sensor and sensor-related electronics into a JPEG image that can quickly be used anywhere. For instance, any local lab, including those at drug stores or other consumer chains, can print JPEG photos. Or, you can often simply put your memory card into a home printer with card slots and print photos directly from the card.

JPEG holds the quality from your sensor quite well and retains the full megapixels of your camera. However, you can usually select a level of JPEG compression (called quality) in your camera. As compression of the file increases, there is the potential to lose fine detail. For that reason, you should set JPEG to its highest quality setting (you can always compress a high-quality JPEG later in the computer if required, but you can never "sample-up" to the same quality when you start with a lower quality JPEG file).

Your camera will usually produce decent landscape pictures when set to its default options, but you will not get the highest possible image quality unless you understand how to set the camera to optimize it for taking the best photos in particular situations and conditions. Manufacturers design their cameras to do a good job with nearly every type of photography. But, as we all know, making a device "good" for all purposes most often means it is great for none.

Consequently, there are several adjustments you will want to make to your camera so that it will give you the best results in the field. You may need your camera's instruction manual handy for this chapter, as the controls we will examine are not always in the same location on all camera models.

Double Arch, Arches National Park, Utah.

A RAW file contains more image information compared to a JPEG file, including a great deal of data about the tones and colors in your photograph. This gives you more flexibility in processing your image. Great Smoky Mountains National Park, Tennessee.

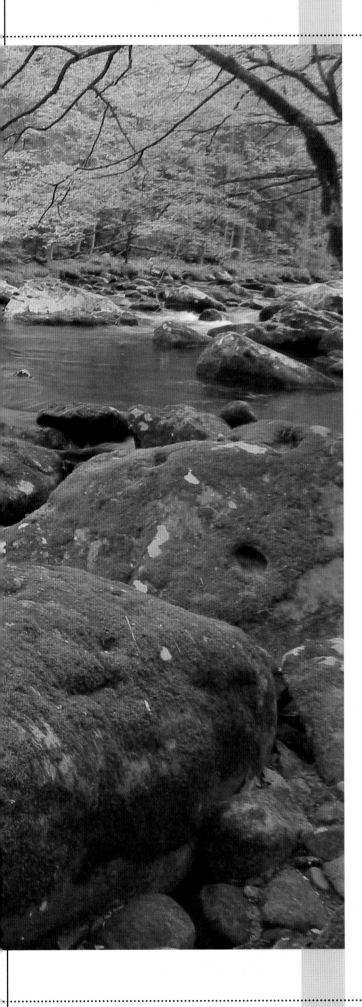

RAW

A minimal amount of processing is applied to RAW files in the camera—much less than that applied to JPEGs—to slightly enhance such attributes as color and tonality. RAW files contain a much larger amount of tonal and color information than JPEGs. This additional file information is not to be confused with the number of megapixels used by your camera's sensor (resolution). If you record a RAW image and a JPEG image on a 12MP sensor, both will have the same quantity of pixels—12MP—as long as the JPEG is shot at the maximum size and quality. But RAW's added file data offers much greater flexibility in processing the image in the computer.

This idea is sort of like using a box of 12 crayons to color a picture versus a box that contains 48—the box of 12 gives you everything you need to make a beautifully colored picture, but the box of 48 gives you more options for using shades of color and nuance. Not only does RAW provide greater processing flexibility, it also gives more tonal and color information than JPEGs within the dark and light portions of the image. This means there is greater potential for revealing detail in dark trees and white clouds when shooting landscapes. However, RAW files take up considerably more space on your memory card and in the computer.

One challenge with RAW is that you do not always have straightforward access to the files—you can't simply open them directly in your computer or send them right to your desktop printer or local photofinisher. Specialized software (such as Adobe Camera Raw, Lightroom, and others) is required in order to read and translate the RAW format. In addition, unlike the JPEG standard that is ubiquitous and accessible to everyone with a computer, RAW files are proprietary, meaning each camera manufacturer produces their own version. This can cause a problem for cameras recently introduced to the market because there is always a lag time of weeks to months before updated versions of third-party RAW conversion software are able to open the RAW files from new models (the software company must first get a copy of the RAW files after they've been issued by the manufacturer and then develop software conversion capabilities for them).

RAW + JPEG

Many photographers shoot RAW+JPEG when that option is available on their cameras. This selection simultaneously records a RAW and a JPEG file. While producing two files per image increases the space taken up on the memory card, you can buy high-capacity cards at reasonable prices to ensure plenty of storage. You will be able to view your files wherever you have access to a computer since any program that recognizes images will be able to open at least the JPEG component of this combination. In addition, RAW+JPEG gives you the chance to quickly make prints by using the JPEG half of the partnership.

The LCD

It's a good idea to customize how the LCD will function on your camera during review (seeing the picture immediately after shooting) and playback (looking at any recorded image on the camera's memory card as leisurely as you wish). By default, most digital cameras have the review time set too short for adequate viewing, and the auto-rotate function set to active. As a result, you are not using the LCD viewing area as efficiently as possible.

First, check your review time, which is usually set in one of the camera's menus. This is the length of time the LCD comes on and displays your photo right after you take a picture. It allows you to see the picture you've just made, offering a quick check on exposure (although, as you'll see later, this is not the best way to confirm a good exposure), white balance, focus (especially when you can magnify the display), and composition. A setting of 8–10 seconds is good. While a long review time theoretically reduces battery life, this duration should not be a significant issue with new cameras. You can always end the review time on a case-by-case basis by lightly pressing the shutter release. That turns off the review and returns the camera to shooting mode.

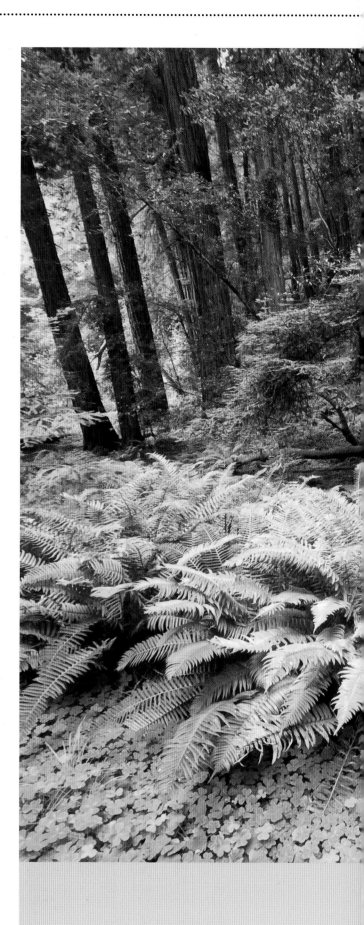

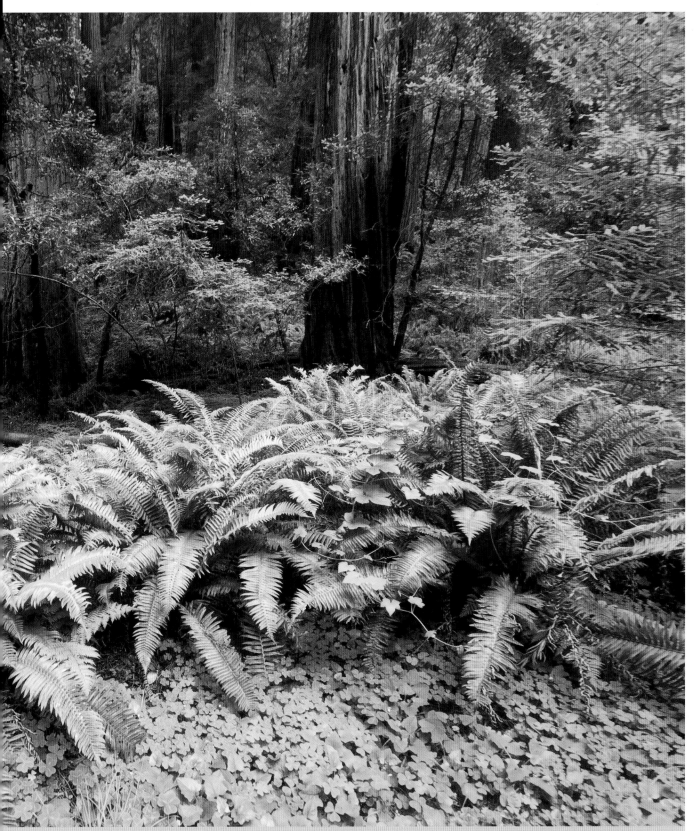

There are advantages to shooting both RAW and JPEG files at the same time. The RAW file gives you more to work with when processing the image. The JPEG file gives you instant access to the photograph for printing on location or attaching to an e-mail. Muir Woods, California.

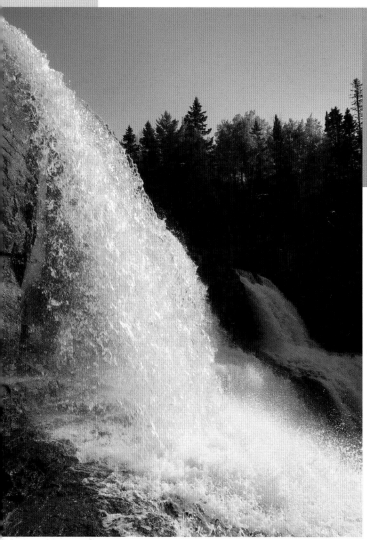

Bright waterfall highlights can be important in terms of detail, so you will want to pay attention to your camera's highlight warnings when photographing such subjects. Gooseberry Falls State Park, Minnesota.

Highlight Warnings

During playback, most digital SLRs offer the capability to show where highlights have been overexposed in a scene, and it is beneficial to learn how to set your LCD display to show this. Check your camera's instruction manual (or the appropriate Magic Lantern Guide, published by Lark Books), because this feature is one that is often accessed differently from manufacturer to manufacturer.

Highlight warnings usually display as blinking spots on your LCD where highlights are overexposed. We'll be discussing exposure for landscapes later, but keep these highlight warnings in mind. You may be underexposing your image if these warnings are completely absent. A good way of using them is to take a picture and check your playback to see if they appear. If they are showing up over most of an important part of your scene, the sky perhaps, then you need to reduce exposure. I will typically decrease exposure until they show only in small highlights that do not need detail.

On the flip side, if these warnings do not appear at all, you need to increase exposure until they just start to show in the review display.

Exposure Modes

Of course, the amount of light that strikes your camera's sensor is of paramount importance. Your camera will have several exposure modes to control this: typically Program, Aperture Priority, Shutter Priority, and

Second, find the camera's auto-rotate function. This is usually in a set-up menu, and most cameras offer the option to turn off this feature. Auto-rotate flips vertical images so that they display vertically in the LCD when the camera is held horizontally, in which case your LCD is not being used to its full capability. When a horizontal image is displayed in the LCD, it fills the entire screen. When a vertical image is displayed, it will fill the entire LCD only if it is not rotated—it fills the screen by lying on its side, so to speak. Rotating a vertical image inside the horizontal frame of the LCD requires the long side of the photo to fit into the short side of the screen. You can lose as much as half of the LCD display, and that screen is an expensive part of your camera. So you are not getting your money's worth when auto-rotate is active, plus you will be able to see details in the LCD much more clearly when this feature is not on.

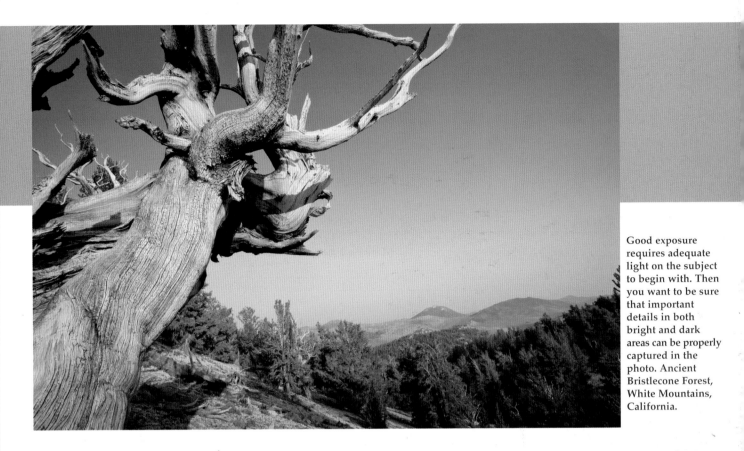

Good exposure requires adequate light on the subject to begin with. Then you want to be sure that important details in both bright and dark areas can be properly captured in the photo. Ancient Bristlecone Forest, White Mountains, California.

Exposure is about choosing f/stop and shutter speed. In this image, a long exposure was important to capture the movement of the water. Gooseberry Falls State Park, Minnesota.

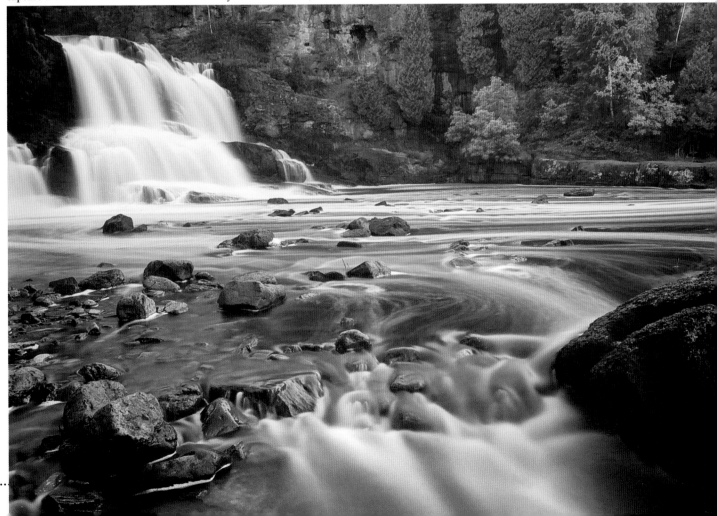

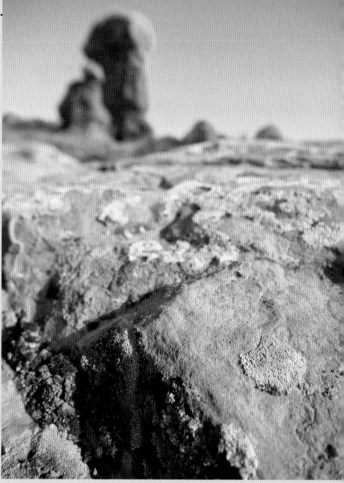

Manual; plus special program modes such as Close Up, Landscape, Sports, and Portrait, among others. While it is possible to record nice photos using that pro-grammed Landscape mode, you will find that Aperture Priority and Manual exposure modes give more control over the image. These are the two most often used in landscape photography, and the two that I almost always use. It is simpler, with fewer decisions to make in the field, to concentrate on using just a couple of the various exposure modes.

Aperture Priority is the mode that utilizes the maximum capabilities of the camera's built-in exposure metering system (see page 68 for information about metering). You set the aperture and the camera measures the light and sets the shutter speed appropriate for the conditions as read by the system.

The choice of aperture (f/stop) is a critical one for landscape photography because it affects depth of field (sharpness from close to far in your scene). A small aperture creates deep depth of field, while a wide (or large) aperture reduces it. Depth of field is a creative control in photography: An extended depth of field can be very important for showing detail in a landscape, from the flowers in the foreground to the mountains in back. But sometimes you want less depth-of-field to emphasize a particular portion of a scene, making that area sharp and everything else less so.

Here you can see how changing the f/stop affects depth of field. The top image depends on a large aperture of f/2.8 to create a minimal depth of field, while the bottom image is based on an aperture setting of f/16, producing much more depth of field. Arches National Park, Utah.

The chart on the next page helps you visualize depth of field and f/stops. Keep in mind that apertures (f/stops) are relative. A change of one full f/stop either doubles or halves the light coming through the lens—if the aperture is larger, the light is doubled; if smaller, the light is halved.

With Manual exposure mode, you set both aperture and shutter speed. This typically does not use the full multi-point metering capabilities of the camera, but it does give you total flexibility to set an exposure for artistic control or deal with difficult lighting conditions.

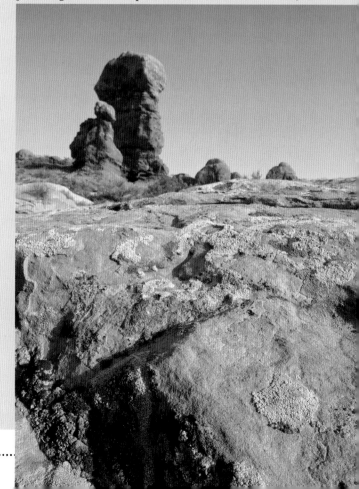

f/number (in whole stops)	Aperture Size	Aperture Visual	Depth-of-field
2.0	large	⃝	least
2.8	decreasing	⃝	increasing
4	continues to decrease	⃝	continues to increase
5.6	continues to decrease	⃝	continues to increase
8	continues to decrease	⃝	continues to increase
11	continues to decrease	⃝	continues to increase
16	continues to decrease	⃝	continues to increase
22	small	⃝	most

This chart demonstrates the relationship between aperture and depth of field.

Manual exposure can be useful when conditions require flexibility in how you set exposure, including using a long exposure to allow enough light while still retaining an adequate depth of field within this relatively dark setting. Olympic National Park, Washington.

The control afforded by Manual exposure mode, for example, allows you to easily slow the shutter to a speed that provides the appearance of silky smooth water as it flows in a stream or water falls.

In-Camera Processing

All digital cameras process image files. RAW files are minimally processed for color and noise reduction as the analog image signal coming from the sensor is converted to digital data for storage. JPEG files are basically automated RAW conversions done in the camera. Because of that, most cameras allow you to select options and variations on how this JPEG conversion is processed. Camera manufacturers have not standardized this processing, but I can give a basic description of the way it might work in your camera.

Generally, in-camera processing affects sharpness, tonal contrast, and color saturation, plus the ability to record black-and-white images directly as a JPEG file. Many cameras actually have preset options such as Landscape and/or Portrait (don't become confused, however, these are not the same settings as the programmed exposure modes mentioned on page 48). The camera's processing options are usually chosen through the Shooting menu or from a button on the back of the camera. The menu also usually permits you to adjust these attributes and create customized settings.

The settings you select for in-camera processing will depend on the ways you want to use your image files. Printing directly from the memory card without downloading to the computer will require different settings than enhancing images with image-processing software on your desktop. In general, you would use stronger sharpness and color saturation settings for direct printing, but you may have to do some tests to see what works best.

You will typically want your JPEGs at least slightly sharpened and color saturation boosted above the median for landscape photography. You can use more than one combination of settings, often customizing your own preset to deal with different conditions. For example, you can set up one combination for sunny conditions with options that are moderate for both contrast and saturation, while another for cloudy conditions will increase contrast and saturation to a specified degree.

Reduce Camera Movement

You will often be taking landscape photos using slow shutter speed settings, especially early and late in the day when the light is not at its brightest. These settings will absolutely require a tripod. It is true that manufacturers have introduced several technologies into their cameras or lenses to help stabilize images that might be blurred due to camera shake, and they work fine for many non-landscape conditions. However, these technologies still do not guarantee the sharpness that you will get when you use a good tripod.

Camera movement during exposure is a big challenge for landscape photographers, which is why it necessary to keep the camera stable. The problem does not always show up as a visible blur in your photograph, yet it can still degrade the image—a slight movement of the camera can cause a loss in image brilliance. Image brilliance is related to the way that tiny highlights are captured by the lens and sensor. If these tiny highlights blur, then the image loses tiny areas of contrast throughout the photo, resulting in a duller image, even if it does not look blurred.

I highly recommend that you invest in a lightweight, carbon fiber tripod with a solid, lightweight head as detailed in Chapter 1 (see page 36). This will pay off in sharper photos better than any other investment in additional camera gear, including more highly rated lenses. No matter how good your lens, its potential quality will never be realized if the camera is not on a solid tripod—or worse, if you don't use your tripod because it is heavy and inconvenient to take along.

Camera movement during exposure is one of the worst culprits in causing unsharp images. This image was shot with the camera locked down to a tripod for 1/8 second at f/22 exposure. Lake Mead National Recreation Area, Nevada.

When using a tripod, be careful about how you activate the camera to shoot at slow shutter speeds (anything slower than 1/20 second for wide-angle lenses, and 1/60 or slower for telephotos). You can easily produce a low-level vibration of the camera that causes unsharpness due to camera movement during exposure. To minimize this problem, press your finger gently down on the shutter button while holding the camera so that you do not allow it to move. An even better method is to use a cable release that lets you set off the shutter without touching the camera. Most D-SLRs have a plug to receive an electronic cable release. And some also offer a remote control accessory that does the same thing.

If you don't have a cable release or remote, you can avoid camera movement by using your camera's self-timer setting. Usually found in the menu system as a shooting or drive mode, the self-timer often has a couple of options, such as two seconds and 10 seconds, for example. The shorter time is to let camera vibrations settle down when shooting on a tripod; the longer is for those occasions when you need to activate the shutter release and then run to join a bunch of folks for a group portrait.

Leveling the Camera

Since we have just been discussing tripods, this is a good place to talk about leveling the camera. It can be frustrating to get crooked horizons in your landscape images. This is a common problem for all photographers from beginners to experienced advanced shooters. While tilted horizons can be corrected in the computer, you will save time and aggravation if you can shoot it correctly with the camera.

Many new cameras have the ability to show a grid pattern in the viewfinder. This can be helpful in lining up a horizon because it gives a straight horizontal line for comparison. And some cameras now have a level inside that can be seen in the LCD panel. Finally, all cameras can use an accessory level, usually available from a camera store or online, that slips into the flash shoe. This small device has a bubble (or preferably two, one for horizontal shooting, one for vertical) that you use to make sure the camera is level.

It is easy to accidentally tilt your camera just a bit when shooting, even when it is mounted on a tripod. Sloping or crooked lines in the photo can be somewhat disconcerting to your viewer, so use whatever tools are available to keep the camera level and record straight lines, like the horizontal one that marks the end of this rocky ledge. Sequoia National Park, California.

Photographer Profile

*Ian Shive

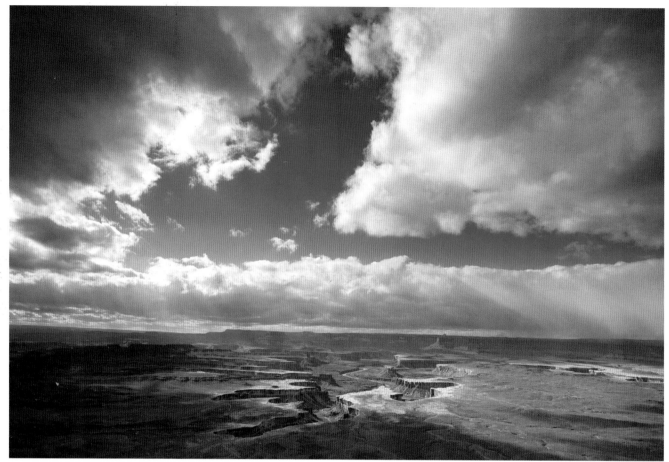

Canyonlands National Park, Utah. © Ian Shive.

A New Look at National Parks

IAN SHIVE (WWW.WATERANDSKY.COM) IS A YOUNG LANDSCAPE PHOTOGRAPHER WHO IS GAINING A REPUTATION FOR HIS DISTINCTIVE IMAGES OF U.S. NATIONAL PARKS. HIS NEW BOOK, "THE NATIONAL PARKS: OUR AMERICAN LANDSCAPE," SHOWS A REFRESHING POINT OF VIEW NOT OFTEN SEEN IN TODAY'S LANDSCAPE PHOTOGRAPHY.

A good landscape shot leads your eye through a journey that makes you want to ask what is behind that next bend or just beyond the edge of the frame. A good landscape should inspire you to want to get closer, like a museum visitor moving in to analyze the individual strokes of a painting.

In the National Parks, there is a definite challenge to making stunning landscapes, not because there is any shortage of great views, but because so many of the grandest views have already been documented hundreds of times by many other talented photographers. My approach is to find places that haven't been photographed before, to catch something that is seemingly ordinary at an extraordinary moment. Perhaps lightning is dancing across the horizon, or a wildflower bloom is twice its usual brilliance because of an exceptional amount of rainfall the previous spring.

Though I often envision ahead of time the landscape shots I hope to get at a certain location, I also try to keep open mind. I went to White

Mammoth Hot Spring, Yellowstone National Park, Wyoming. © Ian Shive.

Sands National Monument (New Mexico) one time with a clear mental image of the rippling dunes under the soft pink light of the setting sun. However, a major thunderstorm tore through the region when I got there. As the rainfall subsided, the dunes began to have an artistic, hand painted look to them with shades of beige giving way to white. At that moment I knew I had something special and took the shot.

I travel to locations with my 17" Mac laptop, a couple digital cameras, and a hard drive. These small and travel-friendly tools have enabled me to not just view my images as I go, but to also begin an edit. As I select frames, I start to see a story emerge. This becomes perhaps the most important element: How will my photos reveal something about this landscape that is not obvious to a visitor? Some stories in landscape photography are subtle, others are much more apparent. Regardless, I work with each photo to convey not just a single subject, but a layered image that demonstrates a sense of place,

revealing to the viewer something with each new look that they hadn't noticed before.

Landscape photography is iconic. It can, and I believe always will, have the power to educate and shape ideas and culture. Along with other photographers, I recently had the opportunity to present images to members of Congress that showed some of the negative environmental impact resulting from construction of the border wall in the Southwestern U.S. I originally questioned how I and my stack of printed photos could convince these heavyweight lawmakers to change the status quo. Soon thereafter, a bill was introduced into the House of Representatives to establish a comprehensive border strategy that will work to ease damage to ecosystems, communities, and natural resources caused by security activities along the border with Mexico. I was not only dumbfounded by their response, but after regaining my composure, was reinvigorated and re-inspired by the power of a great image.

3 light

Light is obviously critical for photography—we can't take pictures without it. But merely having enough for illumination is not all there is to using light for capturing distinctive landscape photos. A landscape is also significantly affected by the quality of light: how the light hits the scene and falls across it, how it alters color, the way it makes highlights and shadows, and much more.

It is important to realize that our eyes do not see the world in the same way as a camera does. You can see detail in a scene that has high contrast from bright to dark that the camera's sensor often cannot register. You might also see vibrant colors in a particular scene filled with light and shade because of the way our eyes can adapt; yet the color might be obscured in a picture because the camera emphasizes the light and shade. So we need to train ourselves to see light as the camera sees it, not as we see it. Here are several techniques to help us do this:

• **See your scene as a photograph**—The LCD helps immensely with this. Consider the image in your LCD as a small photo, not just a quick-check display to confirm that you got the shot, and notice if it shows the scene in a different way than viewed with your eyes. Is the camera translating your scene appropriately into a photograph? You don't want to have an image filled with unappealing shadows, for example, because you didn't realize they would not look good when recorded by your camera's sensor.

• **Look for the light**—This may seem obvious, but many photographers forget to do this. They end up looking for a subject, which is very often a concrete object within the scene. Instead of simply looking for the subject, it is important to look for the light and see what it is doing in your scene.

• **Look for shadows**—As noted on page 62, shadows can be a very important part of your photograph. Remember, they can be a problem if not placed properly, obscuring your subject and making your photograph less interesting. But used creatively, shadows can be a dynamic and central part of your landscape photo.

• **Is the light complementing your landscape?**—Be sure that the light is actually doing something that favors the scene.

• **Watch for distracting light**—High contrast light along the edge of your photograph or at any of the corners will attract the viewer's eye to the periphery of the photo, rather than bring the viewer into the picture. Look all around your viewfinder to notice if there is bright or contrasty light that will draw attention away from your subject.

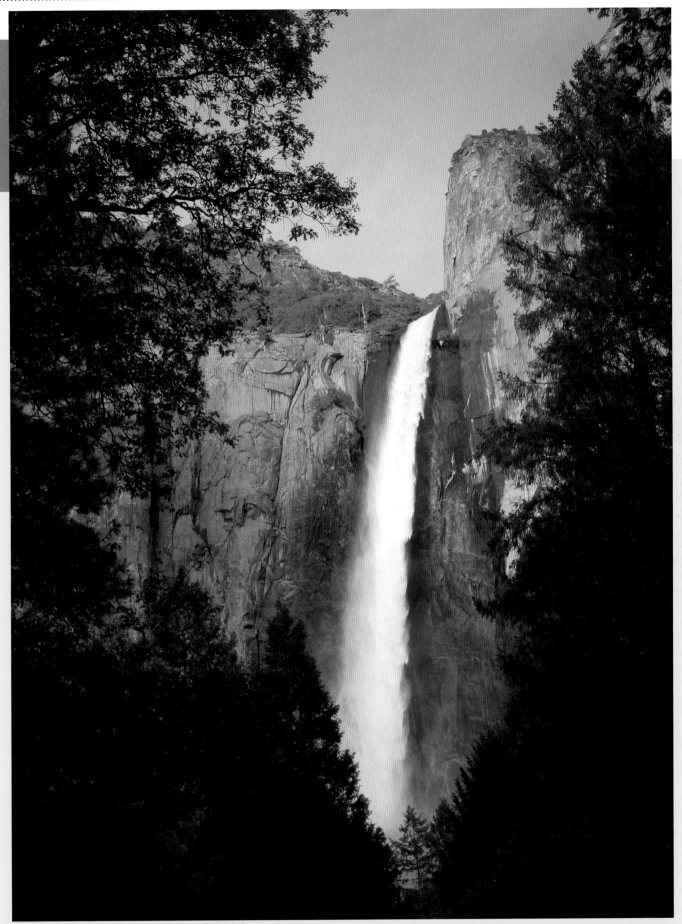

Bridalveil Fall, Yosemite National Park, California.

Include the light in addition to deciding on a subject when envisioning your photo. Sometimes, a landscape does not look right in a certain light. Your best bet in such a case is to skip that particular photograph and find another shot that will be more satisfying.

Different Types of Light

Getting the best possible landscape photographs starts by recognizing when the light is enhancing a landscape by adding character and beauty. But you must also be able to determine when the light is less than striking. As I mentioned earlier, photographers have problems when they only see the subject, and don't take note of the light on the subject. Subject-based photography is not enough unless you are a documentarian recording a "snapshot" of a scene for recordkeeping purposes. A photograph that affects your viewers goes beyond the subject to create an interesting and eye-catching image.

It can be helpful to realize that a landscape photograph is not the same as the landscape. As obvious as that statement appears, many photographers forget that when they are out taking pictures. They often believe that if they find a really great landscape, then point their camera at it, they will then have a great landscape photo. This, unfortunately, will often lead to disappointing photos because that real landscape cannot be crammed into the frame of a photograph.

However, you can capture an interpretation of that landscape in the form of a photograph that uses the craft of photography to display your vision of scene. Light is an essential component in the creation of such an interpretation, with its character helping determine if a landscape photo is successful or not.

The use of light makes a big difference in the ways it can affect a landscape photo. In order to make the petrified wood stand out on this cloudy day, I used a flash to put a spotlight on the rock. Petrified Wood National Park, Arizona.

A shaft of light coming through a forest dramatically lights up new spring leaves on a huckleberry bush. Dungeness Spit, Sequim, Washington.

Dramatic Light

Most landscapes come to life when photographed with dramatic light. I want to be clear, though—dramatic light is not the only kind that can be used with landscapes. In fact, dramatic lighting can sometimes cause problems in a landscape photo. We'll look at that a little later in this chapter.

However, dramatic light generally contributes vitality and interest to a landscape scene. Light tends to be most striking during the early or late hours of day, when the sun is low in the sky. Then, light and shadow combine in ways that help define and show off the landscape. This is often called early and late light.

Mid day light is not usually interesting for a landscape. It is often flat and dull with muted color. This is especially true for large scenes shot at a distance, which is, in fact, what many landscapes are.

As you can guess, one way to immediately work with dramatic light is skip the middle of the day and go out with your camera during the early or late hours of sun-

light, when the light can be truly stunning. I am not referring to the color of the sky, but to the quality of the actual light on the landscape at those times of day. It will stay dramatic for a while after sunrise and before sunset, although how long depends on the time of year and atmospheric conditions.

Shadows are as essential for dramatic effect as the light itself, because they help create form and texture in the landscape. Study a scene, looking closely at the forms within and how the light makes them appear with more or less dimension—shadows are critical for revealing the facets of a landscape. Observe how a light may graze the surface on one portion of a scene, then flow to invigorate another with texture and depth.

Large expanses of shadow in a landscape are inherently dramatic because of the way they contrast with small, sunlit areas. This can create an interesting spotlight effect that will give an image impact. This type of lighting in nature is truly like a spotlight in the theater that illuminates a single actor on a large stage—a light of emphasis.

The light on this cloudy day was gentle and subtle, wrapping around the waterfall and into the forest without harsh contrast. Olympic National Park, Washington.

Shadows can be as important in your photo as the subject (or may even be the subject of your photo), especially when distinct natural shapes appear in them. The long shadows of a tree across the snow, shadows of flowers against a light rock, or shadows of rocks on the sand can all become interesting and powerful images all by themselves.

However, this type of dramatic light does, literally, have a dark side. Shadows that fall in the wrong places become a distraction, overwhelming the scene and reducing its appeal. Over-bright highlights or harsh contrasts can make a landscape look less than attractive. You cannot use dramatic light simply because it is dramatic—you also have to watch the scene and be sure the light complements the landscape. If the light fights with the landscape, if it makes the scene hard to see, then move on.

Remember to use your LCD to review what the scene will look like as a picture. Even though your eyes may note detail in shadows, for example, your camera may not. With experience, you will eventually be able to determine beforehand how the existing light will look in a photograph—not simply how it looks to your eyes in real life.

Review the photo in your camera's LCD also to see if you have interpreted the scene as expected. If not, you may have to adjust your shooting angle, wait for the light to change, or even pass on that photo and find a new one to shoot (to reiterate, a photograph is not the same as the scene). An important decision that every good landscape photographer has to make is when to not take a particular picture.

Subtle Light

Sometimes the light is subtle and quite beautiful on a landscape. A foggy morning is a perfect example of this. The soft tones and understated colors of the fog create a delicate portrayal of the scene.

Subtle light will reveal things that dramatic light can't. While dramatic light makes textures and forms more dynamic and bold, subtle light makes pastel and pale colors look better. Gentle gradations of tone and color often look best with subtle light.

One of the most subtle and beautiful of natural lighting conditions occurs within 10 minutes after the sun sets, when a glowing sky casts a lovely light on the land. This can last for quite some time after the sun is totally gone, giving extraordinary light and color that is revealed by the camera even as the evening turns dark.

Another interesting light can sometimes be found on rainy days. Though at times heavy and dreary, rainy weather can also provide light that is striking and magical. It makes wet surfaces shine and adds dimension to the landscape. But be careful of skies in these conditions. Often they are flat and gray (which usually becomes a dull white in the photograph) and not very attractive. Keep as much of the sky as possible out of the picture unless you see some truly spectacular clouds (see pages 94–103 for more information about photographing skies).

Backlight

Backlight is when light comes toward you from behind the subject. Even on days when the sun is not shining and illumination comes from bright clouds, it is one of the most dramatic, interesting, and high impact types of lighting you can use. It is no wonder that many professional photographers regularly use backlight for landscapes.

Some of the distinct benefits of using backlight include:

• **Drama**—It can add impact to your photo and get your viewers to say, "Wow!"

• **Separation**—Backlight will often separate elements of your landscape into distinct areas. For example, this can make mountain ridges show up better or make trees discrete from each other.

Backlight is dramatic. It can sometimes be too harsh, but it can also prove to be excellent lighting for landscapes. When it works, the light can be exceptionally beautiful. Apalachicola Bluffs and Ravines Preserve, Florida.

- **Rim light**—This is when backlight lights up the edges of objects in a scene. This can be quite bold and make your picture stand out.

- **Glowing colors**—Backlight will make translucent colors glow, causing green leaves on plants and trees to come alive.

- **Silhouettes**—Solid objects effectively turn dark and become silhouettes when seen against brighter parts of the scene.

- **Atmospheric presence**—Fog, mist, and other such atmospheric effects show up better with backlight.

But be wary, because backlight can also produce high-contrast, hard-to-control lighting situations that make it demanding to record a good picture. This is one of those cases where dramatic light can be tricky. One of the first challenges you will experience with backlight is exposure. It can create an extreme range of tones that the camera might not deal with well. In addition, metering systems often interpret a backlight scene inconsistently: One time the metering may overemphasize dark areas; another time it might exaggerate the influence of bright areas.

The basic answer to this is to expose for the most important detail in the scene. Analyze the scene and decide what is or is not key to the image. You may determine that a dramatic interpretation is important, and requires bright areas to show details while the shadows are very dark. Or you may think that the shadows are indeed critical, so you will expose for them and let the highlights "blow out" or become white, because your camera might not be capable of handling the entire tonal range of the scene. In some scenes, no matter what you do with your settings, you cannot make every part of the image look good at the same time. In that case, you have several choices:

Because it was important to show the light striking the rock formations, I exposed for the brighter areas of this scene, letting the shadows go dark. Arches National Park, Utah.

1. Expose properly for the important part of the scene

Let everything else go. This can work well if overexposed bright areas are small. But if they occupy a large portion of the picture, the landscape photo will usually not be attractive. The picture often works better when you then underexpose dark areas, even if they are large.

When trying to get the brightest exposure possible without washing out details, use the highlight warning function if your camera has one. If shooting JPEGs, change your exposure to a point where the blinking warnings have just disappeared—going past that point may mean you have underexposed the scene. With RAW, set exposure to where a few of the blinking warnings are still evident.

2. Decide not to take the picture

Find a new angle or wait to shoot at a different time of day that is more flattering to the scene.

3. Try the technique for high dynamic range (HDR)

It is a way to create a single image from multiple exposures of the same scene (more will follow about HDR, see page 138). The multiple exposures allow you to capture a wide range of tones from dark to light.

Flare

Another challenge, flare, is produced by light that bounces inside the lens and is then recorded in the photo. Diffuse flare weakens the contrast of the landscape by spreading light across the scene where it doesn't belong. Specular flare shows up as small spots of light radiating out from a bright light in the image. There are several things you can do to control flare:

1. Use a lens shade
This can make a big difference, especially with telephoto lenses and zooms with big telephoto ranges.

2. Be wary of filters
Any filter can act like a mirror in front of your lens, reflecting light back into the lens and causing flare to occur. Avoid using more than one filter at a time, and use filters only when needed.

3. Use a smaller lens opening
Small f/stops (e.g., f/16) can help cut flare (and they can give interesting light patterns around the sun).

4. Change your angle to the subject to reduce or eliminate flare

5. Block the sun from the lens
This can be as simple as shading the lens with your hand. Be sure to review your playback in the LCD to check not only that the flare is gone, but also that no part of your hand is in the image. This is another reason why a tripod is helpful, since it can be difficult to hold the camera steady in one hand and block light with the other.

Flare cannot be avoided in photos that are shot directly into the sun, but it can be used for a dramatic effect in the composition. Eastern Sierras, Bishop, California.

Measuring Light

It is clear that good exposure will make the light and the landscape look their best. Exposure meters and their accompanying systems instruct a camera to determine which combinations of shutter speed and f/stop will allow the right amount of light to strike the sensor—the right amount being the quantity needed by the sensor to create a well-exposed image at a particular ISO setting.

Every digital sensor has a limited range within which it can accurately record light intensity before clipping occurs. Our goal as photographers is to ensure that the light arriving at the sensor is within that range. The metering system will try to measure the correct amount, but there are multiple combinations of shutter speed and aperture that will produce a correctly exposed image.

Most D-SLRs and many advanced compacts have exposure meters that can measure a scene's light in several different ways. These metering modes are based on patterns of brightness in the scene being assessed. While I prefer the multi-segment metering that has the camera evaluate multiple readings across a scene, other photographers like using different metering systems.

Multi-Segment Metering

This mode can also be known as evaluative, matrix, or multi-pattern, depending on the camera manufacturer. Today's multi-segment meters have placed many sensors across the viewfinder, and include the power of a

Multi-segment metering has been an important technological advancement, offering consistently good results by allowing the camera to meter and compare multiple parts of the picture in order to determine the best exposure. Canyonlands National Park, Utah.

small computer inside the camera to evaluate the exposure from all of the sensors. This is not simple averaging of the sensor readings. Metering points that happen to match where the camera is focusing are given extra attention, carrying a "heavier weight" in metering than sensors that are not at focus points. In addition, the camera's computer compares the actual readings with an internal database that has compiled thousands of differently lit scenes, so that an exposure can be accurately determined for the existing conditions in relation to the database. The computational power inside a modern digital camera is quite remarkable and will usually give excellent automatic exposures as long as you remember that you, not the camera, are in charge.

ISO

The digital camera's ISO setting provides the meter with a standard way of evaluating light based on a system used in film photography to measure the film's sensitivity to light. Technically, a digital camera's ISO setting does not actually change the sensitivity of the sensor, which is why it is an ISO setting rather than a true ISO number as used with film. Digital cameras can be set to amplify the sensor signal that creates an image. This adjustment becomes a setting on your digital camera that can be compared to ISO speeds for film.

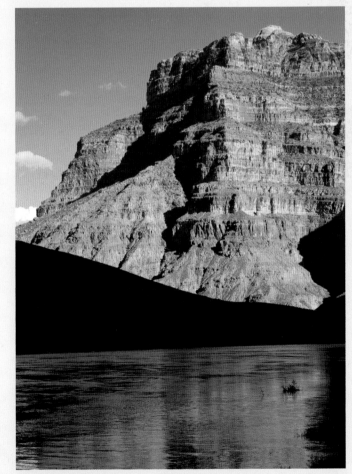

By increasing my ISO setting to 400, I was able to use a shutter speed fast enough to produce a sharp picture while shooting from a boat. Colorado River, Utah.

Spot Metering

This mode bases its calculations on the amount of light found only within a small area (usually less than 5%) of the scene, as shown in the viewfinder. This can be a difficult metering system to use without practice and interpretation of its readings. However, it can be useful when you want to be sure to accurately expose for a specific part of the scene.

Center-Weighted Metering

This method is an old type of camera metering system that some photographers remain comfortable with. It reads the light from the entire scene as framed by the viewfinder, but places a strongly weighted emphasis on a central circle that covers approximately 50% of the scene in the viewfinder, as well as the bottom part of the scene.

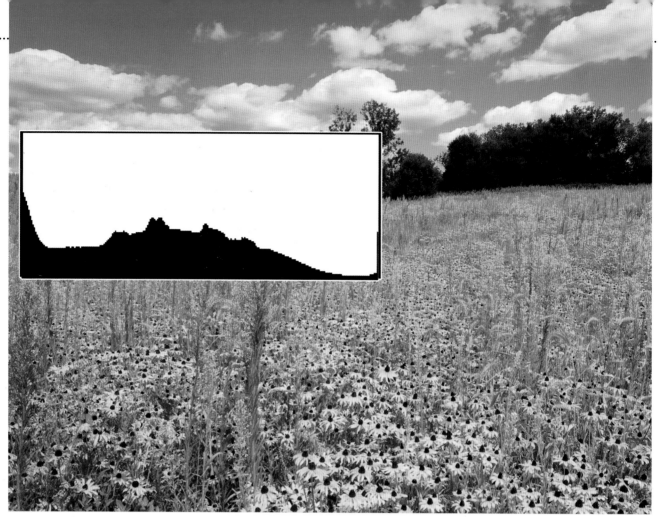

The histogram is a graph that shows the distribution of tones in a photo from dark to light. When reviewed on the camera's LCD, it can help you determine proper exposure. There is no such thing as a perfect shape for a histogram, but look for clipping, especially along the right axis to avoid blowing highlights. Crow Hassan Park, Minnesota.

One challenge with digital photography is that the appearance of noise generally increases as ISO is set higher, though different camera models have different responses to how much noise is affected. Small-sensor cameras can be very susceptible to this type of ISO change, and you will quickly notice added noise as ISO settings are raised. In digital SLRs with large sensors, you can often get clean images (no noticeable noise) at any standard setting, and low noise at high settings.

Regardless of the camera, ISO settings of 400 or lower (preferably lower) consistently give the least amount of noise and the best color for landscape work. However, there are times you will need a higher ISO, such as when a fast shutter speed is required to deal with moving flowers in a scene. Today's D-SLRs offer

excellent results at high settings, better than what you used to get from film. This opens digital photography to new possibilities for shooting landscapes at low light levels, even after the sun has set.

The Histogram

The histogram is an extremely important tool for the landscape photographer because it provides objective information about an image's exposure. It is particularly useful when you have a photo for which you want to nail the exposure just right, or when the light is tricky.

The histogram is a graph that looks like a mountain range or multiple hills. To read exposure, regard the graph from left to right. The left represents tonal data

from the darkest parts of the scene, and the right displays the highlight data. The entire width of the graph represents the range of tones that your sensor can capture. Anything beyond the left edge is outside of the darkest point of the sensor's range, and is rendered as pure black. Consequently, nothing is recorded in those shadows. Anything beyond the right is beyond the sensor's range for highlights, and will record pure white, with no detail.

A good exposure will have a full range of tones appropriate to the scene, with the graph rising from the left axis and falling to an end at the right axis. There is no arbitrarily correct shape to the histogram as it displays between the left and right axes. That will vary depending on the light and tonalities in a particular scene, because each landscape is unique. The key, though, is to be sure no important exposure information is clipped at the right or left (where the graph would cut off abruptly), which represents the exposure level where detail is gone. If the highlights are critical, then the slope must end at or immediately before the right side. If the shadows are essential, then the slope must favor the left side. This can be critical in getting an image with proper data before downloading the image for processing in your computer.

Remember that the dynamic range of sensors is, at some point, limited. Some scenes will have a contrast range (darkest point to brightest point) this is simply too great for your sensor, which will result in clipping at either the dark side or bright side (or both) of the histogram. You may have to decide what's most important for your scene—highlights or shadows— and adjust exposure so the histogram isn't clipped at that end.

Watch out for a sizeable gap between the point where the graph ends on the right and the axis on that side. That represents underexposure, and regardless of what the image looks like on your LCD, it can cause two major problems: (1) less detail and color in the shadows (even if it is adjusted in the computer) and (2) noise. Underexposed dark areas often will pick up annoying and distracting noise. The correction is fairly easy: add exposure.

There are no absolute rules for using a histogram. Every scene is different. You'll need to interpret the histogram as it relates to the scene in front of you and what you believe is a good way of seeing the scene. Since there's no cost to taking extra shots in digital, it is worth the effort to experiment. Try different exposures and see what they look like on the histogram to learn how this function reads various scenes.

Exposure Compensation

Going back to our discussion of exposure modes (pages 48–51), I find that most photographers today shoot with one of the autoexposure modes (Program, Aperture Priority, Shutter Priority). I have shot plenty of photos over the years using Manual exposure mode, but autoexposure today is so good at quickly metering a proper exposure that it makes sense to take advantage of it.

But not all exposures are going to be perfect—you need to interpret how to get optimum exposure for your landscape. That's why it is important to learn how to read the histogram. That graph shows if you have enough exposure, too much, or too little. In addition, the flashing highlight warnings will tell you when portions of the image are overexposed.

If you determine your camera has calculated an exposure incorrectly, how can you correct it? One important method is to use the camera's exposure compensation control. If there is too much exposure (overexposure), use minus compensation. If there is too little exposure (underexposure), use plus compensation. I watch the overexposure warning and set my exposure just to the point where there is no flashing—or only a small amount of flashing if those areas are not important to the subject.

White Balance

It probably shouldn't surprise you to realize that light has color. You can see this as the light changes on a landscape throughout the day. Light in the morning is yellowish, while its tint at mid day is neutral to bluish. Late afternoon and evening light tends to be orangish. Though our eyes are sensitive to this variety of color throughout the day, we don't usually see it the way a digital camera will record it. Our brain, through our eyes, adapts to conditions so we can see colors in a scene without a color cast from the light—the camera is less flexible than our brain and sees that color cast. So, digital cameras have a control, known as the white balance, to adjust for these differences in the color of light.

White balance is a new technology for most of us. It was not part of film photography. It is, however, a very important aspect of the craft of the digital photographer. Because it is a new concept, many digital photographers set their camera to its automatic white balance (AWB) option. However, if you are serious about landscape photography, it is a good idea to learn how to shoot with a specific white balance set to the current lighting conditions (see page 74), regardless if you shoot RAW or JPEG. I feel this is tremendously important.

White balance comes from the video field (I worked in video through the 1980s and 1990s). A standard part of our working procedure was to white balance every set up, meaning every change in the light. There was no such thing as auto white balance. You had to literally balance your camera's electronics to make the light neutral by pointing the camera at a white sheet of paper. Yet, this was a big convenience compared to shooting still film photographs because it was not necessary to use special filters or worry about recording color that was wrong for your subject. Properly utilized, white balance has become an enormous benefit for all digital photographers. It is well worth understanding this tool to enhance the craft of digital photography.

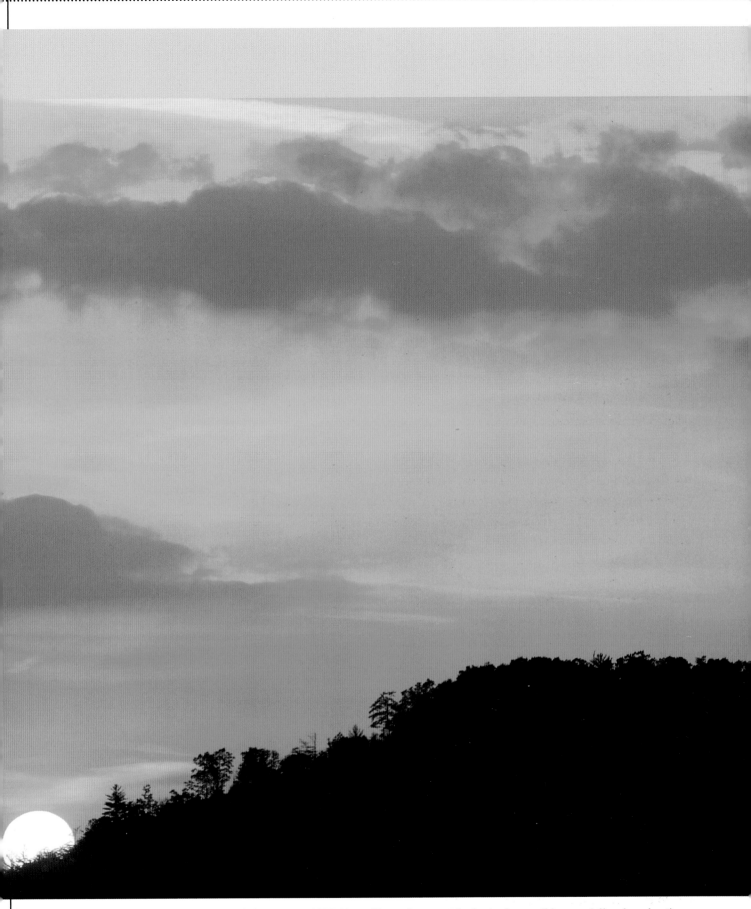

Avoid the temptation to keep your white balance set to AWB. You will not always get the best color possible, especially when shooting a beautiful sunrise or sunset. In that situation, set the white balance to Daylight or, for a little extra warmth, to Cloudy. Great Smoky Mountains National Park, Tennessee.

This shows some of the icons typically used to represent different white balance settings.

Your digital camera has several built-in options for different white balance settings, preset to eliminate color casts in specified lighting conditions (sunny daylight, cloudy, shade, tungsten, florescent, etc.), and AWB is usually one of these choices. However, it is an automated compromise based on what the camera reads as the current color temperature and then interprets with a white balance setting for the conditions. As such, AWB may provide decent results, but can rarely be precise in matching the actual conditions in front of your camera.

For instance, AWB typically reduces the drama from sunrise and sunset images because it doesn't "know" that such light is supposed to have a color cast. Auto white balance can also be inconsistent when recording. It is common to use a zoom lens to shoot a subject and get two different color results at the shortest and the longest settings. That may be fine for snapshots, but not for good color landscape work. In fact, outdoors, AWB is consistent in one way—it gives a consistent compromise in color, usually contaminating all colors with a blue cast. This can often result in landscape scenes with less saturation because of that contamination and a blue cast to neutral tones.

In my experience, based on using D-SLRs from nearly every major manufacturer, the preset white balance settings consistently do a better job in matching real-world scenes when they match the light source. This would mean using a sun or daylight white balance setting for sunny conditions, the shade setting when the scene is shielded from direct sunlight but open sky is above the scene, cloudy when the sun is obscured by clouds during the day, the tungsten option when shooting indoors under incandescent lights, and so forth. When it is difficult to discern the lighting source (mixed lighting, for example), I have found that setting a custom white balance can neutralize the colors quite nicely.

Many photographers experiment and choose a white balance setting that actually warms up the scene because this was a common practice when shooting with film— warming filters were often recommended. In addition, Fuji, Kodak, and Agfa films all had warm biases. Whether you record objectively accurate color or not is less relevant than what people expect and like in photographs. Research has shown that people prefer photos that are slightly warm (more red and orange than blue).

Frequently, I hear people say, "I shoot with RAW, therefore I can change my white balance during post processing in the computer." That is true, but I like to set the most accurate white balance I can on the camera and then rarely change the white balance in my RAW processing software. Changing an attribute at that point of the workflow means additional decision-making and at least one additional step. Plus, how do you know what to change it to?

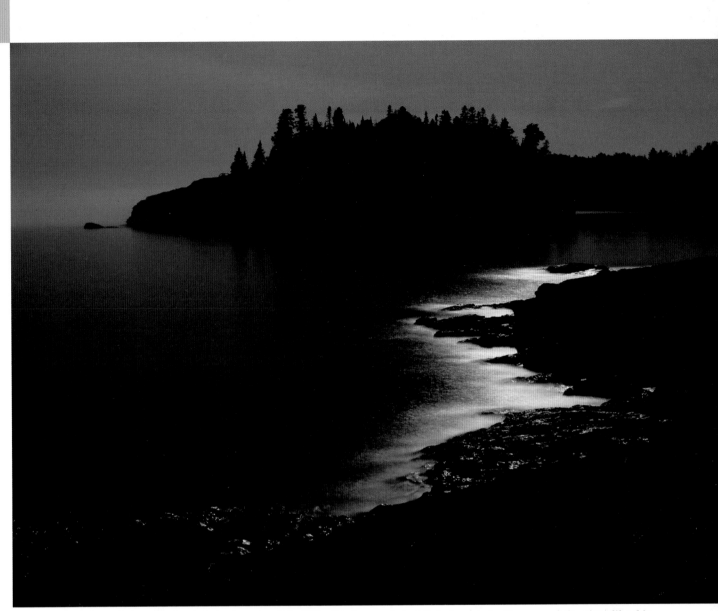

This is a shot of moonlight reflecting in Lake Superior. It is difficult to know what white balance is best in unusual situations like this. It is a good practice to try different settings and review them to see what looks best to you. Lake Superior, Minnesota.

Perhaps the most consistently accurate way to set white balance is to use the camera's option for custom white balance. This is when you set white balance by using a white or gray card. As I mentioned earlier, when I worked in video production, I set white balance for every subject I shot by placing a white card into the scene and using the camera's electronics to balance the light. You can do the same thing with the custom white balance feature in your camera.

Unfortunately, camera manufacturers do not have a standard way of setting custom white balance, so you must check your manual to determine the method for your particular model. Once you have set up a custom white balance, you can keep the camera set to it as you continue to photograph in that same light. When the light changes, you need to reset white balance.

4 composition

If you want to start a lively discussion at a camera club, start talking about composition. Everyone seems to have his or her own opinion. There are certain historical and classical compositional tools from the world of art that use lines and forms to draw the viewer into your photo where they will linger and observe. I like to use a more organic approach that photographers can relate to as they look at the scene before them. Even if it is true that pleasing composition is a subjective matter, it is also true that poor composition can chase viewers away. Composition clarifies the world and helps us interpret nature so we can make sense of it in a photograph.

The "Nature-Is-Perfect" Trap

A common pitfall that plagues many photographers is the belief that nature is so beautiful that they cannot shoot a less than gorgeous landscape. The logic follows this way: Nature is perfect—therefore all I need is a good camera and an attractive location to make an exact copy of nature and produce a great photo! However, that thought process will limit you as a photographer and blind you from a lot of photo opportunities.

Landscape photography is not about nature being perfect; it is about making photos. A photograph is not nature—it is impossible to put real nature into an image. Your photographic recording is a representation, or interpretation, of nature.

We remember the physical and psychological experience of being outside to shoot a scene, so it is easy to lose sight of the fact that the viewer sees only the photograph itself. He or she can merely react to what is in the picture, they cannot reach into the three-dimensional space of the locale, feel the warm sun, smell the pine trees, hear the soft breeze in the leaves, or get bit by mosquitoes! None of these sensations can be duplicated by a photograph. An image cannot give real depth and space, for example, though the photographer might try to give a feeling of both.

Arches National Park, Moab, Utah.

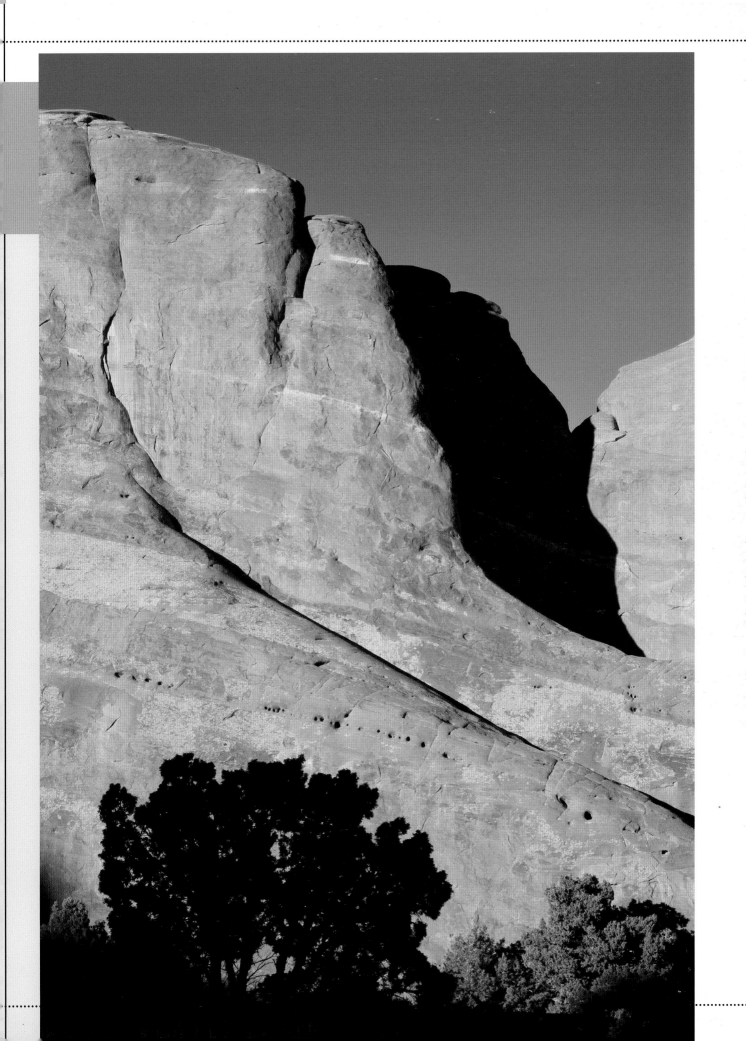

So the effort to reproduce nature with precise fidelity in a digital photo is always futile given the inherent restrictions of the medium. Before recording a picture, you must contemplate what it will say about the land-scape based on the visual aspects of that photograph—what interpretation or translation can you furnish to the scene? Your responsibility is to create meaning with the photograph. Note that I did not say to create meaning with nature: That is something altogether different! Since the recorded picture is not nature, it must visually establish a sense of significance as a photograph in order for the viewer to connect with the image and the nature portrayed within it.

Using Composition

Rather than try to put a scene into a photograph, you must discover a photograph within the scene to get a good image. The world is filled with swirling, changing visuals: a variety of colors, lights, shapes, and spaces. Since your job is to find the photographs there, you need to make sense of the scene for yourself and for your viewers. One primary way to do this is to learn the basics of composition—accepted methods for arrang-ing the different elements within a scene.

In reality, I could see more detail in this morning scene than the photograph shows. Since the camera was incapable of recording all the details exactly as sighted, I decided to work with the sensor's limitations in contrast range to create this dramatic image. Canyonlands National Park, Utah.

Big Meadow, Shenandoah National Park, Virginia.

The Rule-of-Thirds

The rule-of-thirds is one of the best-known methods to determine where to place key elements of the scene within your photo, including the subject, the horizon, and other visually strong aspects of the landscape. It creates an imaginary grid over the scene to help determine where to place key elements. Imagine putting two vertical and two horizontal lines across your photo, spaced at one-third intervals through the image area, like a tic-tac-toe pattern.

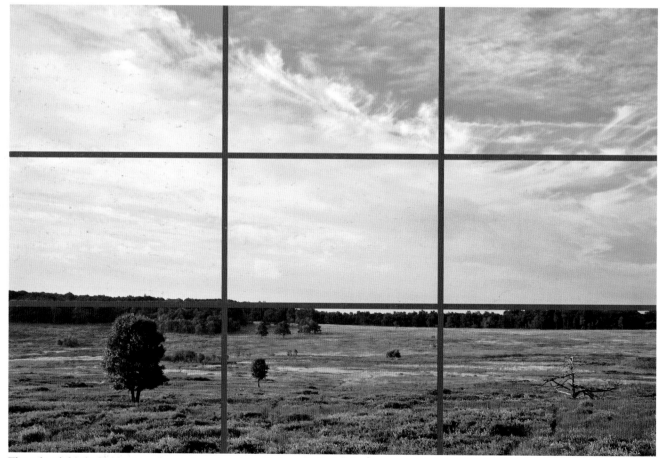

The rule-of-thirds divides your frame along imaginary lines as indicated here.

A challenge for any landscape photographer is to determine where the horizon should be positioned in the picture. Horizons that run through the middle of a photograph can be awkward or confusing because there is no clear definition whether the ground or the sky is more important in the composition. With a high horizon, the ground gains emphasis; with a low horizon, the sky. This type of "thirds" grid can help you locate the horizon at either of those points.

You will also find four points where the four grid lines intersect. These are great places to position your subject (or any object that can be a center of interest). These locations help take the subject out of the middle of the frame, and each position on an intersection gives the subject a spatial relationship with the rest of the photograph. Spatial relationships in a composition encourage viewer involvement because a viewer's eyes will move readily about the image.

This technique can be effectively applied to create compositional interest in your photos. However, this rule should be re-named as the "guideline" of thirds. It is unfortunate that many serious photographers act as if the photo police will arrest them if the rule-of-thirds is broken. It is an aid to composition, not a law. And though many photographers find value in placing their subject at the intersection of grid lines, all landscape photos would look quite similar if every photographer used this "rule" all of the time.

Additionally, there are many times when a natural scene simply won't look appealing by forcing a specific composition technique upon it, so you need to be flexible in order to find the best way of portraying your particular scene. There are a number of different ways to do this.

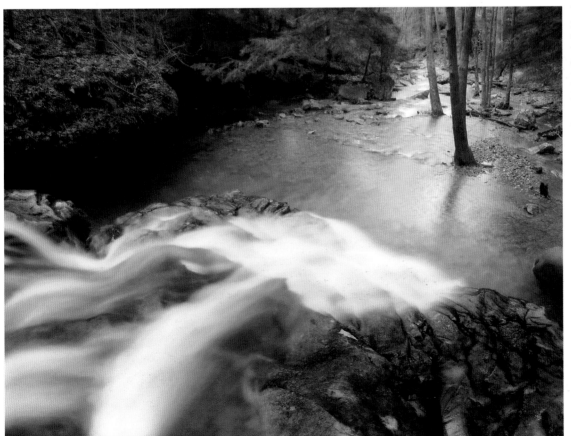

You can't fit every image into a "rule-of-thirds" composition. This photo is about relationships, from the falls at the lower left to the trees at the upper right. The composition is made by examining how the pictorial elements in the framed scene relate to each other and to the edges of the frame. Frozen Head State Park, Tennessee.

Lake Mead National Recreation Area, Nevada.

Dominant Visual Elements

Photos frequently have elements from within the scene that dominate the rest of the image. This is important to understand because the same landscape can have photographs that show a river as the prevailing feature, or perhaps the sky, a field of flowers, huge rocks, and so forth. Finding something to be visually dominant will help viewers simplify their perceptions. What catches your eye; or conversely, what takes attention away from the subject? How can you move, either side-to-side or forward-to-back (and maybe even up or down if possible), to clarify and refine what is dominating your image?

Small and Large Relationships

One way to create dominance is to find relationships between small and large objects in the landscape. If something is big in the frame, it will often draw the viewers' interest simply because of its size. Small picture elements can then become members of the important supporting cast to the hero (the large object) of the story. But be careful that you are using the right objects in this manner based on the story you are trying to show. Something small can also dominate the image when it can be contrasted against something very large. Such size relationships are also quite rich in possibilities for stories.

Use of Space

Space is very important in terms of photographic composition. For one thing, it is closely related to the relationship between small and large objects. For instance, you might contrast a small flower in the foreground with the large space or expanse of land around it.

A photograph consists of two dimensions: height and width. Space inside the photo is then affected by where things are positioned within the two-dimensional frame. This is why you have to be careful about placing your subject directly in the center of the photo. When perfectly balanced in space because of centering, the photo can often lack dynamic qualities and can become visually static. When the subject is deliberately placed outside of the center, the viewer's eye will move around the photo to find it, therefore giving the photo more energy and vitality.

Relationships between visual elements in a landscape are important to the composition. In this photo, I wanted to use space in an interesting way to contrast the small trees with the large rocks. Arches National Park, Utah.

Depth is conveyed by the perspective of looking down the edge of the waves and seeing the size change toward the horizon. Cape Canaveral National Seashore, Florida.

The third spatial dimension of depth cannot be shown directly by a photograph because a picture is only two-dimensional. But depth can be represented through the use of perspective, overlapping forms, and changes in tonality, among other methods. Don't worry too much about such specific techniques for the moment. Simply look at a photograph and note what is happening to the appearance of space in front of or behind the subject. This can totally change the meaning and story of a photograph (For more about stories, see page 93).

Foreground

The foreground in any photograph can be critical in setting context for the scene. Imagine a mountain scene. What is in the foreground—Rocks? Maybe the landscape is really about geology. Perhaps flowers are in the foreground—maybe the scene is about flowers living in harsh mountain conditions. A hiker? Maybe the story is about the connection hikers have to the location. In each case, the basic subject of a mountain landscape does not change, but changes in the camera position and objects in the foreground both reveal and emphasize different things, resulting in different stories.

I used a telephoto lens to flatten perspective and emphasize the bands of color and light. Hill Country, Texas.

Background

Sometimes landscape photos are formed by the subject and background together as a unified image, but many times there is a distinct background in the picture. Backgrounds often help a subject stand out in the photo but, they can also distract from it. Observe the background of your scene before shooting. Ask yourself, does the background visually complement your subject, or is it competing with your subject for the viewer's attention? Does the it help isolate and emphasize your subject, perhaps through contrast of color or brightness, or is it unconnected to your subject or story, and therefore a distraction? It is important to compose so the background does not detract from the concept you want to convey with your photograph.

Distractions

It is very easy to concentrate so hard on the landscape that you forget about what is going on at the edges of the frame. Distractions, such as stray tree branches or perhaps power lines in an otherwise natural field, can easily crop up at the edges of a photo, diminishing its impact, so you want to root them out. It is best when all the elements in a photograph work to support your subject and story.

Composition to Communicate

What is your photo about? That is an important question that will influence how you compose the visual elements in your landscape image. Vague answers such as "the landscape," "appreciating nature," or "the Grand Canyon," will not help you determine the essence of what your photo is trying to say, or what specifically will produce a reaction in your viewers.

You need to be clear about what you want to say with your photograph, and then use the composition to emphasize that meaning. Knife River, Minnesota.

Whether you select a main emphasis deliberately or not, every photograph is about something. You need to establish what that something is and stay focused on the central idea in order to avoid including things in the composition that will keep your viewer from relating to the photograph. When you don't clearly decide what your photo is about, you are not communicating to your viewer. So, good composition helps you communicate clearly and effectively.

Why do most of us take photographs? Sure, it is a fun activity, and more aesthetically, it offers a medium for our creative expression. We use photography to share our views of the world with others. We like people to see places we have been to or appreciate a great scene in nature. This is all about composition and communication.

I have seen a number of photos that are unsuccessful because the photographer had not clearly decided what the image was about. On other occasions, the photographer has tried too hard—the photograph is about the stand of trees . . . and the person pointing at them . . . and the colors of the sky . . . and the texture of the rocks . . . and so forth. All these different "subjects" make it very confusing for the viewer.

Taking pictures is easier once you decide what a photograph is about and how you want to communicate that, because many of the necessary decisions will simply fall into place—you don't have to think about the rule-of-thirds, for example, because you find there is one really solid way of composing the image to communicate something special about the subject.

Arches National Park, Moab, Utah.

This patch of flowers in the sunlight is emphasized by the dark tree and shadows that surround it. Shenandoah National Park, Virginia.

Framing the Scene

A simple and classic technique for defining a landscape composition and giving it visual interest is to look for features that will frame the scene. This technique directs the viewer's eye and structures the relationships in a photograph.

Basically, you look for an element in the foreground that can be used along an edge (or edges) of the photograph to give depth and visual change to the image, so that it produces a partial frame in the scene. This can be a tree branch, a person, an overhanging rock on a cliff, or any number of things. A frame like this immediately creates a relationship between the foreground, subject, and background. A dark frame can also add drama to an image, while an out-of-focus frame can create depth.

When you use a frame, you must not simply treat it as a less important, secondary picture element. You should analyze the object you want to use for the frame to consider if it is formed by complementary aspects in the picture and if it possesses the proper visual shape. Does it fight with the subject? For example, a frame with a lot of detail can look like it is the subject, causing problems with the composition.

As a related technique, many accomplished landscape photographers use a strong foreground element in a wide-angle photo. This foreground element is typically used toward the bottom of the image area, but be aware that it will need some type of visual link or relationship to the background. This foreground object is usually not the subject of the photo, but in conjunction with the background, it creates a strong image that communicates something special about the scene.

Connections

Yosemite National Park, California.

edges

Edges are places in a landscape where a plant community or ecosystem changes from one type into another. For example, an obvious edge occurs when a forest stops at the shoreline of a lake. A less obvious edge might be inside a forest where a stand of trees makes a transition from one kind to a different kind.

Edges play an important role in the study of ecology because they are locations where different plant and animal communities come together. Sometimes, when the edge is abrupt, the plants and animals are quite different from one side to the other. Or, the edge may exist as a more gradual blending of biological communities, creating a zone with a larger range of both plants and animals.

This means that edges can be interesting places to look for a variety of life. If you're in the field, try searching for one of these edges—you may find just the visual stimulus you need. These are places where variation in color, texture, plant sizes, and more are sure to exist.

You will see wildlife at the edges as well. Edges provide both a convenient landmark for wildlife and a location to use for cover because of the changes in plant life there. This is also where animals may find a variety of food. Birds will frequent these areas to feed on seeds and insects. Larger animals, such as deer, frequently use them as transportation corridors.

There can also be problems in these environmental edges. When a natural area is cut up by too much human activity, the edges can occur too frequently, which often results in a decrease in the variety of life. You may also find your landscape is chopped up too much to yield good landscape pictures.

Still, edges are worth looking for. They can provide a visual structure for your composition and add variation to a landscape.

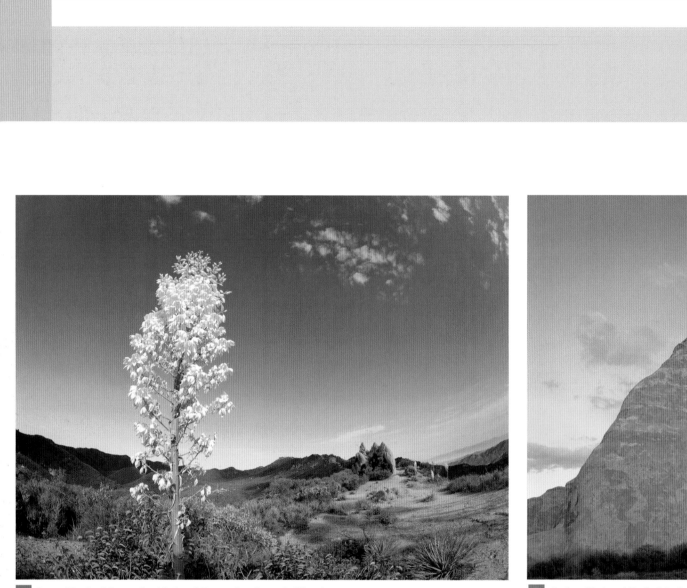

A Santa Monica Mountains National Recreation Area, California.

B Arches National Park, Moab, Uta

Finding Photos in the Landscape

All this discussion of composition is well and good, except it can often seem like little more than an abstract exercise when you find yourself standing in front of a magnificent scene that seems too big to handle in the viewfinder. However, don't get uptight. You will be able to find photos in that scene.

First, as mentioned earlier, stop trying to shove that scene into the viewfinder. It won't fit! Instead, start looking for interesting interpretations of the scene. Here are some ideas:

■ **Search for contrast (photo A):**
Contrast can create interest in a picture. When used well, it helps define the composition and clarify the photograph for a viewer. You do have to be careful, however, to be sure that a contrast between the brightest and darkest tones (dynamic range) in light is not too harsh for the camera's sensor to deal with. Still, different kinds (colors, sizes, etc.) and intensities of contrasts can make a good photograph out of the landscape.

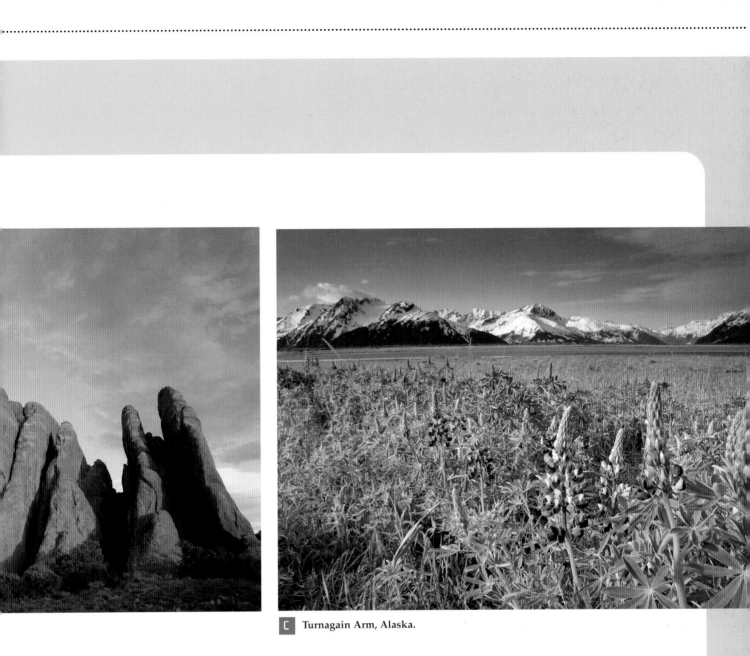

C Turnagain Arm, Alaska.

• Find good light (photo B):

We looked at light in the last chapter, so I won't go into detail here. But it is valuable to look for the light in your scene and note what it is doing to the landscape. Is it creating shadows, or casting a golden glow over the scene? Then find ways to photograph that. This may mean moving around to find different angles to capture the light. It may also mean photographing that landscape at different times of day.

• Feature color (photo C):

Sometimes you will find that a really good landscape photograph is as much about color as it is about anything else. When you look for color and how it relates to a scene, often you can adjust your composition to emphasize that color. Use color as a strong visual element, not simply a realistic part of nature.

A Matanzas National Monument, Florida.

B Santa Monica Mountains, Calirorn

• **Determine textures (photo A):**

Landscapes are filled with textures, and low light will often bring them out. Work with those textures. Find ways to highlight and contrast them within your composition. Sometimes you will find that the entire photograph is about texture as much as it is about a specific landscape.

• **Look for shapes and forms (photo B):**

Often you will find a landscape that concentrates on shape and form. Those sorts of pictures can be a lot of fun to work with because you have great photographic material—you can even get close to create abstract images. Shapes and forms make great photographs, especially when the light underscores their features and makes them stand out.

• **Analyze patterns (photo C):**

I am sure you have come across landscapes with repeating patterns in the scene that make interesting material for a photograph. Whole landscapes are often based on them. There are at least two good ways to make landscape pictures that contain such patterns: (1) Photograph a scene so that the pattern completely fills the image area, or (2) photograph a scene that includes a pattern and one contrasting element that is not part of the pattern, which usually creates an interesting visual.

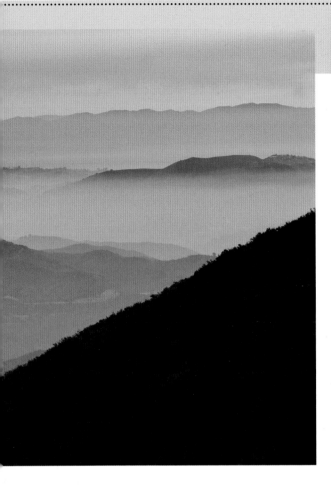

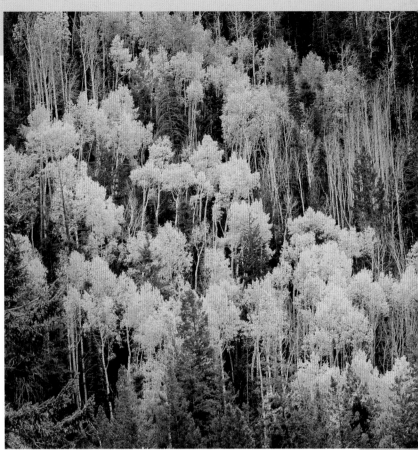

Lasal Mountains, Utah.

▪ Relationships:

Applying the idea of compositional relationships is helpful in discerning a photo in the natural scene. These relationships abound, whether they be in the contrast (light/dark, static/action, large/small) or parallel connection of similar elements (front/back, side-to-side) found in a scene. Always be looking for an interesting foreground that can be used in front of a large scene, or for a dramatic background that can be behind a key element of your landscape.

▪ Stories:

Landscapes usually have stories. I'm not referring to background stories you can tell about your photograph, I am talking about stories that you can capture within the photograph itself. For example, perhaps a river running its course for thousands of years has shaped the landscape—then water needs to be a dominant visual in the photograph. Or maybe there is an exuberance of wildflowers in a particular location—the story is about that abundance, and you can create a composition where the entire foreground is filled with wildflowers.

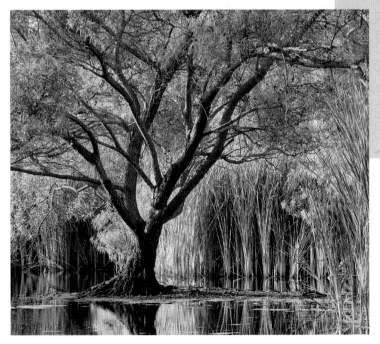

The story of this picture is not that I had to wade through the muck and cattails in the gathering dark of sunset to get this photo, but that this single tree is like an island of tranquility during the calm evening hours in this marsh off the beaten track. Madrone Marsh, Torrance, California.

5 sky & water

Either as separate subjects, or together in the same picture, sky and water are widespread features of landscape photography. The right sky can make a big difference in the appeal of a photograph, often responsible for converting a simple documentary shot into a spectacular landscape image. Meanwhile, water is an intriguing part of the landscape topography, ranging from calm lakes to tumbling waterfalls. Creative photographic treatment of sky an water can definitely result in landscape photos that make the viewer pause and admire them.

Skies Are Important

I've seen many photos by well-meaning photographers who have concentrated so strongly on the landscape that they took the sky for granted. Yet skies have a huge influence on the appearance of landscape photographs. You really cannot become blasé if you want your images to look their best.

Skies are so important that photographers sometimes do odd things to capture and display an eye-catching sky. I've seen graduated neutral density filters overused to the point that bright skies start to look like early nightfall; or, I've seen files so over-processed in the computer that the skies in them appear as something from another planet. And of course, there are those photographs where the original sky has been replaced entirely with a different one through the use of Photoshop or other software.

I think each is an example of a technique becoming more important than the actual scene. It is true, as I have discussed, that any photograph is an interpretation of the real world. However, I am not interested in an interpretation that leaves reality far behind.

This is especially the case where totally new skies have been added to a landscape. Forget for a moment the question of ethics—there is an even more important reason for avoiding this. Such image manipulation ignores the fact that a sky has a strong influence on the actual landscape.

Merritt Island National Wildlife Refuge, Florida.

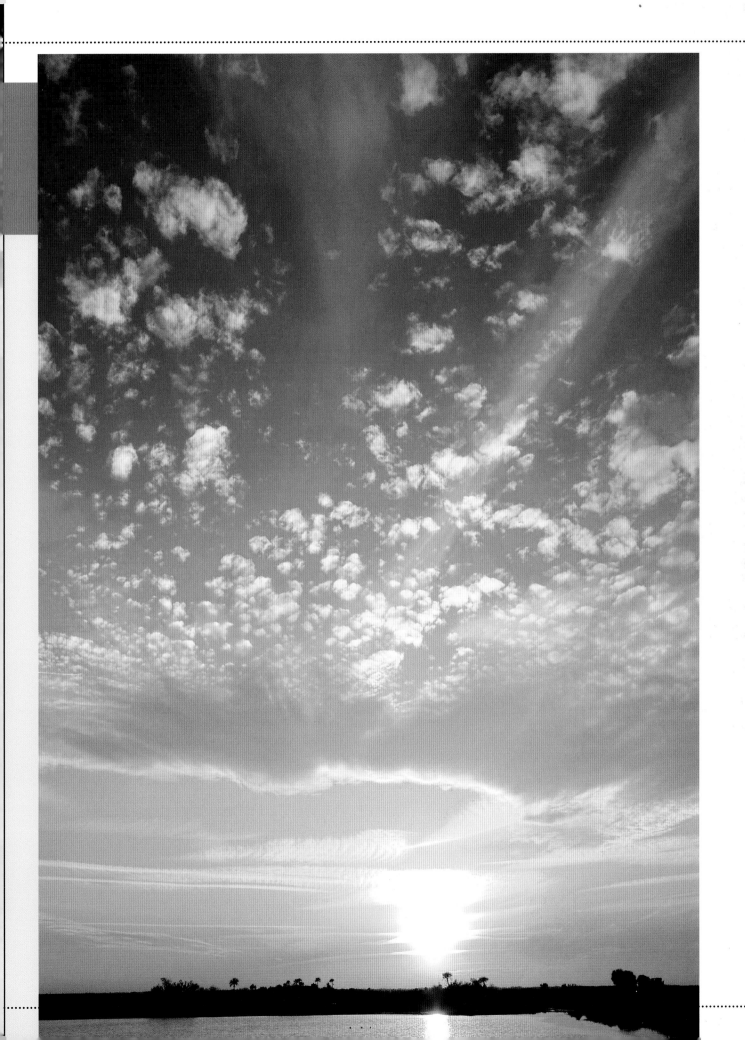

The landscape under a clear blue sky, for example, looks totally different than the landscape under a sky filled with fluffy white clouds. In addition, many skies are endemic to a specific location. Sure, you could use Photoshop to move a sky from the Midwest to sunny Southern California, but such a sky would never look right, since the sky conditions of the Midwest are not found in sunny Southern California. And there are several other issues about visually matching such things as light and focal length between two different photos. You're better off working with the actual sky in the scene you're photographing.

One consistent problem that I see in landscape photos occurs when the picture is devoted to a sky that isn't very interesting. In the last chapter on composition, we discussed the rule-of-thirds and the dynamic of keeping your subject out of the picture's center. Both of these compositional techniques mean that you have to include a considerable amount of sky. If that sky is a bland gray, white, a dull blue, or even clear without any clouds in it, you will in all probability have a photograph with a big, boring visual area that is competing with the rest of the scene within.

This is why it is important to look carefully at your composition. Be sure you are recording sky when it deserves to be photographed, not merely to fill the upper third of an image because somebody at a camera club or lecture (or in a book) has given a couple of compositional rules as an arbitrary system for making acceptable images. There are numerous sources for excellent instruction about your photography, but all too often you will receive advice from those who want to base criticism of photography on structured criteria rather than on what the photograph is really about. Beware of them. This is especially important with skies. If the sky isn't interesting or is competing with the rest your photograph, keep it out.

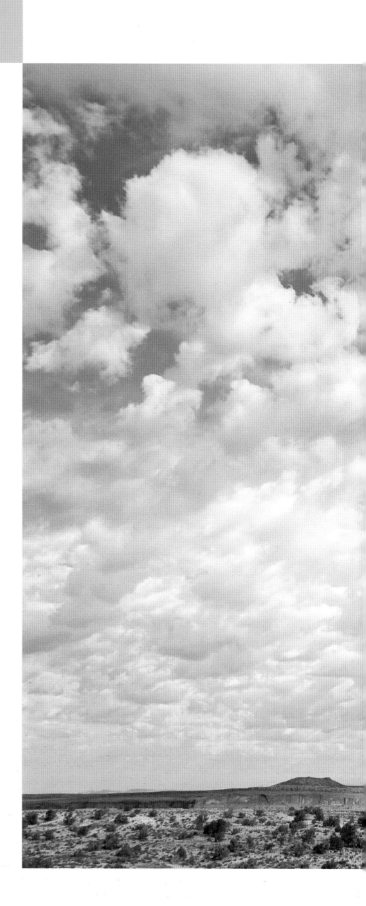

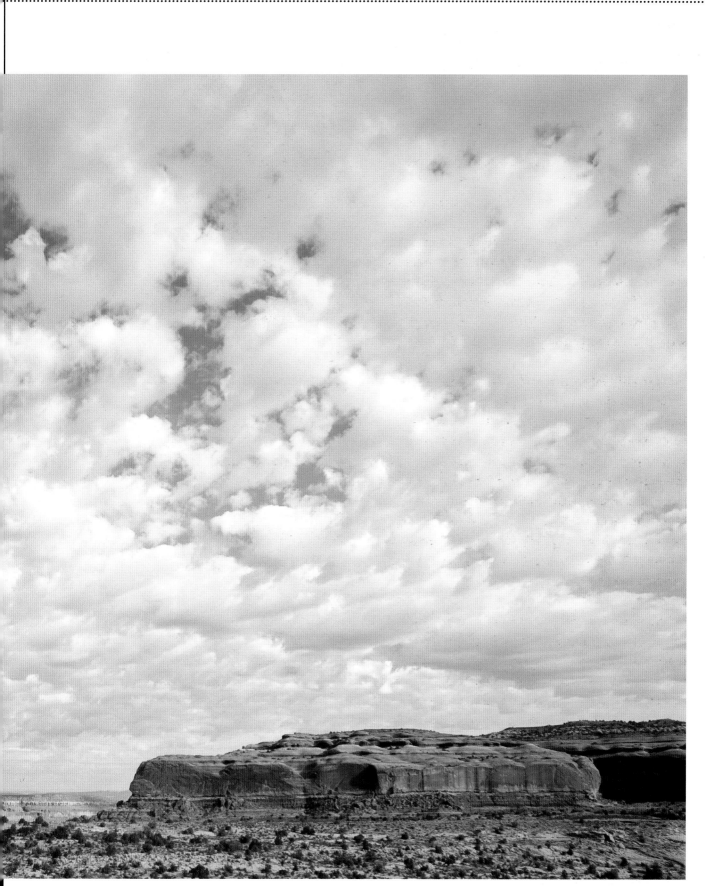

A great looking sky can be as dramatic as many land formations. It can therefore pay to fill most of an image with a sky that is interesting in terms of texture, color, and the way it interacts with the ground formations in the landscape. Near Dead Horse Point, Utah.

Skies can have a great deal of contrast, so you need to be careful how you expose for them. A silhouetted landscape against the sky can work very well. Torrey Pines State Park, California.

With that said, however, I want to qualify this counsel. Sometimes you need a portion of the sky in your photograph. If you keep sky completely out of your image, the landscape may lack depth, appearing flat and soulless. It can actually look like it has been shoved into a box made by the edges of your frame. Adding even a sliver of sky can often avoid this type of photo.

Capturing some of the sky is also useful in providing an outline to the top of your landscape. That might showcase the vegetation in your locale, the geology, or other visual elements that can tell the viewer about your landscape. But in that case, be wary of adding too much sky.

The Challenges of Skies

There are three major challenges that we as landscape photographers must face when dealing with sky:

1. Too much contrast in the clouds.
2. Too little contrast in the clouds.
3. Correct exposure, due to the difference in brightness from sky to ground.

Though backlight can look absolutely stunning with clouds, it can also create very high contrast between the brightness level of the clouds and that of the landscape—a degree of contrast that the camera has trouble dealing with. At other times, you may see interesting shapes in a storm cloud, yet the contrast is not high enough for the camera to adequately separate those shapes.

No current camera is capable of recording the range of tones in this scene. I used an HDR technique to capture detail from the darkest to the brightest areas. Lake Mead National Recreation Area, Nevada.

Many times you will find there is a significant difference in brightness between ground and sky, especially with bright, white clouds. This can make it difficult to record a satisfactory photograph.

Here are some ideas for shooting under these conditions:

▪ **Use a graduated neutral density filter for bright skies (see page 38)**—The gray portion of the filter will limit the light coming from the bright sky and balance it with the landscape exposure (which comes through the clear part of the filter).

▪ **Expose for the largest mass of clouds and let the rest be overexposed**—It is often OK if small areas of clouds are overexposed as long as you can still see detail in most other areas.

▪ **Expose the scene twice, once for the clouds and once for the ground**—This will allow you to capture detail that is beyond the capabilities of the sensor in your camera. Then in the computer, you can combine these two images. This is fairly easy to do in any processing program that offers layers. You put the photographs on top of each other as layers, then you remove the unwanted part of the top picture to reveal the desired portion of the underlying picture.

For example, the top photo might effectively show the clouds, but the ground is underexposed. The bottom picture might show detail in the ground, but the clouds have been washed out. So you remove the foreground exposure from the top picture to reveal the good ground exposure underneath. You can simply erase those areas, or use a layer mask (if you know how) to remove them nondestructively.

▪ **Try HDR (High Dynamic Range) photography**—This type of photography has become popular because it allows us to better capture the real world even with the limitations of the camera. What you do is take multiple exposures of the same scene (auto bracketing works well on most cameras) that range from underexposed dark images that favor the brightest parts of the picture to very bright, overexposed pictures that open up the shadows. Then, in the computer, you use special software that combines these images to create a final photograph that has much greater range than your camera is capable of. HDR photography can actually enhance the clouds on a cloudy day as well as hold detail in very bright clouds that are backlit by the sun. You will find more about this on pages 138–141.

HDR technology is capable of yielding interesting images, yet also some really bad images, some really unusual ones, and so forth. Don't be put off by some of the strange uses of HDR you might see from non-nature photographers. HDR is capable of overcoming the dynamic range limitations of the camera's sensor to give realistic images that truly reflect what you saw.

▪Shoot RAW and double-process your photo—
This can be an interesting technique. Start by processing your RAW file to optimally display the clouds and the sky, and ignoring everything else that happens in the image. Next, process the file again; this time to make the ground look its best and ignore what happens to the sky. So often when we process an image just once, it is a compromise that doesn't really make either the clouds or the ground look their best. By processing twice, you can be sure that the clouds and the ground look their best. You can then put these pictures together in the computer using layers as if one had been exposed specifically for the sky and the other for the ground (see third bullet-point on previous page) There is more specific information about this on my website at www.robsheppardphoto.com.

Clouds

One of the problems with photographing sky is that the clouds in your landscape pictures sometimes do not correspond to the way you envisioned them. We may see what looks like a sky with bold clouds, and the camera records the scene as something much less exciting. This can be especially disappointing if you see eye-catching clouds, and the camera sees a much duller sky.

One solution is to use a polarizing filter. Polarizers help you separate clouds and sky by making the sky dark and intensifying the clouds. However, it does its magic only when pointed at 90 degrees to the axis of the sunlight; in other words, when the sun is shining from your left or right side. If you look directly into the sun, or away from it, the polarizing filter has less effect.

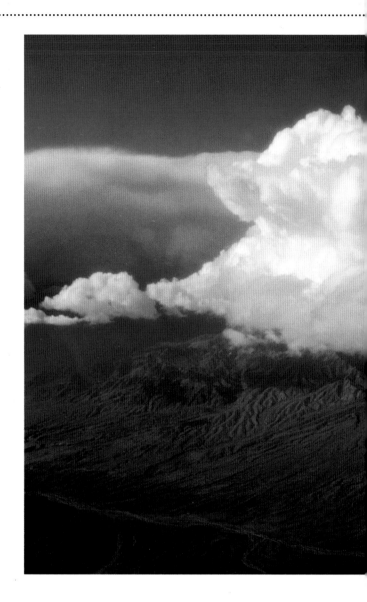

You can see this outcome immediately by holding the polarizing filter up to the sky and rotating it (see page 37). As you do this, the sky will darken (if you are at the proper angle to the sky). You can actually change the effect through this rotation so that the sky becomes more or less dramatic, depending on the needs you envision for the photograph. Then, put the filter on your lens and rotate it into position to take the picture.

There are a couple of things to be careful about when using a polarizing filter: First, you may notice that the polarizer will darken the sky unevenly when used with a wide-angle lens. That's not necessarily a desired effect, but it is normal since the extensive portion of sky seen

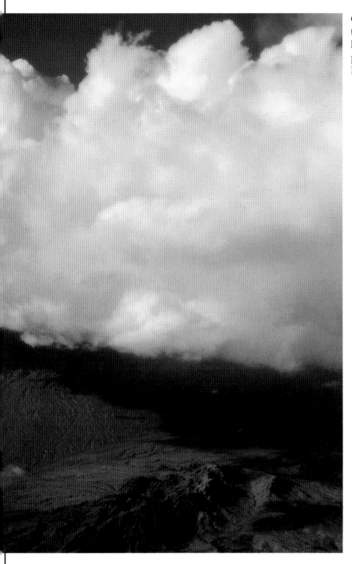

Clouds themselves can be spectacular parts of the photograph, and a polarizing filter can often help define them crisply against the sky. This photograph was shot over the Mohave Desert as I flew to Las Vegas. Mohave Desert, California.

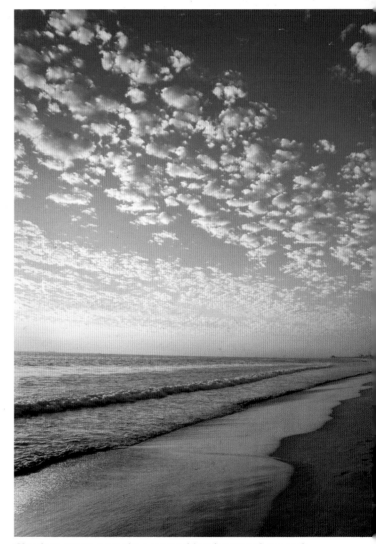

by the wide-angle lens has varying reactions to the polarizing filter. Second, when you're photographing in the mountains, or in winter, you may find that the polarizer makes the sky too dark.

Regardless of any challenges that occur when trying to shoot clouds, they can be beautiful in a landscape photo, especially early or late in the day when there is a special quality to the light. You should always be on the lookout for ways to incorporate them into your scene. If they are truly inspiring, you might not need a lot of ground in the composition—include enough to show off your location, but not necessarily more than that.

Clouds at sunset can make a great subject for your photograph, especially if they can be tied compositionally to the landscape below them. Hermosa Beach, California.

Connections

clouds

If you get the opportunity to travel across different regions of the country, look at the clouds. You'll notice that they change considerably from place to place, appearing quite different from one geographic area to another. The wonderful cumulus clouds of a summer day in the Midwest are absent along the coast of California or in the skies over the Rocky Mountains. Even storm clouds can be different. Both the Midwestern and Southwestern U.S. get thunderstorms. However, the clouds of Midwestern thunderstorms look different than those of the Southwest, so much so that the clouds alone can identify a location.

The way clouds look are dependent on moisture, wind, sunshine, and other environmental factors. The heat of the desert in the Southwest, for example, has different characteristics of sun and moisture compared to the heat of the plains of the Midwest. This is the reason why thunderstorms in those places look different from each other. In addition, atmospheric conditions, although miles away from your location, may develop into a weather pattern that moves along pathways to affect the kind and size of clouds appearing over your landscape. Every location, therefore, has varying preconditions for the cloud formations that will appear over a given landscape

So, clouds are definitely connected to their geographic environment. While they are not living organisms, they can be as tightly representative of a location as certain kinds of animals or plants might be. Sometimes the geological characteristics of a given location, such as a mountain range, a desert, or a large lake, will create unique weather patterns that control the type of clouds in those skies.

Start looking at clouds as an important part of your landscape. A cloudless sky can often be a boring sky. Clouds add interest, not just in terms of what's in the photograph, but in how they interrelate with the particular landscape to create a distinctive appearance in that location.

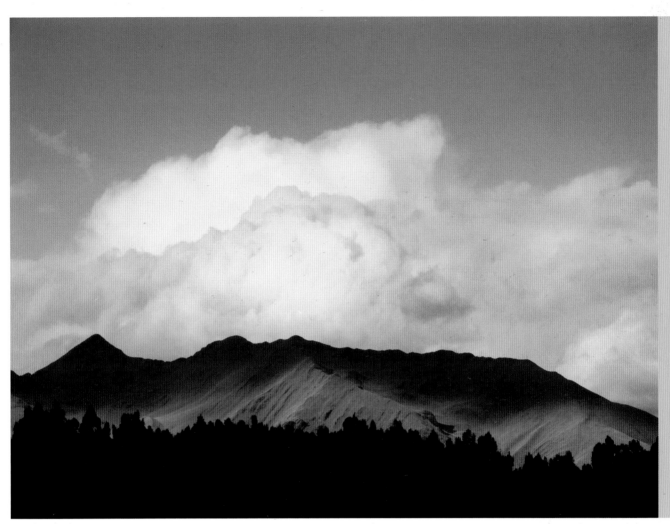

This photograph is about a specific location, but it is also about shapes and graphic elements that include trees, mountains, clouds, and sky. Cusco, Peru.

Sky Is Not Just Sky

As a final note, no matter how odd it may seem to read or hear, it is important to recognize that "a sky is not just sky." This is true in photography because a photograph is not the real world— it is always an interpretation of that world, and as such, shows only a portion of the world cut off at all of the edges.

This means that the sky is not only a physical property of air above our planet, but also becomes a graphic element in your composition; it is a shape or form that interacts with your entire photograph. This means that sky is both a natural phenomenon and a visual shape that helps you with your composition.

Now, instead of simply looking to see if you have sky in the picture, you will start looking at the sky as an integral part of the composition of your photograph. You will notice whether it has a shape worth capturing in your picture, and how that shape may complement your photograph. Does the sky detract from the photograph, or is it worth keeping simply because it is an interesting shape that gives an abstract feel to the overall composition? You will now begin to look at the sky with fresh eyes.

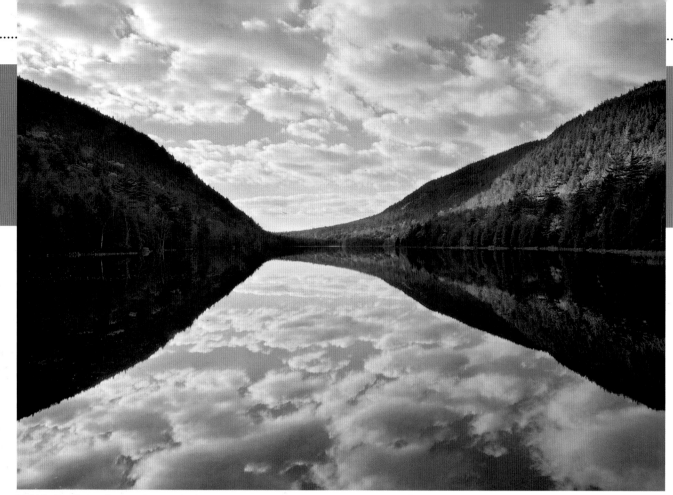

Bubble Pond, Acadia National Park, Maine.

Water in the Landscape

Water can play many roles in a landscape photograph. It can be the key to the composition, or can simply be a part of the overall setting. Regardless of how much of the landscape is taken up by it, water has that magical ability to attract our attention. It can be surprising how the addition of water to a landscape will dramatically change a photograph.

Because water is so influential in landscape photography, you need to give deliberate thought about where it is placed in the composition when you're using it merely as a part of the larger landscape. If water is in the wrong place in the composition, it can throw the balance off in the photograph, detracting from the aesthetic of your landscape picture. On the other hand, when it is in the right place, the landscape can look energized and lively.

Sometimes the rule-of-thirds can be a good way to deal with water. You would have a third of your picture consist of water, a third would show the land, and a final third would consist of sky. Or perhaps the scene is best photographed with the lower one-third made up of the water, while the sky occupies the upper two-thirds of the frame. You might even reverse these proportions, with the water composing two-thirds of the scene, and the sky one-third.

But as I mentioned in the chapter on composition, you should not be arbitrarily bound by rules—don't automatically divide every landscape image into precise portions of one-third each! Water will likely take over the composition when it fills a third or more of the image, yet sometimes it should just be part of a larger scene, and not necessarily dominate the photograph. It is important to look through your viewfinder carefully and review your shots in the LCD to see exactly how the water is affecting your overall landscape. Change your composition until that water balances the rest of the scene.

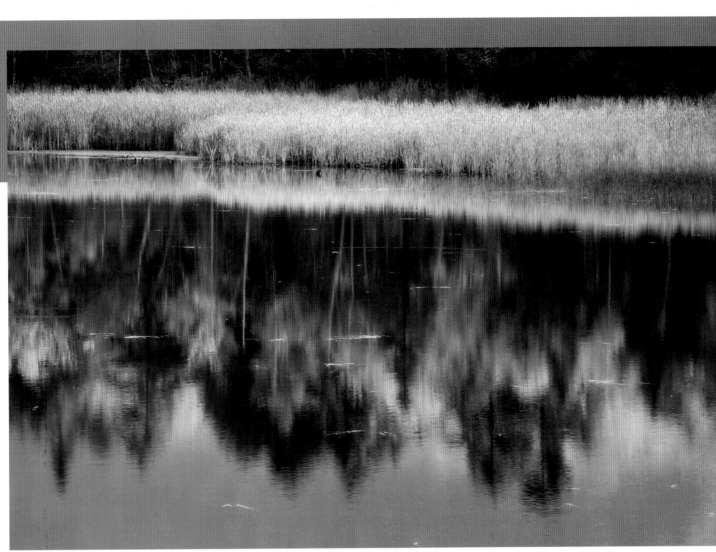

Pond near Rutland, Vermont.

Water Is About Reflections

The fact that water reflects its surroundings can be a critical characteristic in determining how you deal with water in your photographs. Look at the water in your scene not simply as a lake or stream, for example, but as a reflective surface. Ask yourself, "What is being reflected in the water?"

Often, water will reflect the sky, and that can be either good or bad. The water in your photo can look great when it shows blue sky and picks up a blue hue of its own. That can be an extremely neat way of showing off a small bit of water in a larger landscape. Sometimes, by moving a bit to change your shooting position, you can alter the reflection, if needed, to more

suitably mirror your vision of the scene. On the other hand, water may look dull and generally unattractive when it reflects a gray sky. Again, you can try moving and observing the scene until other things reflect in the water, such as shadows from the surrounding landscape that will make the water look darker.

You will have some great opportunities to capture reflections in water at sunrise and sunset. You'll find invitingly warm colors from the light at these times of day, and colors that will change constantly as the sun rises or drops in relation to the horizon. This is one time where you don't want to put your camera away as soon as the sun sets, because there can be some terrific reflections on water lasting well after sunset.

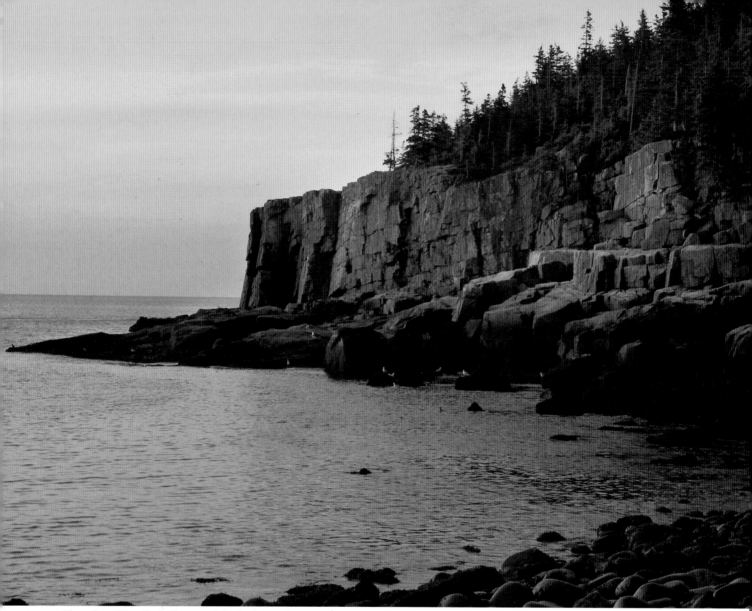

The color of the sky at dawn and dusk often reflects very nicely in water when the brightness of the sky and the water are about the same. Otter Cliffs, Acadia National Park, Maine.

Water obviously reflects differently if it is moving or if still. A calm lake will usually create a great surface for reflecting a beautiful blue sky filled with clouds, while that same lake on a day with a dull sky day can often be a problem—sometimes you simply won't be able to get a good photograph. It may help to move around and try to find trees or other natural objects to also reflect in that water.

Reflections themselves can be an interesting subject to photograph. This can be especially good when there is strong color in the surrounding landscape, such as the bright greens of spring, the colorful leaves of fall, or the rosy warmth of a summer sunrise. These colors will often reflect quite nicely in the water, but you do have to look for strong colors in the reflections, because photos don't always capture the vividness we see in the natural scene with our eyes. Trees that are strongly lit from the front, or backlit leaves, are examples that often reflect well in water, giving you the opportunity for successful landscape photos of this type.

An interesting way of dealing with reflected color is to use a long exposure on moving water. The lenght of the exposure will depend on the movement of the water. Start with 1/2 second and increase your exposure from there. This can be water in a stream or moving water in a lake. Either way, a long exposure blends the movement yet retains the color of the reflections. Look for something solid, such as a rock or tree on the shoreline, that you can contrast with the moving water. Pure moving water can look too abstract for most viewers, although it can be interesting to photograph.

Be careful if you are using a polarizing filter while photographing landscapes with water in them. A polarizing filter will remove reflections, which could be a good thing if the reflections are not attractive, such as a gray sky. But it can also be undesirable if you remove too much and the water loses its feeling of life. Water usually looks best with at least some reflection; otherwise it can almost disappear from the picture. Sometimes a polarizing filter works well with water, but be aware of the potential challenge when using one around a scene with water.

Be careful when using a polarizer around water as it can remove interesting reflections such as these. Red Rock Canyon National Conservation Area, Nevada.

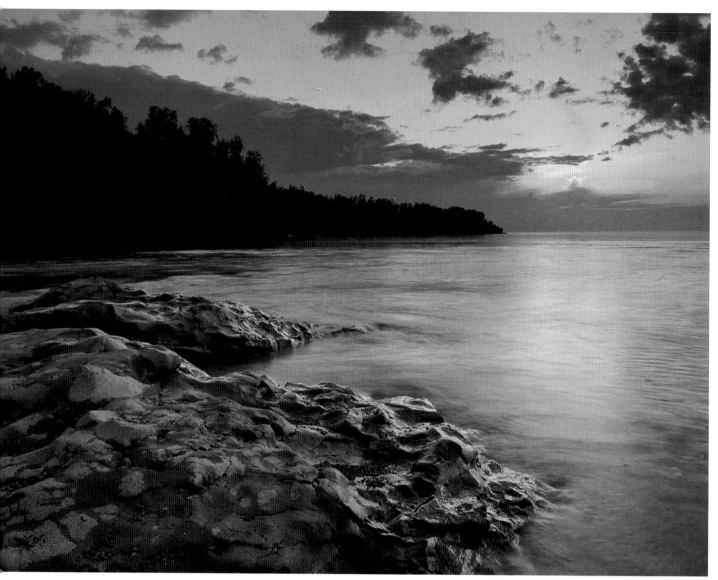

Lake Superior, Minnesota.

Water Has Many Moods

As you photograph water and the landscape, notice how the mood of the image will change as certain aspects of the water also change. Reflection is one factor that has a big effect on this type of ambiance. For example, there will be a very different feeling to the landscape if the reflections are mostly blue than if they are warm colors, like yellow, orange, and red.

However, the mood set by water comes from much more than simply the reflection. Calm water is naturally peaceful, a serenity that you can capture in your picture; while rushing, spilling water is active and energetic, and a photograph of it can depict that action and energy.

However, if you shoot such rushing water with a slow shutter speed, perhaps 1/2 second for example, all of that energy will be blended together and you will have less of an kinetic picture. In fact, long exposures with rushing water can make a landscape look rather serene.

The time of day can affect water's mood as well. For instance, you are most likely to find mist and fog on the water in the early morning. Look for backlight on such scenes to make the mist look even more pronounced. Those conditions can make a landscape look almost magical. Mist and fog, however, do not stay long on water as the sun warms the day, so you have to get out into the field early.

Water Movement

Controlling your shutter speed when photographing moving water offers you the opportunity to interpret landscape images in a range of creative ways. Of course, the specific conditions of water movement will affect how shutter speeds capture it, but here are some general ideas that can work quite well:

• **Experiment with fast shutter speeds and rushing water**—When you're dealing with things like crashing waves or pounding rapids, sometimes you must shoot with a fast shutter speed, even 1/500 second or faster, in order to emphasize the water's action, freezing its movement in time.

• **Try slow shutter speeds with streams**—Often you are in the deep shade of the woods when you're photographing a stream, so you're limited to slow shutter speeds anyway. Stop your lens down as far as it will go (such as f/16 or f/22) and use as long a shutter speed as possible (you often begin to see interesting effects from the flowing water at shutter speeds of 1/2 second). Interesting patterns in the course of a stream may become revealed as you increase the exposure time for a number of seconds. You can also use a polar-izing filter, not for its polarizing ability, but because it reduces light to your sensor, allowing you even longer shutter speeds.

• **Be wary of in-between exposures**—Often, you will find that moderate shutter speeds such as 1/30, 1/60 and 1/125 second don't work well with moving water. These speeds are quite often too slow to completely stop movement, yet they are too fast to allow a pleasing or interesting motion blur. The blur at these shutter speeds usually looks like a mistake in technique.

• **When shooting waves, experiment with long exposures**—Because waves are constantly moving and changing position, a long exposure will even out that movement and give you some interesting effects, such as changing rough water into a smooth looking surface. Long shutter speeds can also create fascinating patterns of water around large rocks in the ocean because the moving waves show as a mist-like, ghosting appearance as they flow past the rocks.

Frozen Head State Park, Tennessee.

6 the landscape & man

There is a strong tendency among landscape photographers to keep people—and their impact on nature—out of landscape photos. However, that has become a difficult task these days. Almost all landscapes that are readily accessible have been influenced by man. For example, most of the landscapes in the Midwest look the way they do because of prior agricultural activity. Many of the landscapes of the West have a less-than-natural look because of fire suppression in areas where regular fires are part of their ecosystem.

Some landscapes show signs of stress due to pollution, while others bear scars from pests and diseases brought on by the activity of humans. The forests along the East Coast of the United States are a good example. These had a high percentage of Chestnut trees just 100 years ago, so much so that the Chestnut was the majority of trees in a number of forests. Then a disease, not native to North America, was inadvertently released that wiped out these trees. Today, there is no significant presence of Chestnut trees on the East Coast.

Of course, it is important to remember that not all of man's influence has been bad. Today, there are more forests in the Northeastern part of the U.S. than there were in the 1800s, due to the way humans have managed these landscapes. In another example, small pockets of prairies now surround Chicago. At one time farmland had taken over these areas, leaving almost none of the original prairie.

The point is, man and nature are connected. In fact, we can't live without nature. After all, green plants are responsible for releasing oxygen into the air we breathe, while natural surroundings make our lives more pleasant; most people do not want to be in an environment devoid of anything natural.

Sacred Valley of the Incas, Yucay, Peru.

Including Man in the Landscape

So why do we so often fail to include people and their influences in our landscape photos? To be honest, it is usually because we're trying to get away from man's influence when we are photographing in natural areas. I totally understand that. Most of my landscape photos do not include mankind's presence in the landscape.

Yet, there are definitely times when I do include man or the signs of his presence in landscape photos. I think this is something well worth considering. If humans and nature truly are connected, then we need to reveal that connection at times. It becomes rather silly to totally avoid showing man's influence when it is so pervasive across our world. I know of photographers who have focused on a tiny aspect of the landscape just to show how wild it is, even though the landscape itself is in an area totally dominated by human activity.

What does it say about us if photographers always try to separate nature and mankind? Do we really want to be isolated from nature? Do we really want the viewers of our photography to think that nature is something remote and apart from them? I think part of the problem in dealing with the environmental challenges faced by nature comes from the fact that many people see themselves as separate from nature. Sometimes, it might be good to actually connect people to nature through photographs.

Some might think that all you have to do is show pretty pictures of nature to people and they will be connected. I wish it were that simple. In fact, gorgeous, beautiful nature scenes sometimes seem so distant and apart from the average person's life that they feel disconnected from the scenes instead. Stunning nature programs on television, such as Planet Earth, may make everyone say, "ooh" and "ahh," but they often have a disconnect with viewers who cannot believe those scenes are something they will ever see in person.

Restored prairie, Chicago, Illinois.

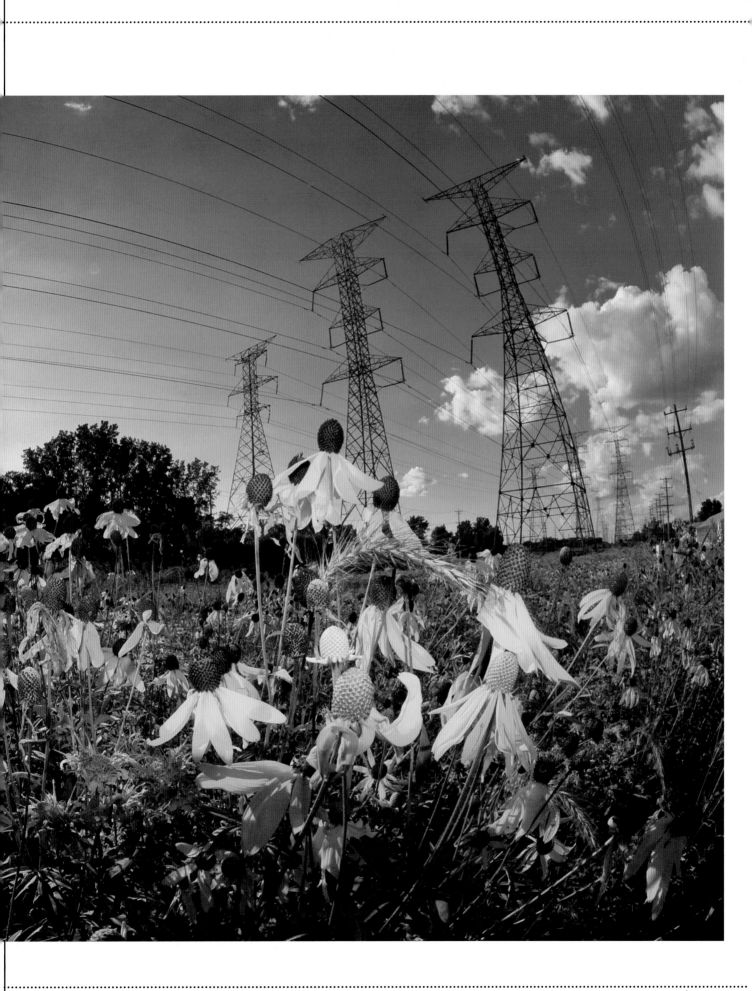

Most landscape photographs of Arches National Park and the nearby Colorado River show the places devoid of people, yet the reality is that these locations are filled with visitors. The tourists in front of the Park Avenue formations (above) are part of that location. The photographer next to the Colorado river (right) provides a sense of scale for the location. Arches National Park and Colorado River, Utah.

Most of us are going to be photographing landscapes that are filled with beauty and may be familiar to our viewers. It can be appropriate to connect our audiences with those landscapes by making those photos more relevant, and one way to do that is by including people in the pictures.

This can be done quite easily by using people as natural elements of the scene. If there is a trail or a bridge by a landscape, and you can include a person walking into that landscape or watching it intently, then you have a person who looks like he or she belongs, as long as you still treat the landscape as an important part of the photograph. Often when photographers start adding people to a landscape picture, they do exactly that, simply add a person to the photograph. That rarely works. You need to find a way to incorporate people into a beautiful landscape so that they become a natural and important part of the composition.

In fact, if you're interested in selling pictures of landscapes, you will find a challenging market if you offer images of only big, beautiful nature scenes. Though those are popular, the competition is extreme. However, you immediately cut your competition to a fraction if you include people in those photographs. Publications love to print wonderful landscapes with people in them—people who look like they belong to that landscape and enjoy being there—yet editors often have a hard time finding those particular types of pictures.

Clear cutting of a forest can be disturbing, yet it is a common management practice for forests where wood is harvested. This photo does not attempt to make a moral judgment, but simply presents a vision of the location that people don't always see. Olympic Peninsula, Washington.

Show the Good and the Bad

As I've noted, man's influence on the landscape can be both good and bad. It is well worth photographing both sides of that coin. Not everyone is going to document all the damaging things going on with our environment, but when you see scenes that illustrate a problem, perhaps your pictures will help others understand what is going on in our world.

There are some photographers who use their pictures to deliberately emphasize the destructive presence of man. We certainly need those photographers to help us see problems that are being overlooked. But most people are not doing that, nor should all of us go out and start taking pictures of ugly landscapes. Frankly, the average viewer is not interested in seeing photos of all sorts of ugly landscapes.

But I believe it is possible to show both the good and the bad in our environment. I think we can take a balanced approach to our photography. Maybe most of our images are beautiful views of nature, but there are many scenes that show the strong effects that humans have on the natural landscape. Why not photograph those things, too? You don't have to get an in-your-face sort of photograph. Maybe you see a beautiful land-scape with just a little portion that is disturbed, a piece that definitely belongs visually in the overall composition. But that part might make the viewer think a little bit about what is happening to this landscape. (See the final chapter, page 216, for an essay by Miriam Stein about ways in which landscape photos can have an affect on our world.)

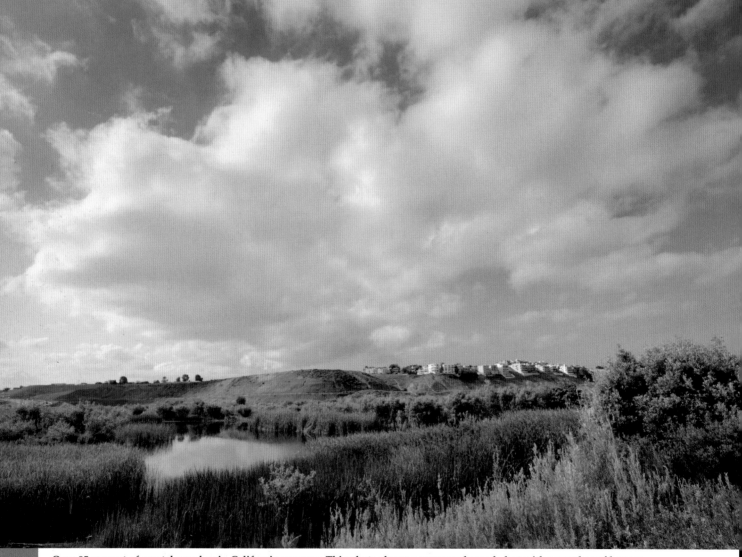

Over 95 percent of coastal marshes in California are gone. This photo shows a preserved marsh, but with a number of houses sitting on the nearby bluff. Ballona Marsh, Los Angeles, California.

Connections

fire

Most of us are familiar with Smokey the Bear and his stern warning, "Only you can prevent forest fires." We were taught from an early age that fire was bad. This was easy to believe since fire is scary and can destroy homes or other property. Also, once a fire burns through a forest, the trees can't be cut down for lumber. And back in Smokey's day, many felt the primary value of forests was their lumber. So the Forest Service tried to keep fires out.

However, fire in the natural landscape is not always a bad thing. Most forested areas experience fire as a normal process. Without forest fires, flammable brush accumulates, creating an overabundance of fuel when a fire does break out, causing it to become a big fire in a hurry. In the natural scheme of things, forests are subjected to low-grade fires every few years that consume the flammable dead wood, thus making huge, horrific fires relatively rare.

In the Southeast, longleaf pine forests require fire to burn off undergrowth or the pine will develop into a different ecosystem that allows other types of trees to crowd out the pine. In California, the chaparral is naturally adapted to fire, so fire is a part of the ecosystem. However, it is not adapted to a fire every year. Unfortunately, as people have moved into the chaparral, man-caused fires are more frequent. Fires that are too frequent will kill the chaparral and allow non-native grass species to take over. These non-native grasses are especially flammable and burn all too readily.

Fire is such an important part of so many ecosystems that you will often see its effects as you travel to different parts of the country. Don't be afraid of photographing this dynamic part of our world. While you may not be able to record actual fire, you'll often find evidence of it within an ecosystem that can make an interesting photograph.

Prescribed burn, Florida panhandle.

Photographer Profile

*Peter Essick

Combining Landscape and Environmental Photography

PETER ESSICK IS A PHOTOGRAPHER WHO LOVES THE
LAND, BUT APPROACHES IT AS A PHOTOJOURNALIST
AND ENVIRONMENTAL PHOTOGRAPHER. HIS LAND-
SCAPE WORK IS DISTINCTIVE AND MOVING. MUCH
OF HIS WORK HAS APPEARED IN "NATIONAL
GEOGRAPHIC" MAGAZINE, SHOWING HOW THE
WORLD IS AFFECTED BY EVERYTHING FROM CLIMATE
CHANGE TO ENERGY USE.

(WWW.PHOTOGRAPHY.NATIONALGEOGRAPHIC.COM/
PHOTOGRAPHY/PHOTOGRAPHERS)

Burning of computer wire and parts to
recover copper. Accra, Ghana. © Peter Essick.

I grew up in Southern California photograph-
ing landscapes in Death Valley when I was young.
I became influenced by the traditional West
Coast landscape photographers of that genera-
tion, like Edward Weston and Ansel Adams. My
interest in social documentary photography was
born after seeing the works of the New Deal-era
Farm Security Administration (FSA) photogra-
phers, especially Dorthea Lange; and then later,
Eugene Smith. This led me to the University of
Missouri School of Journalism.

After graduation, I had the opportunity to
do stories about environmental issues at
National Geographic magazine. I thought these
were important and also challenging from a
creative aspect. It became apparent over time
that more and more landscapes were being
damaged by human neglect or abuse.

For me, environmental landscape photogra-
phy is interesting because I try to combine
tragedy and beauty—two seemingly divergent
aspects—into a single picture. Even in the face
of tough conditions, you still need to keep
your sensibilities as a landscape photographer.

It is important to understand the issues
before starting to photograph. This type of
photography demands rigorous research to make
that idea of tragedy and beauty work in a pho-
tograph. I first research on the internet and in
books, then try to contact experts in the field
by phone or e-mail to get ideas about possible
photo opportunities. This usually takes several
weeks of work before I ever go in the field.

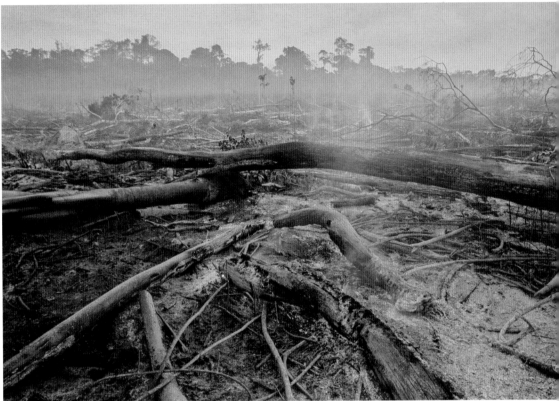

Burning of the Amazon forest for agricultural fields. Near Manaus, Brazil. © Peter Essick.

A background in one of the earth sciences would be helpful to understand the environmental language. However, if you believe that we are in a global environmental crisis, then it is crucial that everyone pull together to look for solutions. So I think any photographer with an interest in these issues should just do whatever they can to lend their skills to the work at hand.

Digital photography has helped me be a better photographer. I have a higher level of successful photographs when I can evaluate the images right away. Also, on a long-term assignment, it helps to have an easily documented record of my photos so I know what subjects have been covered. This helps me determine how best to proceed. In addition, I have been making HDR and stitched panoramic photographs, which are tools that didn't exist before for landscape photographers.

For the future, I think environmental and landscape photography will play an even bigger communications role as many environmental issues become better understood and more urgent. I have found that most people who enjoy photographing in nature are also concerned about conservation and preservation of natural areas.

Aside from the large national parks, many smaller natural areas are under threat from encroachment with development. So one approach to this type of photography is to adopt a local natural area and photograph it over a period of time. This could be helpful in raising awareness about the need for more functioning green spaces near developed areas.

7 special techniques

So far we have examined the primary tools and principles used by landscape photographers: Exposure, depth of field, composition, use of different focal lengths, filters, recording format, and more. These are core techniques used to produce quality images, but there are also some special techniques that can help create interesting landscape photographs with a bit of a twist, including black and white, infrared, panoramas, and high dynamic range (HDR). These can be a lot of fun, but they can also be time-consuming, so you may have to decide which techniques appeal most to you.

At one time, all landscape photos were black and white because that was the only type of photography available. Though color has now supplanted black and white as the main format for landscapes, black and white is still considered a classic form of landscape photography. It has even enjoyed a rebirth of interest with the advent of digital photography and the ease of creating great black-and-white prints without ever going into a darkroom.

Related to black and white, infrared photography is a specialized form that has long had a group of interested followers. With film, however, infrared was not easy because exposures were challenging to predict, the film was tricky to handle, and special filters were required over the lenses. Now it is possible to convert digital cameras to record infrared images directly as if you were shooting normally.

Photographers have been interested in panoramic imaging for a long time. Starting over a hundred years ago, special cameras were manufactured to capture sweeping views across the landscape vista. In color photography, panoramas became a niche technique requiring specialized gear. Today, digital imaging has made it possible for a photographer to use any digital camera to capture multiple images that can be stitched together to make a panoramic image.

We talked a bit about HDR earlier in the book as it related to exposure, especially when shooting clouds. When viewing a real-world landscape, our eyes see a wide tonal range, registering detail in both dark and bright areas of the scene, even on the sunniest days—

Joshua Tree National Park, California.

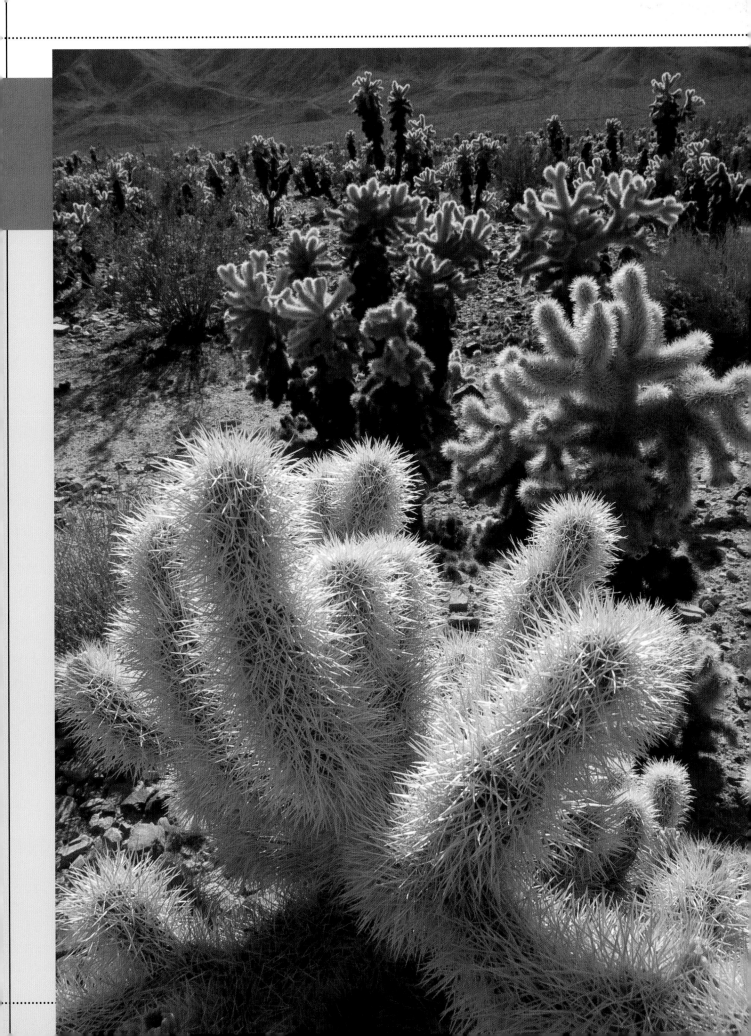

this is the ability to accommodate a high dynamic range. In comparison, because of technical restrictions, camera sensors cannot record all of the tones found in nature, therefore frequently showing a limited interpretation of what the world really looks like. Using the photographic HDR technique, however, you can take a number of varying exposures of a scene in order to capture a wide range of tones, then use specialized software to combine those images into one photograph that better represents what you actually saw.

Black-and-White Photography

This overview section will get you started with shooting black-and-white landscapes, but there is so much to learn that I highly recommend you find a book or a class that deals specifically with black and white landscape photography (for example, Digital Photographer's Guide to B&W Landscape Photography by George Schaub). Working in black and white is truly a different way of seeing the world than working in color.

As mentioned in the Introduction, photography began with black-and-white outdoor images, so the tradition of black-and-white landscape work is especially rich, from the Western frontier photography of Timothy O'Sullivan and William Henry Jackson, to the grandeur of Ansel Adams, to John Sexton's glowing black and whites of today. Black and white was dominant for many years, but began to recede in popularity 20 to 30 years ago as color film slowly took over the market. This change was dramatic because black and white lost its stature and became known as a form of cheap reproduction. Many photographers who once had darkrooms abandoned them as color photography became the norm. However, color darkroom work was difficult and quite toxic, so few photographers went there.

Rialto Beach, Olympic National Park, Washington.

But in recent years, black and white has gained new attention and appreciation. Now, black and white is often considered classy because it gives a fine-art touch to images. It has gone from being king to pauper, and now to royalty again!

A fine black-and-white print can be a wonderful thing to behold, often much better than anything you will see printed in a book or magazine. Yet, getting a good black-and-white print isn't always easy. The local minilab will rarely give you top black-and-white results, and building a darkroom isn't an option for most people today.

Luckily, inkjet printers are capable of making superb black-and-white images. In addition, the computer lets us do things to a black-and-white image file with more control and precision was possible in the traditional darkroom. Both have contributed to black and white's renaissance.

Shooting in Black and White

When shooting in black and white, you sometimes have to forget what you know about photographing in color. Often, we photograph subjects just for their color, which won't work in black and white. Also, color photos can look great in weather conditions that usually result in poor black and whites, while the reverse is also true with black-and-white photos made in conditions that are bad for color. It does require a different thought process.

Here are some ideas to help:

1. Look for differences in tones (brightness), not color
Remember to base your composition on these tonal differences. This is an important key to black and white.

2. Forget color

3. Work with dramatic light
Photographers are often disappointed when their black-and-white images are muddy, not crisp, as a result of dull light.

4. Ignore color except as it translates to shades of gray.

5. Try squinting
Believe it or not, if you squint, you will see less detail of a scene and more of the distinct tones that will become blacks, whites, and grays.

6. Did I mention to pay no attention to color?
It can easily distract you when you are working with black and white.

7. Watch out for big areas of white that are devoid of texture
This is especially a problem with skies. Large blank space can be deadly in black-and-white landscape photography, detracting from nice tonalities in the rest of the photo.

8. Beware of large areas of pure black
Though you can sometimes produce a dramatic photo with a large zone of black space, such as dominating shadows in the landscape, these areas more often look visually dead. Most photographers find it better to hold some detail in those areas.

9. And of course, forget about color
Maybe I have over stressed the color bit, but this is something photographers struggle with when starting out in black and white. It is so easy to be distracted by color and forget that the viewer of your black-and-white image will have no reference to the colors of the original scene.

Though you have more creative options if you convert to black-and-white images after first recording in color, you can also usually set the camera to produce black-and-white JPEGs. Joshua Tree National Park, California.

Creating Digital Black and White

There are at least two readily available ways of producing black-and-white images in the digital age. The first is to record black-and-white images directly to the memory card using a shooting mode found on many digital cameras that records an image file (JPEG) without color. (We'll look at the second way in a moment—converting a color image file to black and white using software in the computer.) This also allows you to see the black-and-white effect on your LCD monitor during image playback. You can often adjust your camera with internal settings that give filtered effects to better define black-and-white tonalities. There are several reasons to set the camera in this way to shoot black and white:

You see what you get—Good black-and-white images are not simply a color scene without color. There is an art to recognizing and capturing black-and-white tonalities. If you have not shot a lot of black and white, there are big advantages to shooting it in-camera instead of converting during post-processing, because you can review and revise what you have recorded based on what is in the LCD.

The experience is more direct—When you shoot using the camera's black-and-white recording mode, you begin to work in a creative space that is different than when shooting in color. You see things differently

and work the scene in new ways. This can be a disciplined and connected way to shoot black and white, providing a different creative challenge and experience.

You can adjust filtration effects to fit the scene while you are there—By using the camera's built-in filtration effects, or by using filters made for black-and-white shooting, you immediately see how black-and-white tonalities can be changed and adjusted for a scene. This allows you to view and fine-tune the image on the spot to fit your interpretation of the scene.

The image is close to finished—When you record in black and white, you don't have to use the computer to convert from color. You will likely still need to work with the image based on blacks, whites, and midtones, but your processing time is shortened. On the other hand, this is a disadvantage because the tonalities are locked in by the camera's processing and you cannot use a software program's capabilities to convert the colors into tone interpretations.

RAW + JPEG format gives you flexibility—When the camera is set to shoot black and white, you are locking the JPEG files in to black and white, but the

By shooting this scene in color, I had many options in my processing software for translating the colors, such as those in the sky and tree, into shades of gray. Eastern Sierras, California.

RAW files are not converted (the camera does include black-and-white processing information attached to the RAW file's metadata, but few RAW converters other than the manufacturer's recognize it). So RAW+JPEG in the black and white shooting mode offers you the ability to record both a color and a black-and-white image.

The second method to produce black-and-white pictures is to shoot in color and then convert the file to black and white in the computer using software. You gain several advantages shooting this way that are unavailable when the original image is captured in black and white. These advantages are related to filter effects—how different colored filters change the tonality of a scene as it is captured from real-world color to black and white.

Here's why you might want to shoot color for black-and-white prints:

You are not locked into one black-and-white image—A big disadvantage of shooting black-and-white directly is that it can't be changed to color or any other black-and-white tonal interpretation of the scene. You are locked into that one file. Shooting in color keeps the options open, but it does mean you need to understand how color changes into black and white.

Filtration after the fact—Filters strongly affect contrast in black-and-white photography. Dramatic skies are created using red filters, bright foliage is enhanced with green filters, and so on. You can always filter the color image in the computer, after shooting, to translate the scene into these preferred black-and-white tones.

Interactive filtration—Suppose you are new to black-and-white photography and don't totally understand filters and their effects. With the digital darkroom, you can try different filter effects on the same scene and instantly see how they change it.

Totally variable filtration—No matter how many filters you take with you into the field, you still have a limited set of filter colors to use in order to control the tones of the scene. In the computer, you can fine-tune the filter colors to very subtly adjust grays in the black-and-white image.

Multiple, yet separate filtration—Think of a scene with red flowers against green foliage in a landscape that includes beautiful clouds in a blue sky. A red filter will make the sky darkly dramatic, setting off the clouds, but maybe you don't like its effect on the plants because the red flowers will be light against dark foliage. You could use a green filter to make the leaves light and the flowers dark, but the sky will not be so dramatic. In the computer, you can select the flowers and foliage part of the photo and apply a green filter, then select the sky and apply a red filter effect.

How to Translate Color into Black & White

You can easily convert—or translate—color images into black and white in the digital darkroom with an image-processing program and a printer. "Translate" is a good word, because you need to make the shades of gray convert aesthetically and appropriately from the original colors. Just as translations in language can be good or bad, so can black-and-white translations.

Many image-processing programs have single commands that turn the color image into black and white in a single step. These are usually marked as Grayscale or Desaturate. However, I can't generally recommend this one-size-fits-all method. These simple commands are quick and easy, but they tend to make images look too gray without enough contrast.

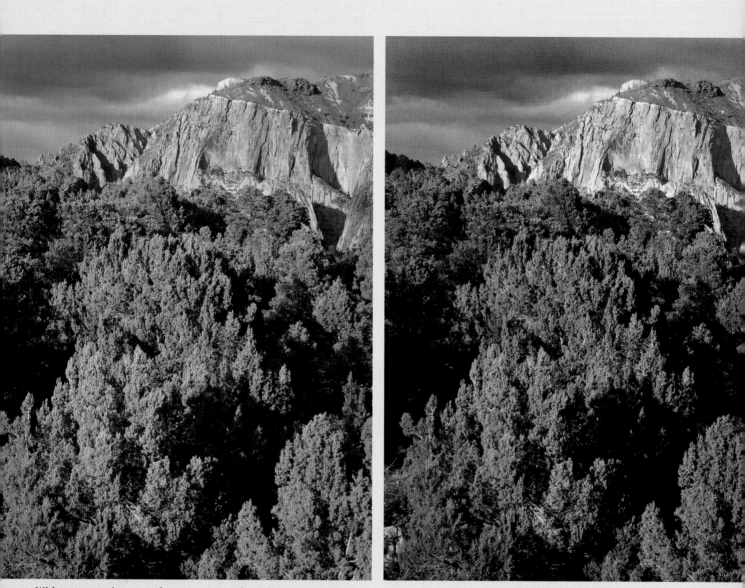

Without processing control over separate colors, the green and the red in the original shot will typically translate as a similar shade of gray, making for an unattractive black-and-white image. I used Lightroom to individually control how bright the red and green colors would become as grays in the black-and-white conversion. Zion National Park, Utah.

There are a number of good software programs that translate color to black-and-white tones. This not an all-inclusive list, but a selection of programs that has worked well for me:

• Photoshop

Photoshop includes an excellent black-and-white conversion tool under the Image drop-down (Image > Adjustments > Black&White), but I recommend doing this as an Adjustment Layer for more control. This tool offers sliders for adjusting the black-and-white tones as they correspond to each of the various colors in the image, but the really neat application is the ability to go right to the photograph and adjust where you want to on it (introduced with Photoshop CS4). You move the cursor onto the image, click on a portion within, and Photoshop automatically highlights the adjustment slider tool for that color. Then move the cursor right or left to make that tone lighter or darker. This is very photographic and a lot less "computerish." Recent versions of Photoshop Elements include very good black-and-white conversion adjustments as well.

• Selections for Photoshop

Using selections (or layer masks) can really set your black-and-white adjustments apart. This computer processing technique gives you control that is impossible to achieve when shooting black and white in the camera. You can select portions of the image and make the black-and-white conversions separately. For example, you could use one translation on the bottom of a photo that has flowers and grass, then apply a completely different conversion for the sky and clouds. This allows you to selectively change colors to gray tones, as if you shot part of the scene with one color filter and another part of the scene with an entirely different filter. That is impossible to do when shooting directly to black and white.

• Nik Software Silver Efex

This excellent program from Nik Software functions as a processing plug-in for Photoshop, and an export plug-in for Lightroom and Aperture. It is one of the most advanced and versatile black-and-white programs I have ever used. There are effective presets that are easy to use, plus you can control the filtration of the scene (i.e., how colors are translated to specific tones of gray) with a simple slider that goes across a spectrum of colors. As you adjust the slider, you can watch how the colors affect the gray tones in the image. It is like having an infinite set of color filters for black and white. In addition, you can control the strength and brightness of the effect as well as apply them locally.

• Nik Color Efex Pro

This plug-in for Photoshop offers several excellent black-and-white conversion tools. It is available in the Color Efex Pro complete collection as well as lower-priced bundles of effects. It has some black-and-white

controls that Silver Efex has (though not nearly the range or ease of controls), along with a group of color adjustments that have been well thought out by the designers.

• Lightroom

Lightroom's black-and-white control is similar to Photoshop's. Click on a small button at the top of the Grayscale Mix slider panel to activate the cursor. Then click on the photo and Lightroom finds the right color to translate, and you make it lighter or darker by dragging the cursor up and down. One nice feature of Lightroom is the ability to create a virtual copy of your image, so that black-and-white adjustments can be made to the copy while the original stays in color.

Computer programs like Lightroom make it easy to convert color landscapes to black and white.

Traditionally, the classic landscape photographers would often add a slight color tone to their images to give them a little more feeling of depth in the print. You can do the same using filters found in many image-processing programs. Arches National Park, Utah.

Grayscale vs. RGB
Color for Black & White

A grayscale image is a photo without color except black, white, and gray. It is a smaller file than a color image. All of the above techniques can be converted to grayscale if needed. Having a black-and-white photo remain in the RGB color mode, however, allows you to color or tone the image with a color toner effect such as sepia or cool selenium tone.

Adding a slight color tone to an image can give it more depth when printed, as well as making it easier to print if your inkjet printer does not have multiple black or gray inks. If Ansel Adams could do it, why can't you and I? In fact, all of the well-known black-and-white photographers toned their photos. If you go to an exhibit of Adams' work, or perhaps Paul Strand's, you will see most images have at least some color toning to them.

Infrared Photography

Unaided, our eyes cannot see the wavelengths of infrared (IR) light. However, with the right equipment, cameras can record infrared light. Consequently, infrared photography has always held a fascination with photographers since it allows us to see how this normally invisible spectrum of light affects the landscape. The distinctive appearance of infrared photos will immediately draw attention to your pictures.

Infrared was not easy to use with film. You did not know what results you were going to get, you had to guess at exposure, you often had to do special testing with your cameras to be sure they did not have infrared leaks, you had to handle the film containers in total darkness, and so it went. The photographs could end up looking cool with their white foliage and black skies, but the look was not worth the effort for most photographers.

Digital has changed this considerably. Sensors do see infrared, though most high-end cameras today have special IR cut-off filters that greatly limit or remove the infrared light (this allows for higher-quality normal images). These cameras may still be sensitive to some degree of IR light as long as a special filter is used on the lens that blocks visible light (allowing IR to pass through to the sensor). This cut-off filter was weaker or less restrictive of IR wavelengths on many early digital cameras, and even in some low-priced units today. So, keep your eye open for an older digital camera in the used marketplace if you want to experiment with IR photography.

You can check your camera's sensitivity to infrared wavelengths by pointing a remote control unit at your camera and pushing the remote's button. Assuming your infrared remote doesn't also include an auxiliary visible light, you will be able to see a bright spot (the IR beam) in your LCD with live view (or in a photo recorded in the black-and-white shooting mode with D-SLRs that do not have live view) coming from the remote that you could not see with your unaided eyes.

The distinctive look of infrared photography is unlike any other black-and-white effect. Foliage reflects infrared light, so it becomes white, while skies can look quite dark (below). Tejon Pass, California.

Many different D-SLR models and some advanced compact digital cameras can be modified for infrared by having the IR cut-off filter removed (search the internet for "digital infrared conversion"). A number of photographers will do this with an older or outdated camera, so it becomes an extra camera dedicated to infrared photography. This IR modification can offer stunning results without the need for dark, external IR filters and long, tripod-supported shutter speeds (see below). I have an advanced compact digital camera modified for this purpose, and it is great fun to use. You can see the infrared effect immediately in the live LCD on the camera.

Yosemite National Park, California.

An infrared external filter to cover your camera's lens will be necessary if you want to shoot IR with an unmodified camera that is at least somewhat sensitive to IR light. You can get these filters at most camera stores—they look black. Ask your salesperson for advice on the type of filter to choose.

IR images usually look best, in my opinion, when recorded using the camera's black-and-white mode or when converted in the computer to black and white. Because the IR external filter is so dark, it blocks the visible light. Standard digital cameras are great for experimenting with infrared because they will show a live image in the LCD to aid in composition. But with D-SLRs, you cannot see your scene through the viewfinder. With all unmodified cameras, the dark external infrared filter means you will have to set long shutter speeds to permit enough IR for exposure. Tripod use is therefore a necessity. In addition, some cameras produce a hotspot in the center of the image. All of these are reasons why many photographers who love IR photography choose to convert a camera by removing the IR cut-off filter, as described above.

IR photos often have an impact and drama that is heavier than photos recorded with visible light. It is interesting that you can make IR photographs in light that usually gives poor results for normal photography—for example, strong midday sun. Yet, that is exactly the right light for IR photography because the infrared light is strongly reflected to the camera.

Finally, infrared shooting will allow you to cut through haze on those all-too-common hazy days of summer, when a distant landscape would usually look terrible in photographs. With IR, you literally cut through that haze and find a landscape that is otherwise easy to see.

Panoramic Photos

Wide-framed panoramic images have long been popular. At one time, people would shoot multiple pictures across a scene, then line up and paste the prints together as a makeshift panoramic—but they could not blend the images together into one. True panoramic images were difficult to make into large prints, and the specialized cameras needed for quality panoramas were expensive and scarce.

The computer changed this dramatically. Anyone with a camera can now produce panoramic images. All you need to do is take a series of photos across a scene, then have the computer stitch them together into a single photo. Photoshop (CS3 and CS4) makes it easier than ever to align multiple images with its Photomerge option. In addition, ArcSoft Panorama Maker offers great results at a good price.

Still, just because you can create a panorama doesn't mean any landscape can actually be made into a good panoramic photo. You need to compose and shoot a scene that uses the entire image area effectively—simply doing a wide landscape might just create a boring horizontal photo. A panorama must work over the full print from left to right.

There are a number of common mistakes to avoid in order to produce an effective panoramic photograph:

▪ Don't create an image that has all the interest in the center. If you can crop off the sides without hurting the scene, you don't have a good panoramic photo.

▪ Don't make a photo simply because there is a lot to see across the scene—there should be an element within the landscape that defines or gives structure to the image.

▪ Even if a portion of the scene makes an interesting photo, don't record an unbalanced image where distinct gaps appear in the visual material in the landscape. Not all landscapes make good panoramic photos.

Shooting Panoramas

While a tripod may not be a necessity, sophisticated tripod heads make the process work more smoothly and accurately. The method is to shoot a series of overlapping photos from one side of the scene to the other, and later put them together with software in the computer.

During the shooting phase, keep the following pointers in mind:

1. Plan the final image

Figure out what the composition will include from left to right (or top to bottom if you are shooting a tall panoramic image—that can be an interesting variation on the technique). Visually interesting things should be happening from one side to the other with no dead space.

2. Level your tripod and your camera

As you move across the scene taking photos, the camera needs to move in a horizontal plane or the resulting images will be difficult to align properly. First make sure the tripod is level, then the camera. Visually check to see how level the camera is by panning it across the scene.

3. Shoot a series of overlapping photographs across the scene

Take a series of photographs from the left to the right side of the panoramic area, moving the camera slightly as you go across, overlapping the shots by 30–50%. More overlap can make it easier to line up the photos in the computer, especially with automated programs. Look for strong visual elements that are in the overlap areas—they will help in the alignment of the images.

4. Shoot using manual exposure mode

The camera's exposure needs to be limited to one setting through the entire sequence of images, or else the separate images of the pan will have tonal variations that will be hard to match up. Also, set white balance to one setting (not AWB) or you may get color variations, too. Strive for consistency.

Stitching the Images

Bring your image files into the computer once you have recorded your shots. Do not crop or change the size at this point (see next page).

As mentioned earlier, among the most convenient methods for beginners are stitching programs such as ArcSoft's Panorama Maker or the Photomerge option in both Photoshop and Photoshop Elements. These programs make stitching quite easy, but they require distinct objects in the overlapped areas in order to work best. In addition, a healthy overlap of 30–50% between images produces the best results.

The steps are pretty straightforward. First, check all of your photos to be sure they are consistent in tonality and color. Any big changes in brightness, for example, will show up as unevenness in the final image. Then you tell the program to go to work—this may take a little time, depending on the processing speed and RAM of your computer. Having enough RAM is critical because panoramic photos can be quite large.

Once the processing is complete, review the photo. You may find a section with uneven tones, which means you may have to go back and adjust that photo, then redo the panorama. Minor problems can often be corrected with the cloning tool. You'll usually have to crop to the final image to fix the edges.

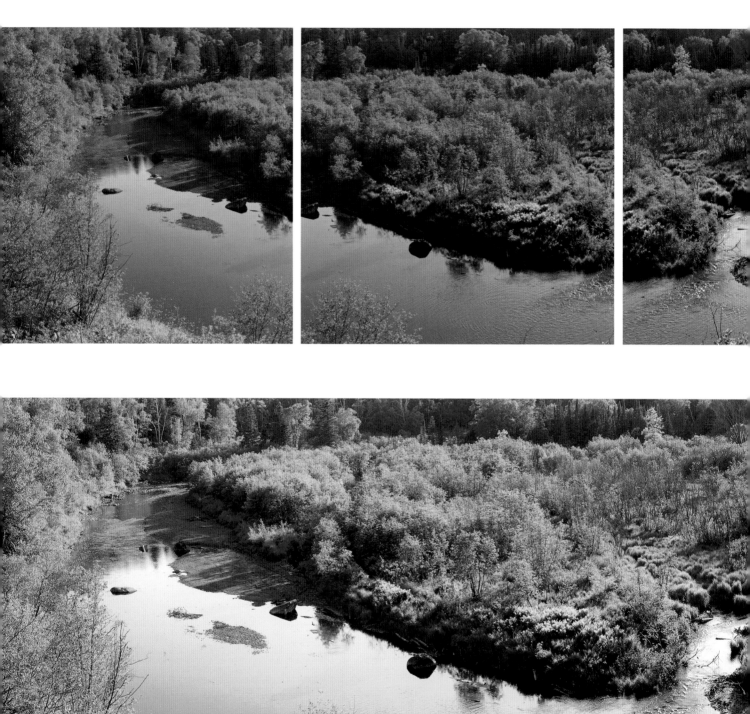

I was on a hill when I saw this wonderfully backlit scene of the Gooseberry River. As, illustrated above, I needed five separate images going across that scene in order to create the impact I wanted for the final panoramic shot. The full panorama is a bit lighter than the individual photos becasue of additional processing applied to the final photo. Gooseberry Falls State Park, Minnesota.

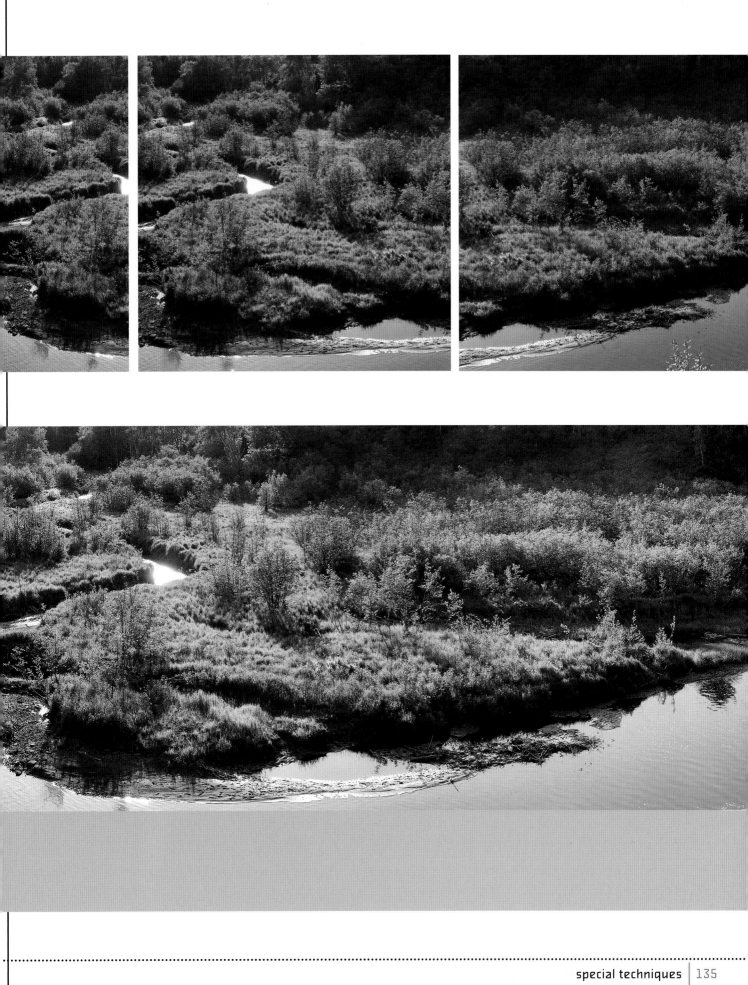

Photographer Profile

*George Lepp

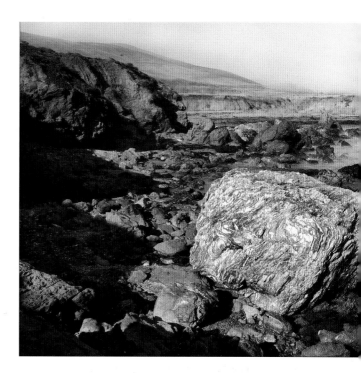

The Panoramic Vision

George Lepp (www.geolepp.com) was one of the first professional nature photographers to go fully to digital. One reason was because of what it allowed him to do with panoramic views. Early on, he was stitching multiple landscape shots to create panoramas, then making huge prints. He created a panoramic image a few years ago of a herd of zebras that was printed over 20 feet long (6 meters) and was used by Canon in their trade shows.

Interestingly, I started doing panoramic landscapes over 40 years ago, when I would take several prints that covered the width of a scene and tape them together to give the whole view. Landscapes lend themselves to the panoramic view because of their expanse, especially where I live in the Western U.S. I'm frustrated trying to capture these images within an 8 x 10 or 16 x 20-inch format (20 x 25 or 40 x 50 cm). Now it's more like 5 x 20 feet (1.5 x 6 meters). The viewer can become a part of the image and stay within it for a longer time.

Panorama photography is almost as big as life. You can capture so much more detail than you could several years ago. Back then, it was about the width of the image; but now we see both the width and the depth. With the huge file size of a gigapan image (www.gigapan.com), we can enlarge the captured picture and show a tremendous amount of detail.

The ability to do this sort of thing has been enhanced by the digital revolution in photography. Every time I think I've made the ultimate panorama or macro image, new possibilities open up. Ten years ago I couldn't imagine using a computer to assemble multiple images into a simple seamless view. Now I'm compositing hundreds of images that not only make up that same view, but also allow it to be enlarged to reveal incredible details. Before, we kept our distance to see the whole picture, now we walk right up and, in a way, right into the image.

It just keeps getting better. There will of course be cameras with more resolution, printers that print larger, and computers that can handle the ideas we have conjured up. Yet the exciting things about the future are the technologies we don't even know about, and the possibilities we haven't yet dreamed about.

Estero Bluffs State Park, California. © George Lepp.

HDR composite, Los Osos Oaks, California. © George Lepp.

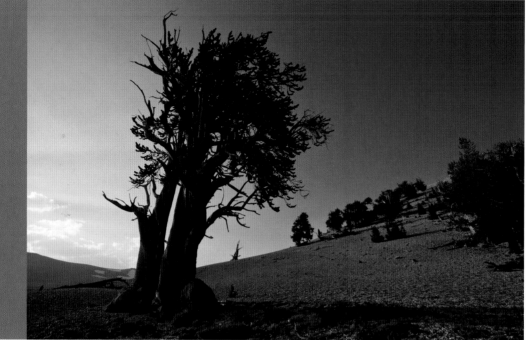

The three images along the top of these pages were recorded at differing exposures. By combining them using HDR software, I produced a final image (below right) that exhibits a wider range of tones and colors than is otherwise possible without losing detail in either the highlights or shadows. Ancient Bristlecone National Forest, Big Pine, California.

HDR

HDR (high dynamic range) photography is a great way of dealing with extreme lighting conditions that are all too common in the real world. Our eyes can see detail within a wide range of brightness in a landscape, and sometimes photographers expect to capture that same range in a photograph—but it is often a range that is far greater than the recording capability of the sensor. I find, based on numerous questions from students, that many photographers expect more from their camera's exposure function than it is not able to deliver. Many want a well-exposed image for a scene that, in reality, is impossible to expose without clipping—an exposure that cannot hold detail in the lowest (black) and/or lightest (white) levels of brightness.

HDR photography can help deal with landscapes that used to be impossible to properly expose. The technique involves taking multiple images of a scene (from a tripod-mounted camera) as you vary the exposure from dark to light. Then, you combine those images in the computer using special software that builds a photo with much greater tonal range than the camera can record in a single file. The result is a photo that is closer to the natural scene, rather than one restricted by the limitations of camera technology.

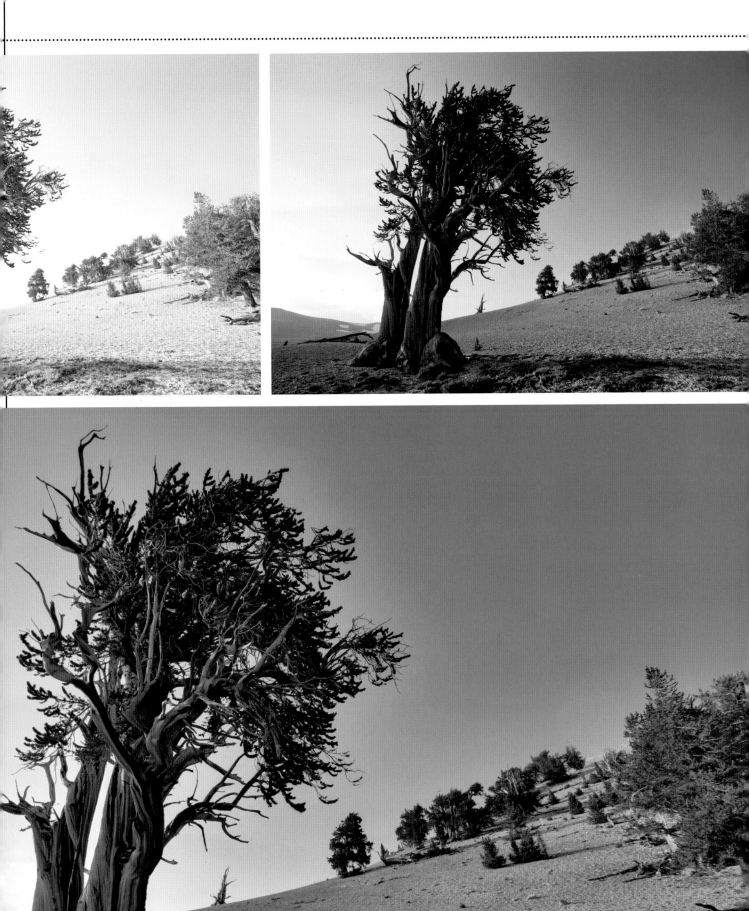

Some photographers have said it is unfair to use multiple shots because it is not "real" photography, while some publications refuse to run such photographs, saying they are illustrations rather than photographs. I find this debate rather silly. I want the real world to be in charge of what is true in a landscape photograph, not obsolete technologies or limitations of technology. One has to wonder when some of these editors are going to understand that hiding behind old ways of doing things can keep us from seeing the world with fresh eyes, and seeing it better.

I don't use HDR all the time, but I like having it as an option. I was recently looking at a book of Ansel Adams' photographs. I saw a couple of photos that stood out, and they were the darkroom equivalent of HDR. One was a scene of backlit woods with sunlit grass and dark tree trunks. Adams held detail throughout the scene because of the way he applied technology (exposure and chemistry) to the specific conditions of the scene. Adams generally overexposed such shots and underdeveloped them, plus added more processing when he made the print.

That scene could not have been captured in color with such detail straight from any camera, film or digital. Yet, with digital imaging, we can make several different exposures and use special processing methods to capture scenes like this that were simply not possible in color before.

Follow these basic HDR steps:

1. Lock your camera down on a tripod

2. Set your camera to AEB
(autoexposure bracketing)

Also set continuous shooting, and record three to five exposures with an interval of at least one whole stop between each. AEB is convenient because it changes exposure automatically with a simple press of the shutter release. This means your camera will not shift or move between exposures, which can accidentally occur if you are adjusting each exposure separately.

3. Play back your images to check exposures

You want a range of exposures that are dark enough to hold detail in the brightest areas of the image and bright enough to reveal color and tonality in the dark parts of the picture.

4. Record variations

For example, if using AEB, try using your camera's exposure compensation settings to shoot another series of the scene as brighter or darker.

The next step is to download your pictures into the computer. There are several software choices for combining the differently exposed images. Photoshop has a Merge to HDR option, but I'm not a big fan because its implementation is not as photographer-friendly as it could be. There is also an interesting software plug-in called LR/Enfuse that is technically an exposure blending program, not true HDR. It creates a single image with a wide tonal range from several shots while working in Lightroom.

On the other hand, Photomatix is a program that creates a true HDR image. It can give excellent results, but be aware that it is easy to overuse, creating funky-looking landscapes are not always natural looking. An advantage of a program like Photomatix is that its HDR file can be interpreted in a number of ways (Photomatix can also do exposure blending). When you first create an HDR file, you will find that it will not look very good on your computer monitor. It actually has a wider range of tonality than can be properly displayed.

Photomatix allows you to map a limited range of visible tones to the complete range of tones in the HDR file. Although it is possible to simply click on a single default button to create an HDR image, the program's slider controls allow a great deal of flexibility in how you interpret that HDR data and adapt to a number of different conditions. For example, it can bring out cloud details, even on a cloudy day that does not have a lot of contrast.

HDR presents new possibilities for landscape photography, including opportunities for capturing landscapes in conditions that photographers often avoided in the past, thereby giving you fresh looks at even well known landscapes.

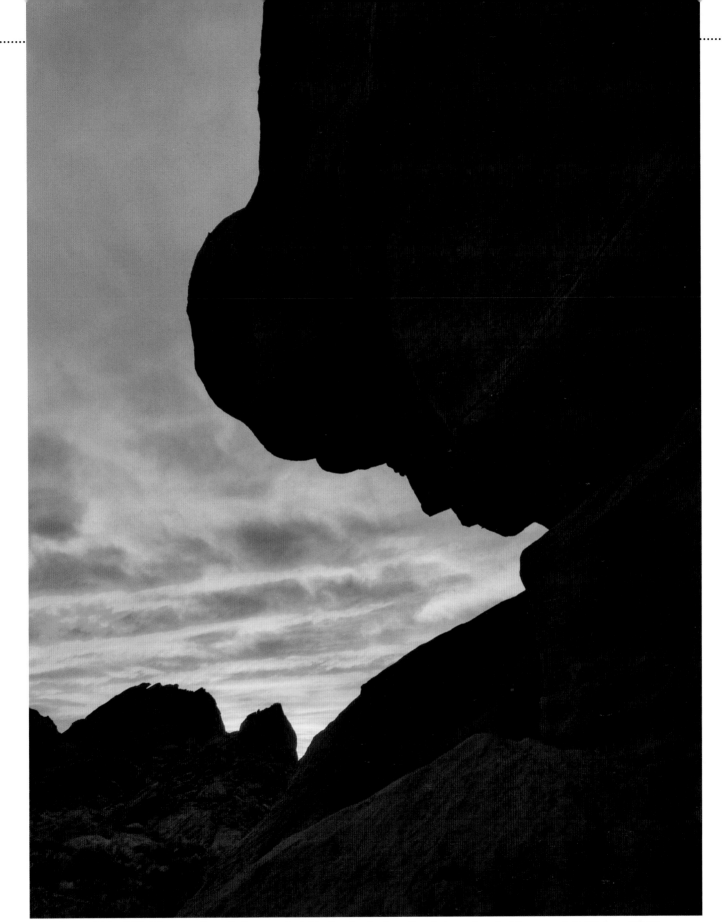

Some have criticized HDR because the technique can be taken to a level where the photos end up looking surreal. But it doesn't have to be that way. As demonstrated here, you can extend the image's dynamic range and still have a photo that is realistic in portraying the scene as it appeared to your eyes. Lake Meade Recreation Area, Nevada.

themes

144 mountains

152 forests

160 deserts

168 oceans

176 flower

182 wetscapes

188 prairies

196 small scale

204 natural icons

210 winter

Landscapes literally come in all shapes and sizes. There are opportunities for photographing a landscape anywhere in the world. Some photographers seek out the bold landscapes of the Western United States, while others find great images in the more confined landscapes of the East. Other photographers photograph outstanding landscapes where ocean meets land.

We will now we look at a number of specific types of landscapes, and examine how you might deal with them photographically. Though everything that you have read up to now will give you ideas for photographing any landscape, there are unique challenges and opportunities that come with making pictures of specific kinds of landscapes.

This workshop-like section will also give you ideas on how you can vary your landscape photography. For example, some photographers might think that the only great landscapes are those in the West, particularly those with mountains. That is an important location for landscape photography, so I will discuss it. But it isn't the only place you can shoot an extraordinary landscape. When I was editor of *Outdoor Photographer* magazine, I'd often get queries about Western landscapes from people in places like Boston! Yet they had the opportunity for getting outstanding landscapes in New England. So use this section to gather new ideas for shooting landscapes. You may find something different within your own back yard.

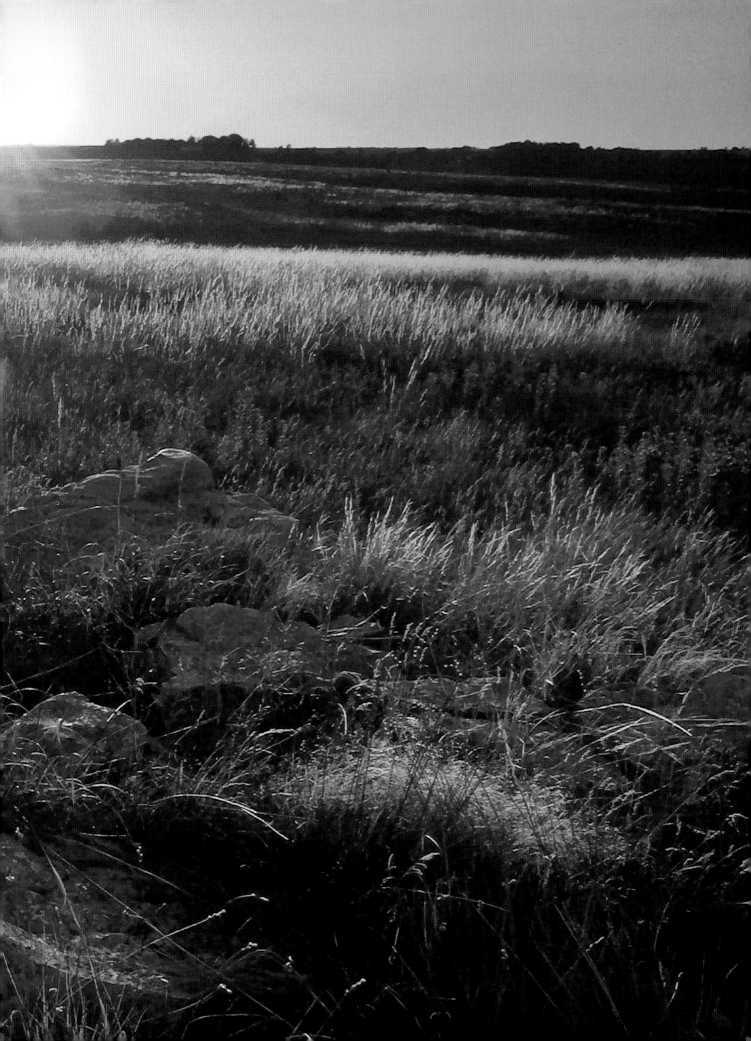

mountains

The mountain landscape is a classic, one that many photographers dream of photographing. It is the realm of Ansel Adams and other heroes of landscape photography. Mountains can be bold and dramatic, making them great subjects to photograph. Many people travel great distances just to get to these locations.

Mountains are an important part of North America's landscapes, from the wooded slopes of the Appalachians to the rugged peaks of the Rockies, from the barren rock surfaces of the deserts to the granite cliffs of the Sierras, up to the endless mountains of Alaska. Each place has its unique characteristics. Mountains are different, depending on where you are, but many of the same techniques can be used to get photos of them.

It is important to look carefully at the mountains that face you and determine what is distinctive about them; then think about how that distinguishing quality can be captured. If trees are a big part of the scenery, then highlight them as a part of the composition. If glaciers are key to the scene, find ways to draw attention to them. Use composition and lighting to feature what is unique about the mountains you are photographing.

It is common to discover that a photo does not live up to the impressive grandeur of these natural landscapes. As we discussed earlier in the book, a photograph is not the same thing as the real scene, and this is definitely true for mountain landscapes. Photographers are often disappointed in the images that they bring home from their trips to mountain country.

Near Machu Picchu, Peru.

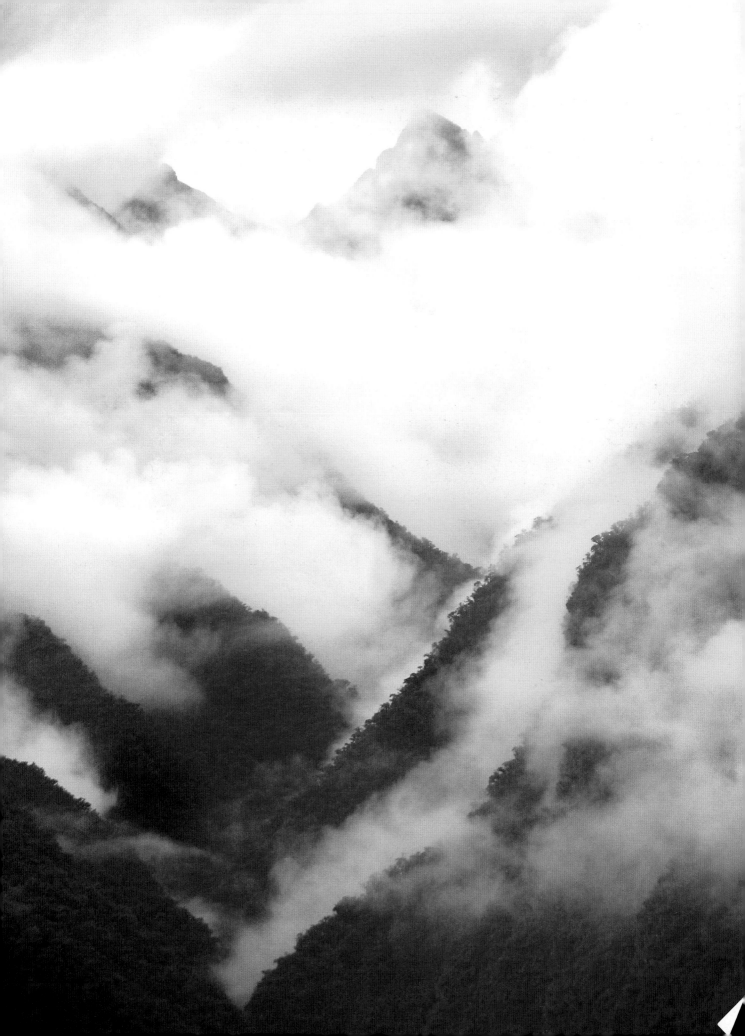

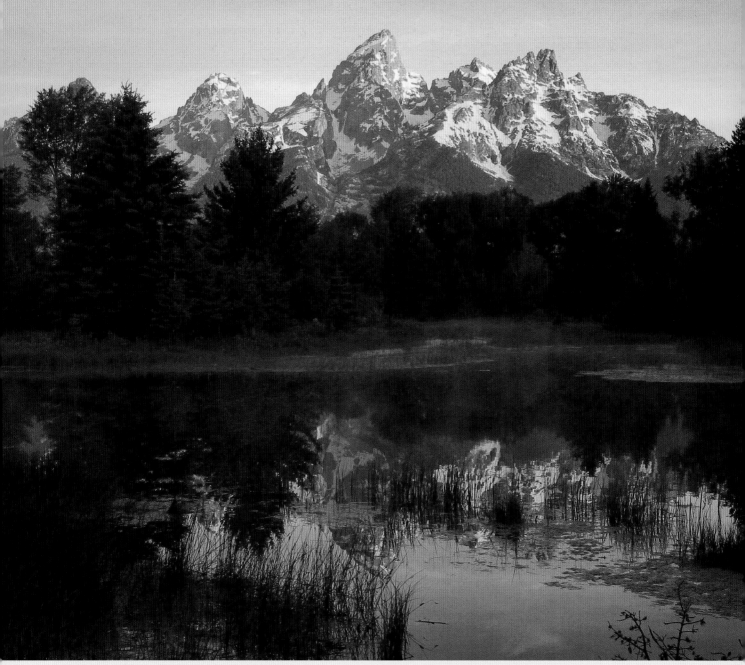

Grand Teton Mountains National Park, Wyoming.

So to start working with mountain landscapes, you have to take a step back from the bold beauty of the actual location and think about the photograph. There are a number of ways to interpret the mountain landscape so that your photo will still be interesting even though confined to a two-dimensional representation. Lets look at some of those ways.

You know the old real estate saying, "Location, location, location." For mountain landscapes, think composition, composition, composition. I find that photographers too often simply surround a mountain landscape with the edges of their viewfinder and then stop. Remember that these big landscapes really can't be confined within your viewfinder. You need to find a way to structure the composition so that it is interesting to look at as a photograph.

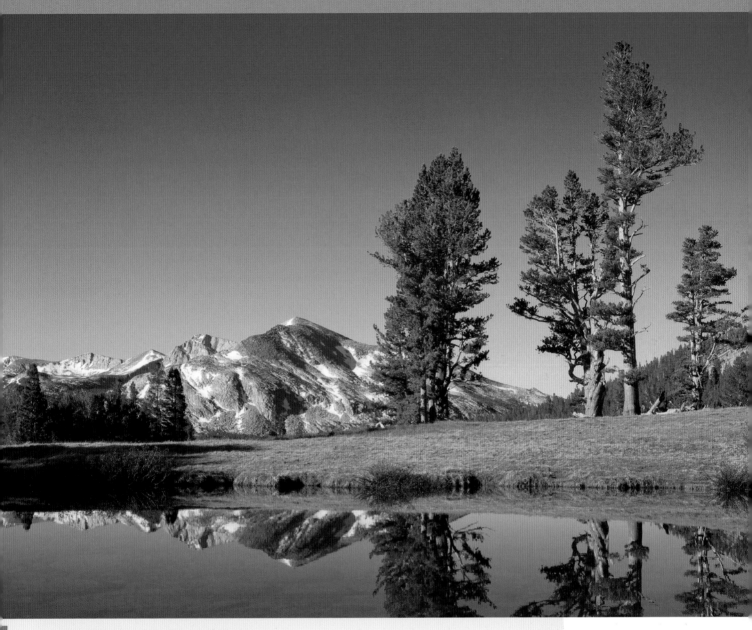

Yosemite National Park, Eastern Sierras, California.

• **Pay attention to foreground (photo A):**
I can't begin to tell you how many potentially attractive mountain landscapes I've seen that were severely compromised by an uncomplementary foreground. Watch what is going on along the bottom edge of your frame, because this is a place where things sneak in to detract from your scene. Check the lower left and right corners to be sure there is nothing like a treetop or outcropping that does not belong to the scene.

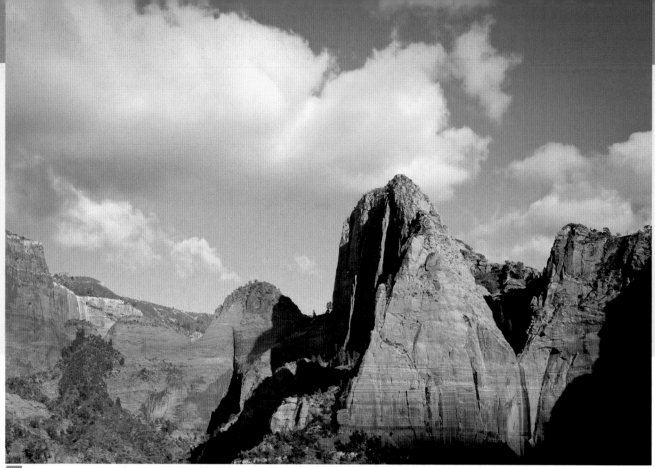

A Zion National Park, Utah.

B Lasal Mountains, Utah.

C Santa Monica Mountains, California.

• **Be careful with centered compositions (photo A):**
They rarely work with these landscapes, and in fact, will often take away from the drama of the scene. Compose so that the main subject is not directly in the center of the frame.

• **Watch the sky (photo B):**
Skies can be dramatic additions to a mountain landscape, or they can be an unattractive distraction. Be sure your sky is the former—avoid including the sky if it is bland or in any way unappealing.

• **Be there early and late in the day (photo C):**
Most mountain landscapes simply do not look their best during the middle of the day. The light at that time can be flat and bluish, plus you may get an unattractive haze in the distance. If you are there at sunrise, you'll often get remarkable light appearing on the tops of the mountains. If you're there at sunset, you'll often find wonderful light on the peaks as the sun drops below the horizon, as well as for the half hour or so that follows.

A Olympic National Park, Washington.

• Try a telephoto lens (photo A):
Mountains often look more dramatic when you see them from a distance. As you get physically closer, it usually becomes more and more difficult to see the impact of the full mountain scene.

Using a wide-angle lens when you are far enough away to see a range of mountains will typically result in a photo where the mountains look small and not very bold. That's the time to get out the telephoto lens and concentrate on a portion of the total scene.

Take a good look to determine the location that will give you an interesting distant view of the landscape for your telephoto.

• Don't be afraid of light and shadow:
Sometimes a really effective picture of mountains results when the light is boldly illuminating a peak while the rest of the scene is in shadow. In that case, base your exposure on the bright areas and let the shadow areas go dark—or try HDR (see page 138).

geology

All landscapes are tightly connected to the geology that lies beneath them, which is why, as a landscape photographer, you will find it pays to be aware of a location's geology and what it means to the particular landscape. This knowledge can help you find better pictures.

Many regions in the U.S. are greatly affected by water, where streams sculpt valleys, rivers cut through canyons, lakes dot the forests and pastures, and waves erode shorelines. While it takes a long time for a river canyon to be created, we can still see plenty of places where water is actively working on the geology of the landscape. This can often be a place of vitality in an otherwise static scene.

For example, it is exciting to find places in a stream where the roiling water is lively and swift, careening

Zion National Park, Utah.

around boulders in the water. And coming across a beach where waves crash against the shoreline with bold sprays clearly demonstrates the power of water. Both types of scenes offer dynamic subjects and can give you some really cool photographs.

Naturally, water is the foundation for ice that makes its presence known during cold-climate winters. Solid ice can be as powerful as water in its liquid form, prying rocks apart and breaking down landforms, changing the landscape over time, even forming great mountain ranges as glaciers have receded over thousands of years. Though glacial effects occur too slowly to observe in real time, you will see the ice as it forms on the landscape. That ice can create interesting formations, colors, and compositions for your photography.

Another factor that shapes geology is the wind. In some areas, the entire landscape, such as sand dunes, is affected by the wind. Sand dunes illustrate the power of wind and are a fascinating landscape. They're also great fun to photograph.

Other, more exotic activities, like volcanoes or geysers, can show the immediate effects of geological processes. The immediacy and drama of active volcanoes fascinate us; certainly they make great subjects for landscape photos. You can see the effect of volcanoes even in areas where they are not currently active. Large areas of black rock spreading out across a scene, for example, in locations from New Mexico to California to Idaho, produce a great opportunity for photographers. In some areas, volcanoes from long ago leave behind cone-shaped hills or spectacular outcroppings of obsidian or basalt. It is fascinating to consider the conditions that have formed these rocky landscapes as you are outside using them as settings for your photography.

forests

Forests are sometimes harder to photograph than any other landscape because of their density. It truly can be hard to see the forest for the trees! Still, the forest is an important landscape for all of North America and in other parts of the world, so it is a one that needs to be photographed. It is important to consider whether you're photographing from within the forest or from outside, since each gives different kinds of views of this particular landscape, and has different challenges.

Inside the forest, you are literally surrounded by the landscape. Light varies from dim to bright as shafts from the sun illuminate parts of the interior forest. This creates contrast that can be extreme, and is one reason why a cloudy day might be the best time to work inside of a forest. You must also deal with limited views when inside, so it is necessary to pick your angles and compositions carefully.

Outside the forest, you see the shape and form of the landscape and trees. Light is now over the whole scene and not spotty with deep contrasts from the shade. The three-dimensional form of a forest starts to appear, especially when shot early or late on a sunny day. Textures and shapes of different trees show up boldly if you can find a vantage point to show them off.

However, it is good to remember that not all forests are the same. An evergreen forest is considerably different than a deciduous forest, not least because the leaves change color in the deciduous and drop during the autumn, leaving bare trees during the winter. Forests made of different types of trees also vary in terms of shape and texture. Of course there are also differences from one evergreen forest to another, or one deciduous forest to another as well.

The differences in forests affect how we approach the landscape, because we will have a variety of pictorial elements to deal with. For example, an evergreen forest consisting of all spruce trees will have lots of triangular shapes. A deciduous forest based on maple trees, on the other hand, will present rounded shapes for photographing.

Cloud forest, La Paz area, Costa Rica.

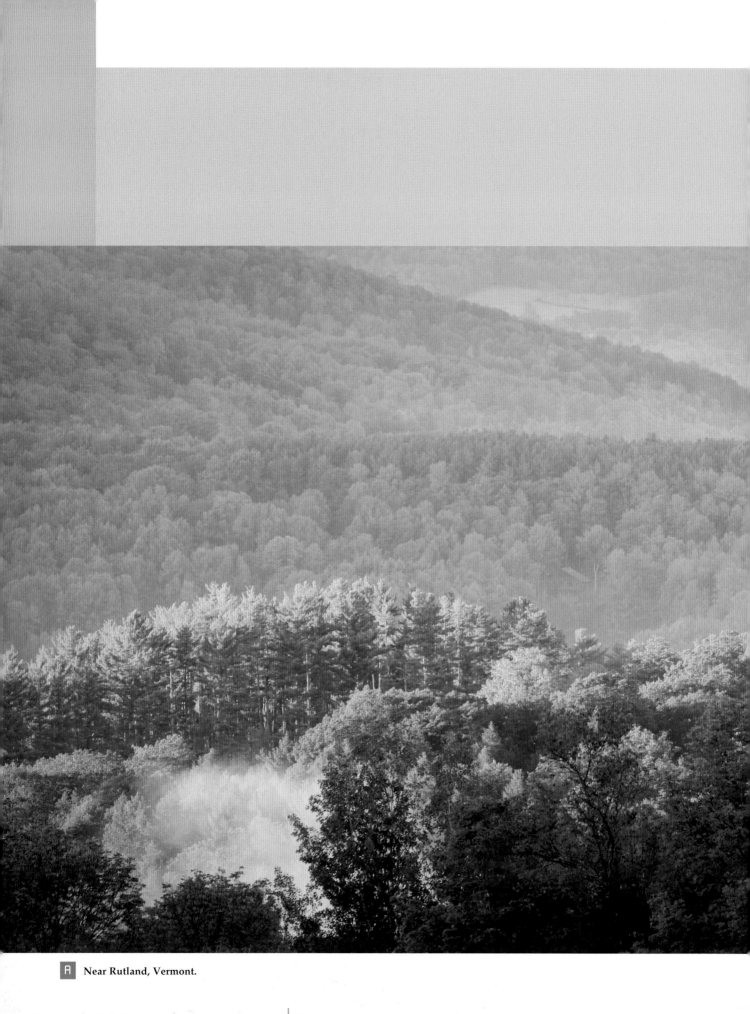

A Near Rutland, Vermont.

Here are some things to consider when photographing forest landscapes:

● **Photograph the forest from a distance (photo A):**
When you get close you begin to see individual trees rather than the over-all form, color, or texture of the forest. These more general characteristics that emerge from a wider view are interesting to photograph if you find a location from afar that gives you a good vantage point. Overlooks from the top of a hill, or even from forest service towers when available, can give you an overview that shows the forest as a forest.

● **Photograph the forest from inside (photo B):**
When you get up close, it is often worth going inside a forest and look-ing for smaller landscapes. This is when you search for details that can create a strong composition. For example, find an interesting fore-ground, such as a patch of forest flowers or ferns, a decaying stump or fallen log, tree roots, or perhaps a small tree.

B

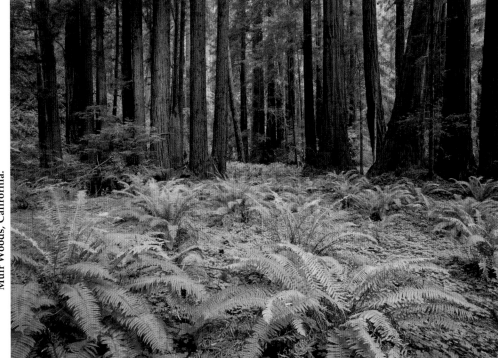

Muir Woods, California.

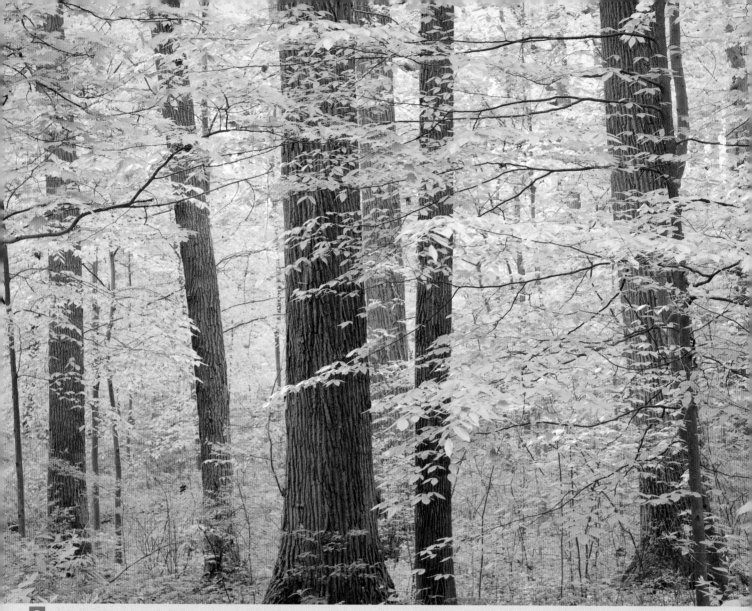

A Great Smoky Mountains National Park, Tennessee.

• Look for appealing lines among the trees (photo A):

You can often find attractive patterns in the vertical lines of an evergreen forest, or you may find interesting intersections of diagonal lines in an old forest where trees have started to fall. In deciduous forests, look for contrast—even if individual trees blend together, you can still differentiate distinct patterns and lines when you are aware that this is something to look for.

• Try looking up (photo B):

Thic can be an interesting way to present a forest and discover patterns of trees against the sky. Though it has nearly become a cliché to tell photographers to "look up," you can create an unusual underside view of the forest's canopy if you find a unique group of trees or other strong compositional elements in the tree trunks.

• Seek out a foggy or misty morning (photo C):

It is terrific to be in a forest with your camera under these conditions because they simplify the scene and help define your composition. In addition, fog or mist produces lovely tones and colors. Set your exposure with care—too little, and the fog will just look gray and blah; too much, and the atmospheric conditions will get washed out in tone. As insurance, try changing your exposures to take several variations; that way you can select the best result from the different pictures.

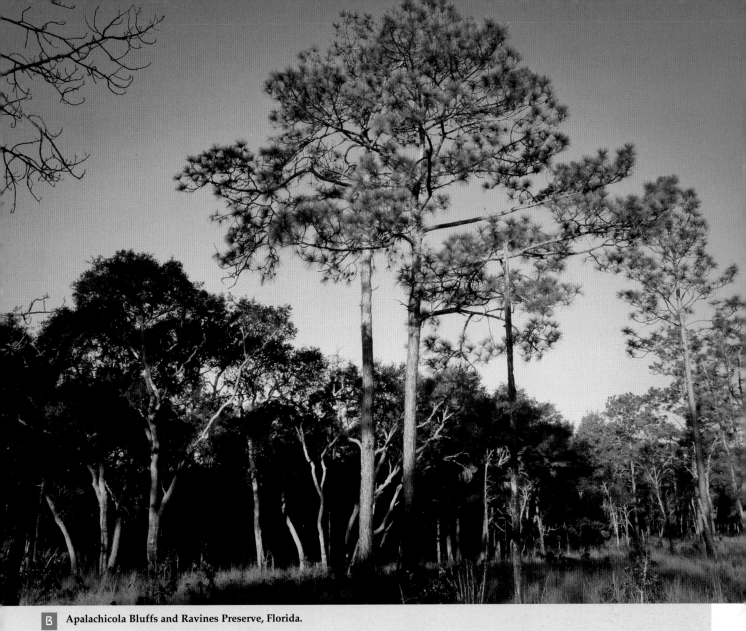

Apalachicola Bluffs and Ravines Preserve, Florida.

Shedandoah National Park, Virginia.

Green Mountain National Forest, Vermont. A

• **Seasons are important factors (photo A):**
During spring, you will get amazing greens in the Eastern and Midwestern deciduous forests of the U.S. Of course you will find stunning colors in autumn, and the chance to photograph the forest's skeleton of bare trees in winter. In coniferous forests, you will find a whole different set of greens from season to season. In addition, there will be flowers in the spring, or fall color from scattered deciduous trees in the autumn. There are other forests, such as aspen clad hills and river bottom growths, that will have their own unique attributes throughout the year.

• **Snow is an amazing addition (photo B):**
A late autumn snow on aspen is magical. Snow that has fallen on evergreen forests looks enchanted, and a winter's white blanket on maple-basswood deciduous forest gives a sense of peace like no other season. So get out in the woods and start taking pictures when the snow starts to fly!

B Wasatch National Forest, Utah.

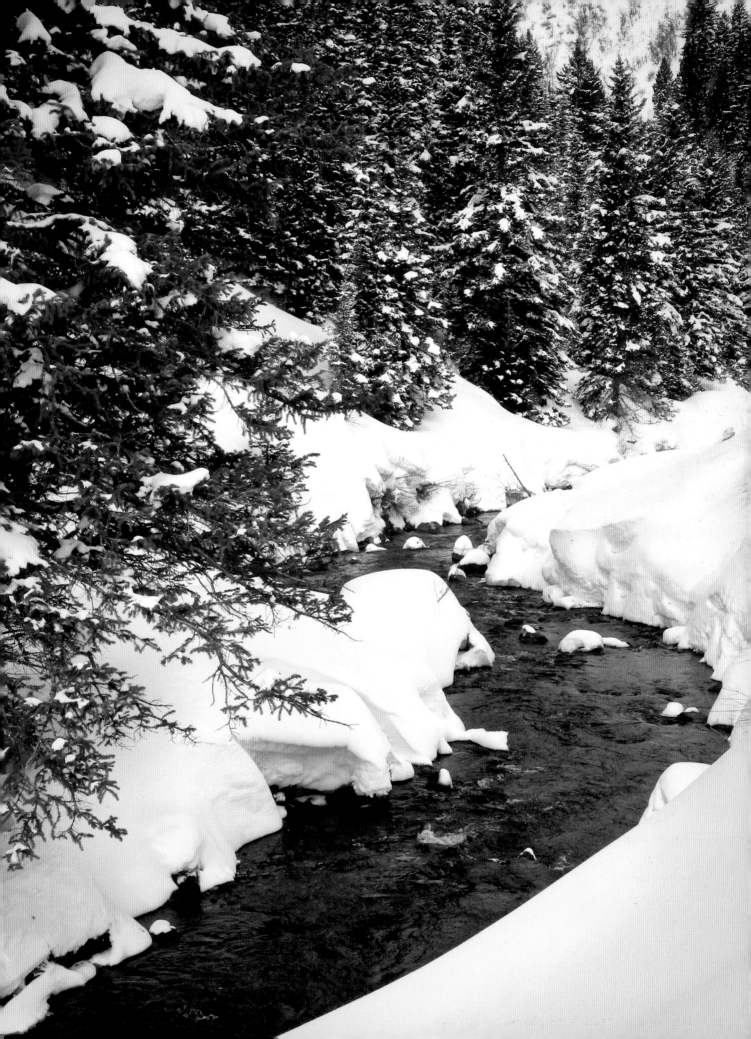

deserts

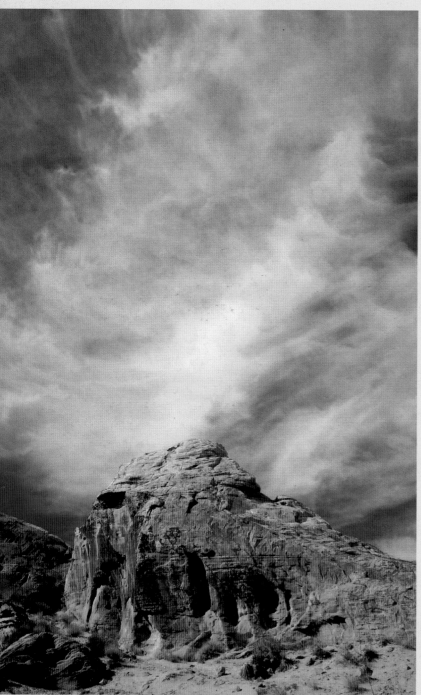

Valley of Fire State Park, Nevada.

The desert presents a huge contrast to the forest. When I first traveled through the deserts of the Western U.S. after growing up amid the forests and prairies of the Midwest, I was truly amazed. Deserts are not simply dry versions of other places: They are unique landscapes and ecosystems.

The desert is a different world for most folks, yet it holds a great deal of fascination for landscape photographers. This is the place of wide-open landscapes, of big rocks, of strange and unusual plants, of space, of geology that shows the bones of the earth, and of many other elements that give it a sense of mystery and power.

For most photographers, the desert is not a comfortable place, either because of its hot and dry conditions, or in its stark visuals that are so different than the grass and tree surroundings where most people live. This can make it hard to truly see the landscape for what it is, instead of missing what it is not. The old song about missing a lover "like the desert misses the rain" reflects what most people think about the desert—that somehow something important is absent.

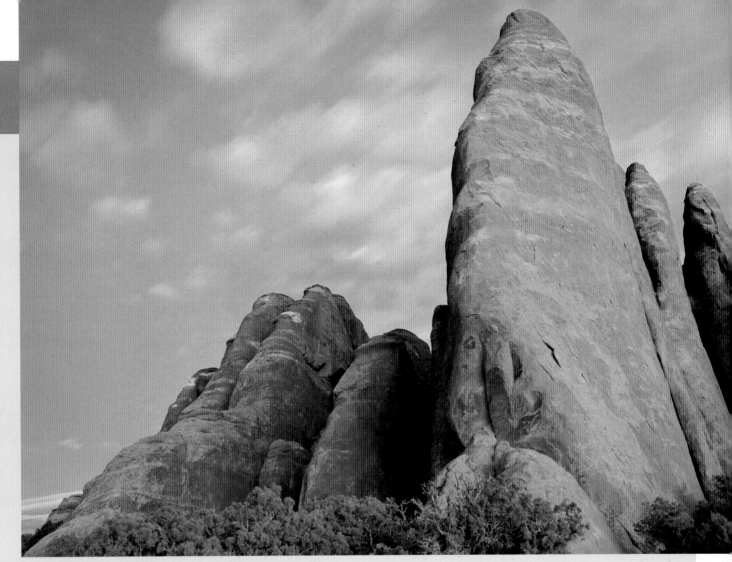

Arches National Park, Utah.

That thought is actually quite important from a photographic standpoint. If you are trying to photograph the desert while still thinking about rain-based landscapes, you are bound to see the wrong things, and perhaps miss the desert altogether. Deserts, for example, have large expanses of bare ground (or sand) with plants largely scattered across it. The plants themselves are seasonal—sometimes dormant for most of the year, then having a flourish of growth during the rainy season. Trees are not a major part of this land, growing mainly in areas of local water, such as a river or spring.

Land formations make up a big part of desert photography. All sorts of rocks and rock structures become obvious in a landscape with few plants. This makes them very important to a photograph. Light then becomes a critical factor in making these forms show up well—sidelight and backlight work very nicely. Front light can work for showing off color patterns in rock, but it is generally a poor choice to reveal the diverse forms and textures of the landscape. The top light of midday sun is almost always terrible for photographing in the desert.

Another important part of the desert scene is the sky. Since it doesn't rain much in the desert, you usually have open skies. The most interesting skies come when there are clouds, and in many desert areas, these clouds can be spectacular—especially at sunset. If you see broken clouds on the western horizon as the sun gets low, be prepared for stunning color and light.

The desert can be interesting to photograph at all times of the year, but you really do have to be careful in the summer. Then, temperatures climb and humidity drops—even a short hike can become life threatening in the heat, especially without water. Luckily, the best times to photograph the desert then are at sunrise and sunset, when temperatures are less extreme.

There are a number of tips to keep in mind when shooting landscapes in the desert. First, and foremost, bring lots of water. I know, this is not a photographic tip, but it is very, very important. The desert is hot and dry—it will dehydrate you in a hurry. Unfortunately, people can become hospitalized or die because they don't respect this.

• Get out at sunrise and sunset (photo A):
The clear air of the desert will give amazing light at sunrise and sunset. Then you will find all sorts of dramatic images to capture, including wonderful silhouettes of rocks and plants against a colorful sky. Deserts also usually have a very long twilight, which means you can get stunning photographs of scenes way past the sunset itself. The best light typically happens about 5-10 minutes after the sun sets and the camera will continue to give excellent results even when you have trouble seeing the scene. Bring a flashlight, though, because when it does get dark, it can be very, very dark in the desert.

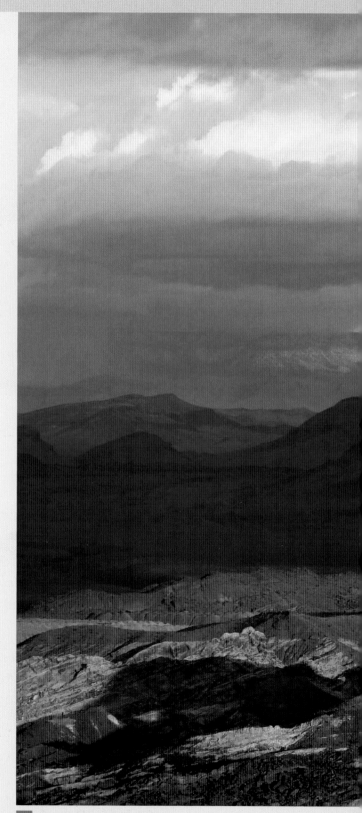

A Muddy Mountains, Nevada.

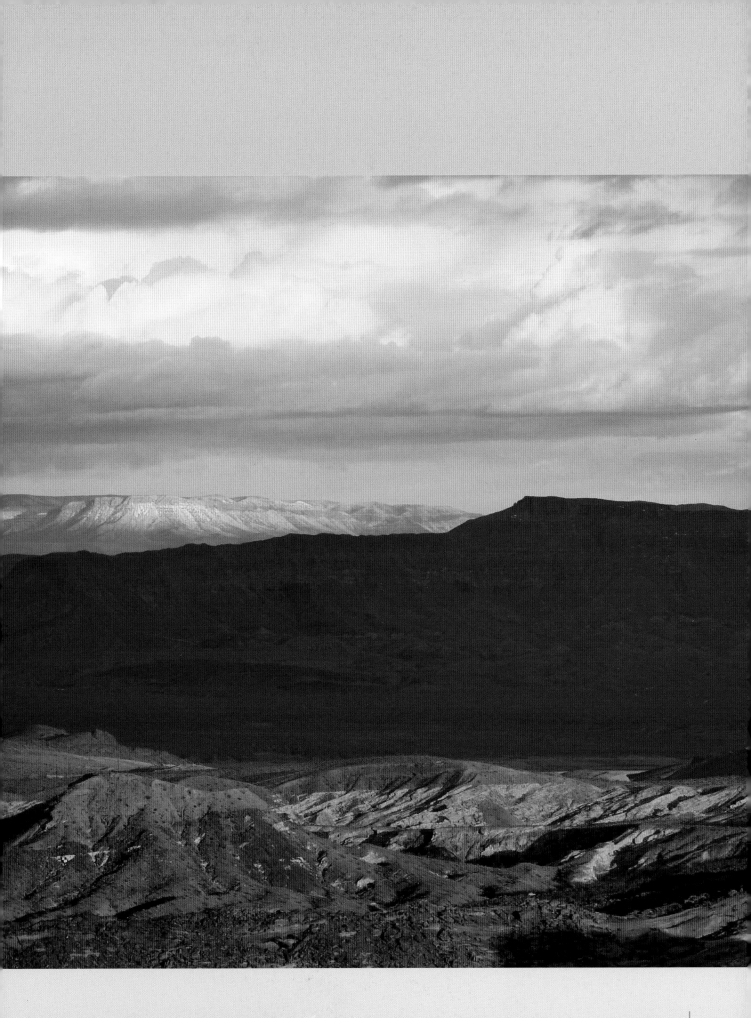

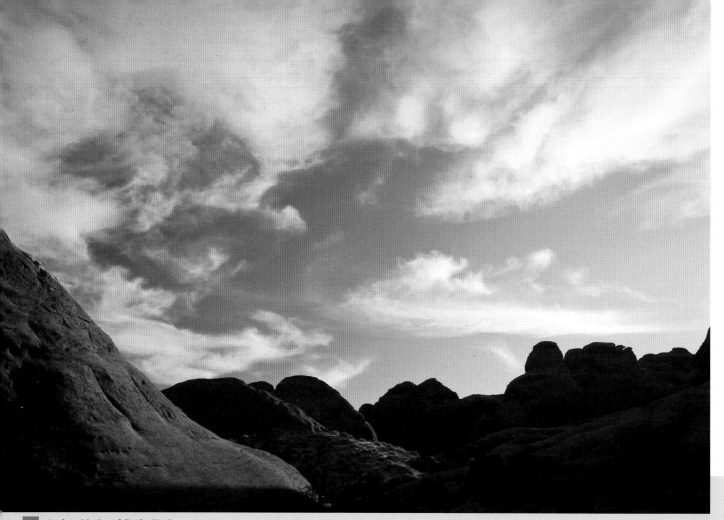

Arches National Park, Utah.

• **Use the sky (photo A):**

Desert days are mostly clear, so skies tend to be open, both with and without clouds. This can be quite dramatic when you compose a scene with a lot of sky and a smaller area of plant life and rock formations at the bottom of the image. At certain times of year, you may find the skies filled with amazing clouds that are an integral part of the scene because of the expansive vistas. Work with those skies—put them into your images.

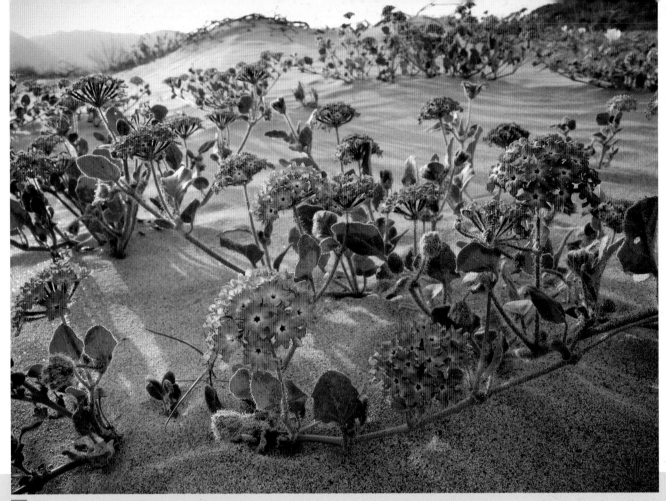

Anza Boreggo State Park, California.

• **Learn about the blooming season (photo B):**

Many deserts have a wonderful bloom of wildflowers, but it will be during a specific (and often short) period of the year. In addition, cacti often produce beautiful flowers, but again, they will usually bloom for a limited period of time. If the winter rains fall, deserts can come alive with flowers in spring. This can vary anywhere from early March to the end of April, depending on location.

• **Look for backlighting (photo C):**

Backlight and shadows can be a great way to capture the desert. This type of lighting creates wonderful shapes and forms, plus the backlight will make the spines of cacti glow. The bare spaces between plants can be a perfect foil for interesting shadows cast by the backlit plants. The light itself in the desert is different than other locations. Big areas of shadow contrasting with small areas of highlights can also give you very effective photographs.

C Joshua Tree National Park, California.

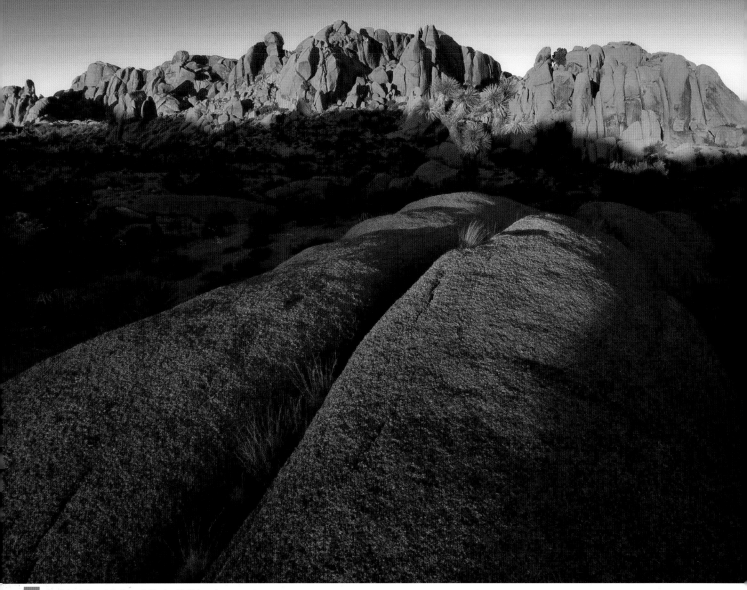

A Joshua Tree National Park, California.

• **Work with the space of the desert (photo A):**
Without trees, the desert is usually wide open. Use that feeling in your photographs. Wide-angle lenses pointed toward the ground so that you have a long foreground with just a little sky can give very interesting results.

• **Photograph the bones of the earth (photo B):**
I am not being literal here, but because deserts have very little vegetation covering the ground and hills, the underlying geology of the area—the "bones of the earth"—tend to be exposed, and are therefore easy to see and photograph. This usually looks best with a raking sidelight to bring out forms and texture. This sidelight will be evident at different times of the day, dependent on the actual geology and compass orientation of the landscape. However, you will almost always find great light for this subject matter early and late in the day. Beware of trying to capture these bones just because they look good to your eye—often they will not look good to the camera unless the light is just right.

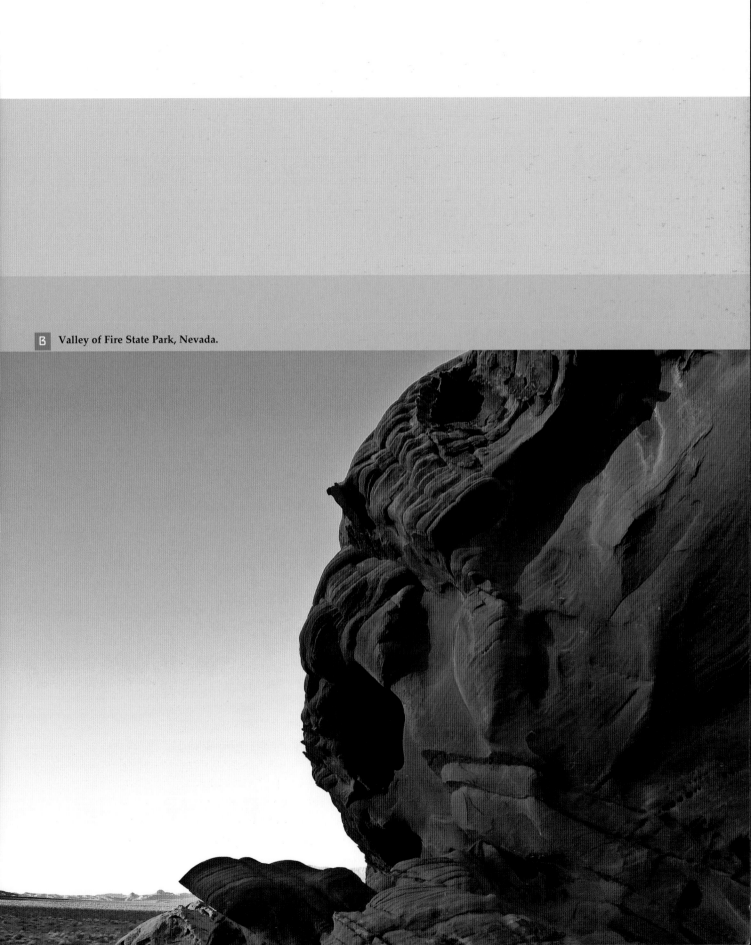

Valley of Fire State Park, Nevada.

oceans

Though the ocean is not land (obviously), the principles of landscape photography still apply. Clearly, the water itself is most often a major element in the scene when you are at the ocean. But even if you don't show any water in the photo, almost anything shot near the ocean illustrates the effects such a big body of water has on the landscape, from sculpted trees changed by the wind off the ocean to eroded cliffs to rounded rocks. All of these, by the way, can make excellent photographs.

Great photographic opportunities often emerge where the ocean and land come together—at those points you can usually find a combination of interesting visual elements, from the water to sculpted rocks to dramatic headlands.

Rarely will your photograph show water exclusively. You will be photographing texture, color (both in the water and reflected from the surface), space and depth, and tonality, among other characteristics. This is why you cannot take the ocean for granted as "just water."

Another important aspect of an ocean photograph is the air. The atmosphere around a shoreline is both important and varied. You can have extremely clear skies in some conditions, then haze or fog the next. This has a huge effect on what you can and cannot photograph. Sure, you can take a picture of the ocean no matter what the air looks like, but if you aren't paying attention to atmospheric effects, the photo may well be a disappointment. One of the biggest factors of which to be aware is the quality of

Pacific Ocean, Rialto Beach, Olympic National Park, Washington.

Pacific Ocean, Montana d'Oro State Park, Californ

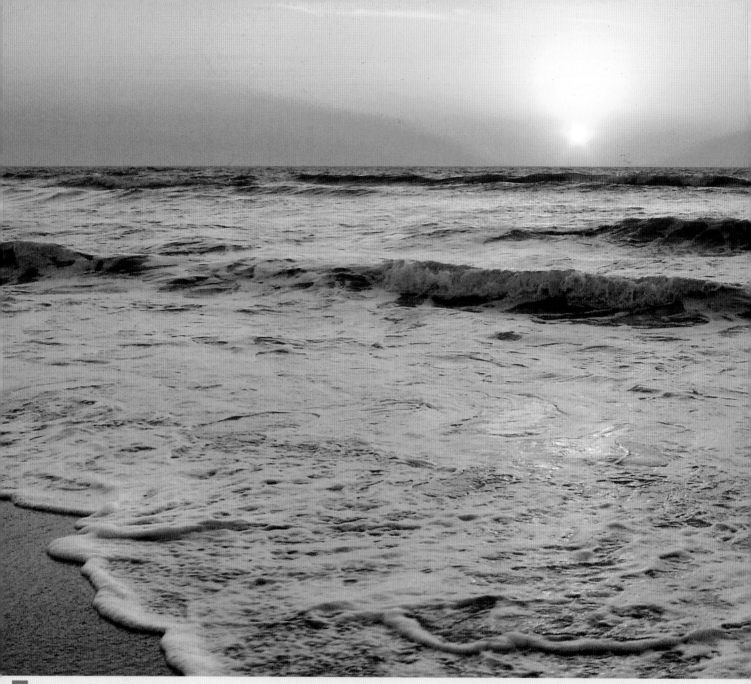

A　Atlantic Ocean, Southern Florida.

the light and the effect of haze in the distance. Sometimes that distant background just isn't photogenic, so you have to say no to a particular scene and move on to get a better photo by shooting a detail or close-up of the beach or water.

Keep some effective tips in mind when at the seashore:

• **Be aware of tides and waves (photo A):**
I know, this is not specifically a photographic point. However, it is critical. It is entirely possible to be hiking up a beach for a great photo, and then get trapped by a rising tide. In addition, always keep an eye on what the ocean is doing. So-called rogue waves can suddenly appear and drench you and your gear.

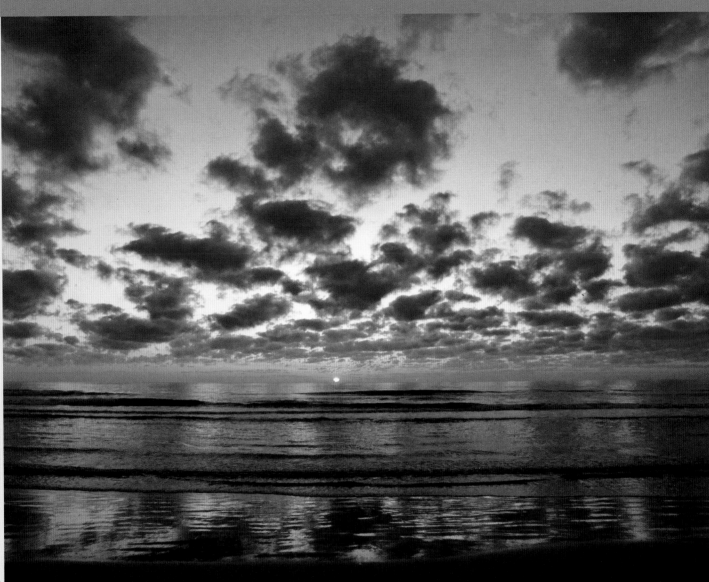

Atlantic Ocean, St. Augustine, Florida.

B

•Try a polarizing filter:

This won't always help which is why "try" is the operative verb. Still, often a polarizer will reduce haze and give you richer water and sky color.

• Watch your wave exposure:

It is very easy to overexpose the white parts of a wave, which will hurt your image. Be aware of this and compensate for it.

• Use the sky (photo B):

The sky can often provide additional interest for this type of photo. Skies by the ocean are often very different than inland skies, and can become effective parts of the image. But do make a conscious decision about whether sky or water is more important to your photo. The image will appear in conflict if both are equal, meaning it will be less effective for you and your viewer.

• Get up early for East Coast sunrises over the ocean and stay out for sunsets on the West Coast (photo A.):

• Incorporate landscape with ocean (photo B): This gives the ocean context and place. Even a little bit of rock can point to Maine, a sand dune can tell of Florida, a sea stack might indicate Washington state, and an eroded cliff the California coast.

A Pacific Ocean, Palos Verdes, California

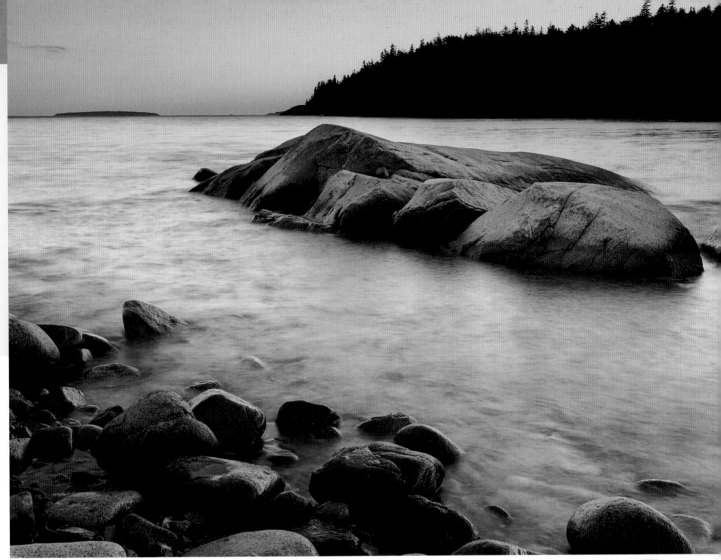

Atlantic Ocean, Acadia National Park, Maine. B

Matanzas National Monument, near St. Augustine, Florida.

Photographer Profile

*Richard Hamilton Smith

Fall color in birch forest near Carlton Peak, north shore of Lake Superior, Minnesota. © Richard Hamilton Smith.

Perceptions of Place

Richard Hamilton Smith is a nature photographer who is difficult to categorize. He has long been interested in finding unique and unexpected views of the landscape. He has done a number of photo books covering the landscapes of the Midwest, including Minnesota and Wisconsin. For many people, this is flat farm country, but for Richard, this land holds stunning scenes.
(www.richardhamiltonsmith.com)

I got my first camera while working a summer job as a canoe guide in northern Minnesota, so my earliest pictures were canoe-country landscapes. The successful images were those composed of the fewest parts possible and yet still told the story. Next was to see how or what I could do to challenge my own perceptions of the place. Part of that meant letting go of the face value of the view. It's not just a grove of birch trees, but rather a forest of shapes, textures, patterns, colors, light, and shadow. What can I do with these photographic elements to make an image that is more than birch trees? Beyond that, I wanted my pictures to be different from others. So, I worked deliberately to find different points of view whether with camera position, camera settings, different lenses, techniques, or compositions.

With the exception of one darkroom class, I'm a self-taught shooter, so I entered the medium without preconceived notions or rules about how to make pictures. Without those restraints, I was free to experiment and screw up as much as possible. Getting it right was nice; getting it wrong was often more illuminating.

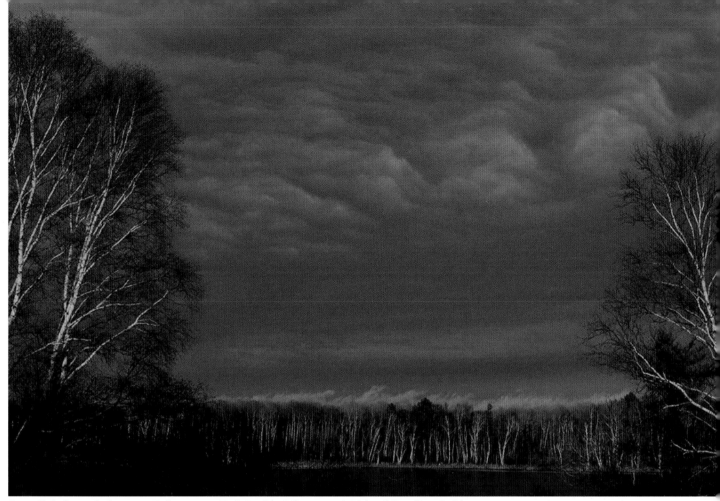

Sweet light beneath the storm, Lake 16, near Park Rapids, Minnesota. © Richard Hamilton Smith.

The interesting aspect of landscape photography is that it's always changing. There's a piece of TS Eliot poetry I've always liked:

*"We shall not cease from exploration.
And the end to all our exploring
Will be to arrive where we started
And to know the place for the first time."*

We can return to a place time and time again and it's never the same. The interplay between light, weather, time of day, season, and the effects of nature and man are always providing a fresh view. They cannot be controlled. And for those rare times when the light and weather conspire to transcend the mundane, it is a flat-out rush of visual adrenaline. I do love those baptisms.

To new photographers who want to create a distinctive style, I'd say start in a place you know, but make it look different. Don't be afraid to play. Break the rules and shoot from your gut. What you learn there will help you when you're in one of the world's famous and most photographed landscapes. See past the conventional view. Have patience, but be persistent. You can go to the landscape, but often you must wait for the landscape to come to you.

There will always be a future for nature and landscape photography because it is always changing, and because humans need the connection. It's visceral. I hope that once the glitter is off this digital technology, we will see higher quality images with more discriminating, more innovative, and more illuminating perspectives of our natural world.

flower landscapes

Flowers are an exuberant expression of nature. They are always a welcome sight for those who suffer through a long, gray winter. Just getting out and photographing them can be a joy in itself, regardless of the photographs you bring back home.

Of course, flowers bloom everywhere in the spring. You can spot their intense beauty in the Hill Country region of Texas, the trillium-carpeted ground of the Great Smokies, the screaming orange of poppy fields in southern California, the bold summer displays of alpine flowers—all offer great opportunities for landscape photography as well as for macro work. That combination can be a lot of fun.

In some locations, color will be a key part of your composition. When you take a picture of a landscape filled with flowers, you are often photographing more than just those petals and blossoms. Yes, the flowers are important, but the photograph ceases to be simply about them—it expands to be about color as well. This is exactly the point of the question, "What is your photograph about?" The answer will be color in some way.

This changes your mindset. When you focus on color as you view the landscape, you will find yourself starting to look for color and its relationships. Color contrasts can then be a good way of structuring your composition. Look for lively colors that make each other look bolder because of their contrasts. Look for bold color

contrasted with subtle color—a saturation contrast. Look for cool blue colors contrasted with warm colors. Look for bright colors contrasted with dark shadows. All of these color effects can have a strong impact on your photo.

In addition, this is another great subject for strong foregrounds. Flowers can be a great foreground, but be careful of standing up and shooting at eye-level. Get closer—eye-level can put your camera too far away from the flowers so they become small and less important to your composition.

Usually, skies are not a significant part of a flower landscape (though this does not mean a good sky won't work with such a scene if integrated carefully). There are several reasons for this. First, photos with a strong color and texture along the ground often conflict when there is a competing area of strong color and texture, like a sky with broken clouds. Second, flowers often look great on bright cloudy days. These types of days typically feature dull and formless skies, which are best to be avoided in photographs. Third, in many areas where flowers are blooming, there are also trees or tree trunks as part of the scene. They can be a challenge when they are seen against the sky, creating contrast and brightness that can attract a viewer's eye away from the flowers.

Hill Country, near Burnett, Texas.

 Grand Teton National Park, Wyoming.

the magic of digital landscape photography | 178

B Tehachapi Mountains, California.

There a number of ideas and techniques that can aid in creating photos of flowers that will beautiful enough to frame and place on your walls:

• Use a telephoto:

A telephoto lens will compress distance, which manes you can bring patches of color closer together within the image area. As you move around, you will see color relationships changing, plus note where shadows are in relation to the colors. Because you have to back up when shooting with a telephoto, you are farther away from the flowers, meaning that details of flowers will often be obscured when you are photographing from any distance. The pattern of the flower group will be more important.

• Use a wide-angle and get close (photo A):

With a wide-angle positioned close to the flowers, specific flower detail will show up more, plus you can see the entire landscape behind the flowers. It is also a good idea to try shots when pointing the wide-angle lens down, with foreground flowers at the bottom of the image and a distant part of the landscape at the top.

• Get down to flower level (photo B):

Most flowers are low, so get down to their level. Shooting with the camera higher, at normal eye-level, will minimize the impact of most ground-loving flowers because of the distance. By getting down to ground level, your photos will stand out because you are creating pictures from a perspective that is different than the majority of flower shots taken from eye-level.

• Look for patterns:

Flowers rarely bloom in solid, perfectly geometric and filled forms. Interesting patterns can come from within a group of flowers, or between the flowers and their surroundings. Flowers can create some very appealing pictorial elements due to their patterns. Also, look for contrasts to patterns, such as a blue flower group in a larger setting of orange flowers.

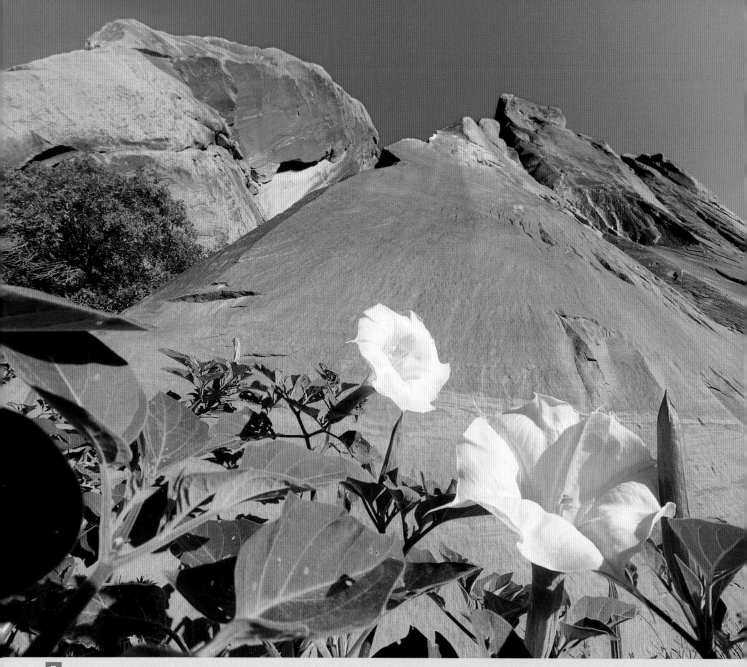

A Along Colorado River, Moab, Utah.

• Be careful of white flowers and exposure (photo A):
They can make a terrific flower photo within the right
setting, but white flowers when found in a wooded
landscape can be easily overexposed because the forest
is dark. Watch your highlight warnings and the his-
togram for exposure problems with them. However, you
don't want to deliberately underexpose, either, in the
hopes of keeping the white flowers properly exposed.
This will make your dark areas dim and murky without
good tonal and color detail, plus you will pick up noise.

• Be respectful of the flowers (photo B):
Even if a nearby group of flowers look appealing as a
photograph, avoid trampling through another group of
flowers to get to a photo-shooting spot. Some flowers
will not recover from such abuse.

B Burned Chaparral, Southern California.

wetscapes

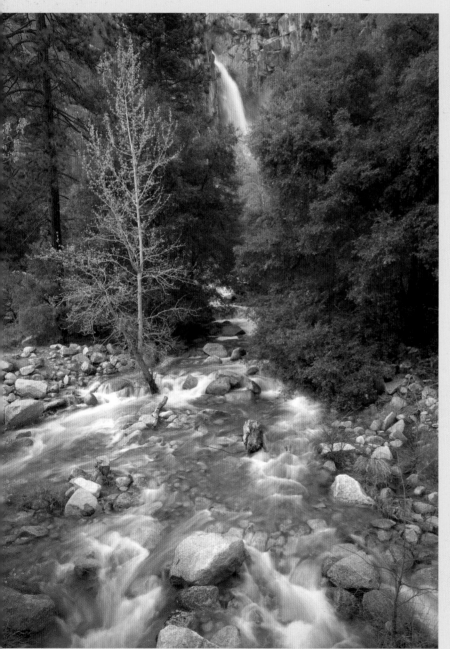

Yosemite National Park, California.

We looked at photographing water in a previous chapter (see pages 104–109) because it is often an important part of a landscape, and because lakes, rivers, and streams are so well suited for photography. In this section, we'll look more specifically at these types of (usually) freshwater environments. We might describe these scenes as waterscapes, except you can photograph a wet landscape without water being the main thing you see, as in marshes, swamps, or riverbanks.

Positioning is particularly important when photographing a landscape like this. You can't do much about your position when photographing the ocean because it is so big—even though you move to a different place on the shoreline, not much changes relative to the ocean itself unless you travel quite some distance. However, with most inland scenes, changing even a short distance can significantly alter your photograph.

A lateral change (sideways) in position can modify what you see in terms of water and how things line up from foreground to background. Changing your position by moving forward or backward will affect the relationship of how much water you see compared to ground. That can be quite significant and it pays to try different positions. I have seen photographers go to a convenient distance from a lake or river, for example, and

Selva Verde, Costa Rica.

take pictures from there without considering any other distance. They lose the opportunity to infuse their landscape photo with a viewpoint that is out of the ordinary.

As you get closer or farther from the water, you gain some wonderful composition options with regard to using foreground and water. Sometimes a slight change in this distance, plus a slight change right or left, can make the difference between a mere snapshot and a photograph that is special. Thinking about where you want to be when taking your photo will make you more aware of how the water relates visually to its surroundings, rather than just how much of the water you are showing.

Elevation is also important. Because water in this type of landscape can be so visually dominant, the lake, stream, or river can overwhelm the photographer's thought process, causing them to get the shot they see most immediately. Consequently, most photographers simply shoot with the camera at eye-level and don't consider either up or down alternative positioning. Looking for heights that can give you a fresh perspective. Changing this eye-level camera position can have a big effect on how a foreground shoreline looks compared to the rest of the scene, even if the actual amount of shoreline in the photograph doesn't change. A low shot lets the viewer see more detail there, making the them feel more connected to it. A higher shot makes

the shoreline look more like a frame for the water, leaving the viewer feeling less connected. Not to judge either way as good or bad, these are simply methods to emphasize different things in your composition.

Altering elevation also changes the visual size of the water in a composition. By going low, the water shrinks because you can't see as much from that position. By looking from the high angle, you often see new aspects to the water portion of the landscape because it is spread from bottom to top of your composition.

Finally, high or low shots greatly affect reflections in the water—what is reflected and how much you see of the reflection. Positioning has a huge influence on the way a reflection is portrayed in a photograph. In addition, elevation can also reveal interesting reflections that might not otherwise be seen, such as the reflection of fall color in a stream. The best reflections often come from a very specific angle to the water, an angle that is affected by your camera height.

Wetlands, those landscapes with underlying water such as marshes and swamps, deserve a special mention. These places can be hard to photograph because the ground is so wet that you cannot move easily through the area. Yet they are an important part of our world. Remember that as a landscape photographer, you are the eyes for other people in showing parts of nature that would not otherwise be seen by them. Wetlands are important for a great deal of wildlife, as well as serving such important functions as flood control and water purification.

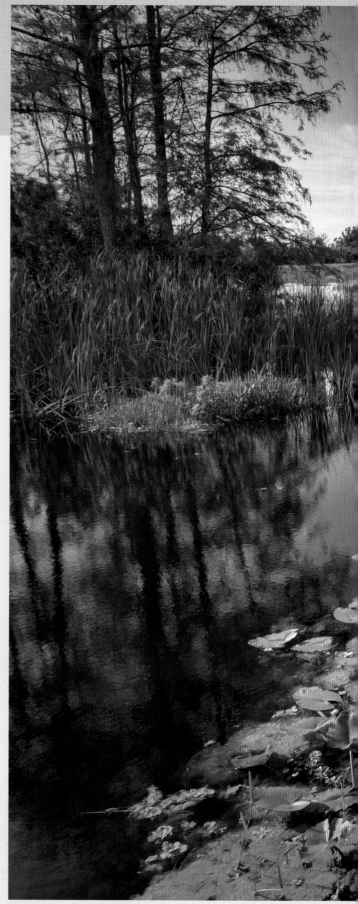

Loxahatchee National Wildlife Refuge, Florida.

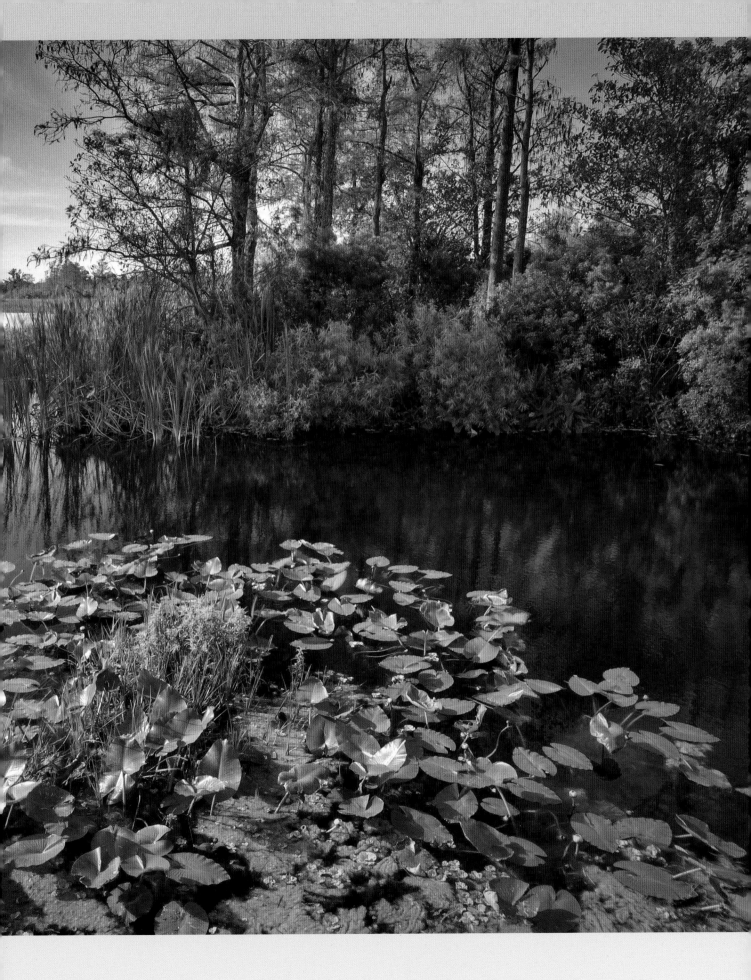

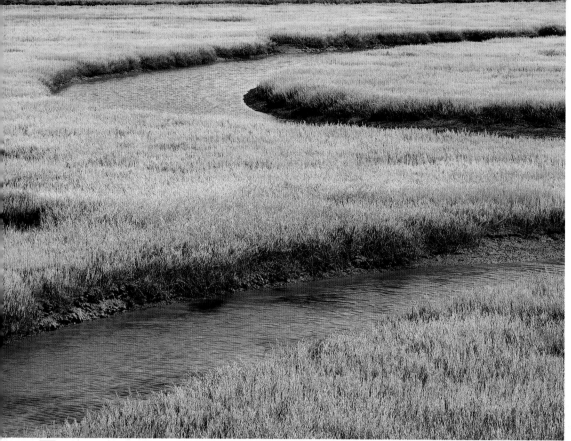

Salt Marsh, San Diego, California.

Many parks, refuges and nature centers include boardwalks into wetlands. Often photographers only see these as ways of getting closer to ducks and other water birds. Yet, this can also be a great opportunity to capture unique and important landscape photos. Look for contrasting areas of water and marsh, or water and plant growth such as trees or shrubs. Be open to seeing what water is doing in these locations, and find ways to express that in your images.

There are a several ways I suggest you try shooting when out in an environment that is wet.

• Change your camera height (photo A):
You might think that if you are on a flat shoreline that you can't change your height much other than going from eye level to down low. But you can try different, higher angles by placing your camera on a tripod, setting the self-timer, then hoisting the camera over your head to get a high angle shot. Because you are shooting digital, you can instantly see the results, decide if your camera was angled properly then change it as needed.

Don't automatically avoid water with visual barriers such as brush along a river's shoreline, or a protective chain-link fence that you cannot look over. Again, try the trick of raising the camera on a tripod over your head and above the barrier.

• Shoot reflections as the photo's subject (photo B): Reflections are a key part of water photography and can be much more than simply a mirror image of a background or light patterns on the water. They can make for very interesting subject matter all by themselves. One thing that often helps such reflection photography is to include something in your composition that is not water and not as reflective, such as rocks or water plants.

• Look for color reflections (photo C):
Reflections can be shapes and forms, but patches of color reflected in the water add a great deal of interest to the photo. This can happen as summer or autumn leaves reflect in patches of smooth water on a stream, as well as with certain angles on a lake. But you can also get color from late light reflecting on a hillside or a clear blue sky reflecting in a pool in a stream.

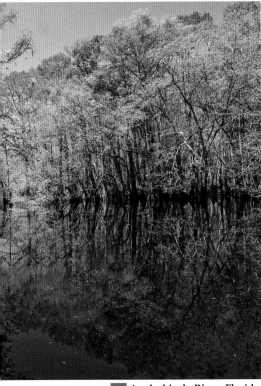

B Apalachicola River, Florida.

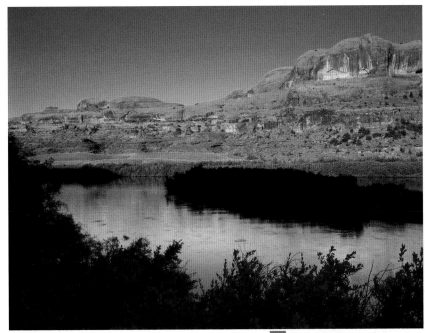

C Colorado River, Moab, Utah.

• Check out sunrise and sunset (photo D):

Flat landscapes can be challenging because of their limited change of height. That can make a larger scene hard to deal with as the horizon looks so flat, as well. But such a location with a lake or pond can give you wonderful sunrise and sunset opportunities. There are beautiful, colorful moments that make great photos when the sun is near (or just below) the horizon. This can be hard to capture with a picture shot in an area of flat land. But when a body of water is involved, you can get some beautifully colored reflections of that sunset light.

D Merritt Island National Wildlife Refyge, Florida.

• Try getting out on the water:

A canoe or kayak, for example, can give you totally new ways of seeing a lake, stream, or pond. It will put you into positions that obviously cannot be seen while standing on the land. You do have to be aware of camera movement (tripods are usually not useful unless the water is extremely still and the boat is stable). Use higher shutter speeds and image stabilization lenses or camera bodies to minimize this problem.

prairies

Schaefer Prairie, Minnesota.

At one time, the prairie was a major part of North America's scenery, covering huge areas of land through the Midwest. Most of this is now gone, turned into farmland, but in some areas the prairie has been preserved and can be worth seeking for landscape photography.

The prairie is different than other vegetated landscapes because there are very few, if any, trees or shrubs—most often there is no plant life that grows very high. Grass is the major part of a prairie, both ecologically and visually. Because large expanses of grass can look boring, the prairie is often overlooked as a place for landscape photography. And since grass will extend from foreground to background with little visual change, it can be hard to find interesting foreground/background relationships.

There are at least two other challenges to prairie landscape work. Prairies are typically part of flatter landscapes that can, at first, seem less interesting than differing types of landscapes, such as mountains or rivers or oceans. Second, they often don't look like much from a distance because you don't see a lot of variation along the horizon. Sometimes this means you might have a problem finding potential landscape photos of interest. That doesn't mean you should pass the prairie by. There are usually a lot of great possibilities for close work, including flowers, grass details, and more.

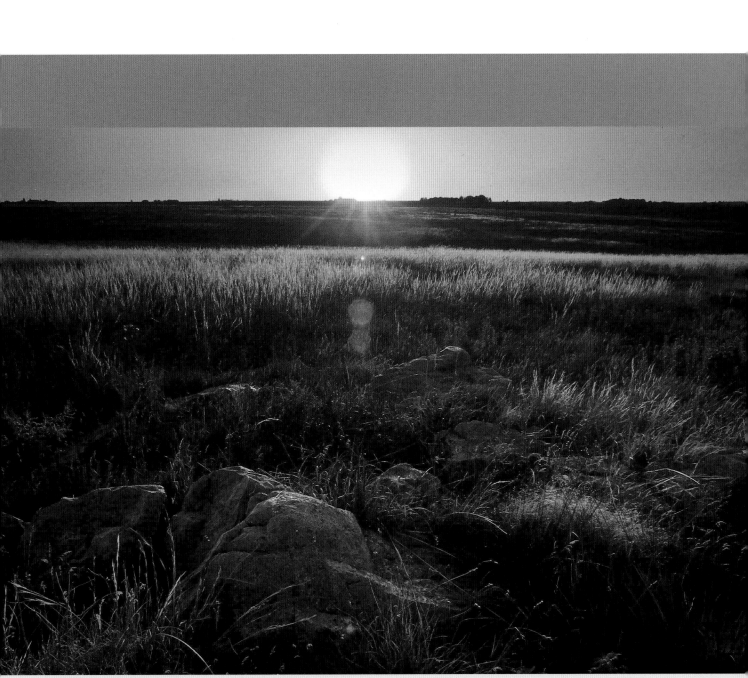

Pipestone State Park, Minnesota.

But prairies can be photographed in such a way that they show drama and are welcome additions to any landscape photographer's work. One of the keys is low light. Low light, whether early or late in the day, is always important for landscape photography, but it is crucial to prairies. Without it, prairies often look so mundane in a photograph that it isn't worth taking a picture, other than a detail or close-up.

However, low light does some wonderful things for prairies. First, low backlight illuminates the grass so that it literally glows. This can make a landscape come alive, especially if you are close to the well-lit area of grass. Prairie grass is typically made up of a number of bunched grasses that shows as clumps. Backlight will make these different clusters more visible and create some lively patterns in the scene.

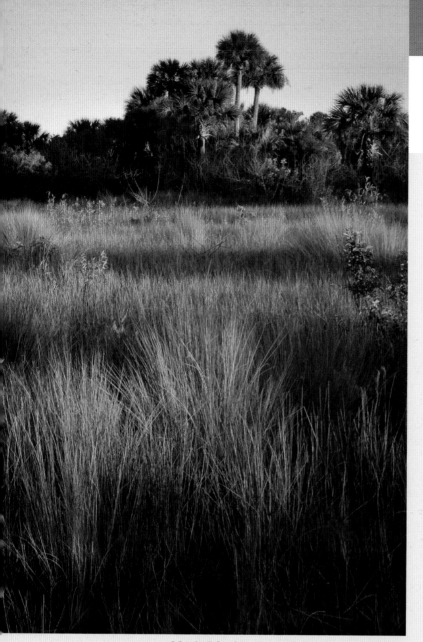

Merritt Island National Wildlife Reserve, Florida.

tion of the rolling ground. Low light will enhance height differences, illuminating a scene with variation and shape from what appeared to be a flat prairie. However, this effect is often at its best very close to sunrise or sunset. At those times, the sun will give a skimming type of light across the scene—one that emphasizes any variation in height.

Prairies look their best at different times of year. Many prairie flowers bloom from mid to late summer. You will often find some wonderful scenes in August and September (partly dependent on how far north or south you are) that can show flowers running from the foreground to background. The prairie flower landscape is often easier to photograph than other types of flowery landscapes, not just because of the pure beauty of the flowers, but also because the flowers provide visual diversity to your composition. You'll find they lend structure to the landscape that can be hard to find at other times.

Fall is also a good time to photograph the prairie. Many grasses have beautiful red and orange fall colors. This is one time when a low front light can be spectacular, because it enhances this color. This can also be a great opportunity if the sky is clear and blue, since it offers a rich color contrast with the grasses (a low front light will often enhance a good blue sky).

A low sidelight can give a prairie scene some wonderful textures and forms, including showing off the bunched grasses in a different way. Variations in the grass species, including different shapes, as well as the way they contrast with other plants growing there, can be quite interesting.

Both low backlight and low front light can add dimension to a prairie landscape. The height of the prairie as you look across it often changes due to the different species of grasses that usually grow there, as well as the existence of any slight changes in the eleva-

Morton Arboretum, Chicago, Illinois.

The sky is an important part of prairies, too, because there is very little in the landscape to interrupt or block it. In fact, sky can often be the dominating element of a prairie scene, which can give you the opportunity to deal with bold clouds. You can see storms forming from a distance when you look out over a prairie. Big thunderheads and other cloud formations can be well worth photographing. But remember that you are exposed in a prairie landscape, so be wary of lightning or other severe weather.

But that isn't to say that all prairies totally lack trees. You will find them from time to time in areas called oak savannahs or prairie openings. The contrast of these taller trees with low prairie plants can offer some terrific photo possibilities. In addition, many of these trees are oaks, such as bur oaks (hence the name, oak savannah), which grow into fantastic shapes that provide amazing branch patterns when viewed against the sky. That will make a good contrast with the grasses and other prairie plants below.

There are a number of tips and techniques that can help when shooting prairie landscapes:

• Place flowers in foreground (photo A):

When the prairie is in bloom, find some interesting flowers up close, then make a composition that shows the prairie receding into the distance behind those flowers.

• Shoot from a height (photo B):

Since prairies are so flat, it can be difficult to see what forms and patterns are in the landscape before you. Try the tip about raising the tripod overhead with the camera on it, as discussed on page 186. Or, sometimes you need to climb onto the bumper of your car or into the trunk—just that small change in elevation can make a significant difference when shooting prairies.

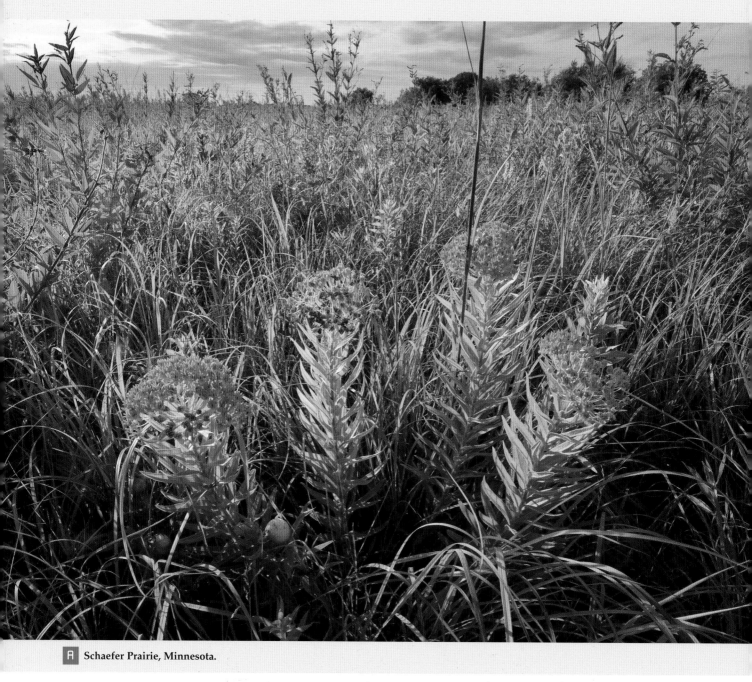

A Schaefer Prairie, Minnesota.

Don't be afraid to include manmade structures. In fact, people have so heavily influenced the prairie that a number of scenes will show evidence of human hands. The openness of a prairie sometimes makes it difficult to avoid things like windmills, grain elevators, and churches at a distance, so why not include them in the composition.

• Use existing trees effectively (photo C):

Don't simply include a tree in the prairie photo because it looks different than the prairie grasses. That can actually detract from the nice qualities of the prairie (if you want to photograph just the tree, then do that and don't try to make it part of the prairie). However, you can contrast that tree in many ways. A small tree in a large expanse of prairie makes the prairie look bigger. Or crop a portion of the tree out of the photo so the viewer doesn't focus on the tree's total shape, but also on the surrounding prairie.

Notice different green colors within the landscape. As you look over a prairie, you will often find that there are groups of plants with separate shades of green. Sometimes a polarizer will help differentiate those greens, or you may find that they only show up with certain light.

B Minnesota Prairie near Mississippi River.

C Prairie land near Chicago, Illinois.

A

• **Check out snow in the prairie (photo A):** The wind can be a problem when you are out in the open on a cold prairie, but the wind also creates dramatic snow forms that can be wonderful elements of a landscape scene. In addition, you can sometimes find interesting forms against the snow created by dormant or frozen plants. And because prairies are so open to the sky, sunsets can give an exceptional warming hue to the snow.

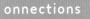

microclimate

Take a good look at any landscape and you will find variation in it. This variety is often due to the existence of microclimates.

A microclimate is a variation of a location's general climate that falls into smaller areas of the total landscape. The most obvious microclimate is the change that is demonstrated as you go from sun to shade. In the sun, conditions are hotter and drier; while in the shade, the conditions will be cooler and moister.

Even in a large, open landscape, you can find changes in microclimate due to the direction in which the sun hits the ground. The sun strikes a south slope directly and intensely compared to a north slope in the Northern Hemisphere (it is the opposite in the Southern Hemisphere). The result is a hotter and drier place for plants and animals to live. This changes the types of animals and plants that live in those locations, and that changes what you can record in your photographs.

As trees grow taller in certain locations, they bring changes to the microclimate. A hillside will be considerably different at ground level if it is fully covered with trees, lightly covered with trees, covered with shrubs, or covered in grass. In each case, different plants and animals will live under the trees, shrubs or grass, which will further change the area.

Microclimate also affects timing of the life in a location. Spring flowers are greatly affected. Those on the south side of a Northern Hemisphere slope often bloom earlier compared to plants on the north side, while plants on the west side may come out earliest of all.

The idea of microclimate is something to keep in mind when you are looking for interesting things to photograph in your landscape. For example, you might arrive in an area and find some flowers in the last stages of bloom. Noticing that they are on a south-facing slope, you could then look for more protected locations where you might find these flowers still in earlier stages of bloom.

Apalachicola Bluffs and Ravines Preserve, Florida.

small scale landscapes

Big landscapes are dramatic and pleasing to the eye, but you can't always find big landscapes to photograph. While my home area, the Western U.S., has many views of big landscapes in a number of locations, many other places in the world do not. That doesn't mean the camera has to be put away. There are great opportunities for landscape photography anywhere if you change your reference to a smaller scale.

Think about moving into a scene and looking for small landscapes. You can use all of the techniques and tips discussed in this book for these condensed landscapes as well as the more conventional, vista-oriented ones. As you get closer and closer to your scene, you will begin to discover mini landscapes with wonderful details and colors that make excellent photographs.

The classic landscape photographer, Eliot Porter, had a name for these types of settings. He called them intimate landscapes. These are scenes on a small scale that connect you and the viewer with the details of nature. In many respects, you become more intimate with the landscape.

The mini, or intimate, landscape can be found anywhere, even at home. Just look and you will find a small-scale landscape just begging to be photographed within any big scene. Such images often connect you and your viewer more closely to the surroundings than a larger view. Big scenes can be overwhelming—small scenes can be comforting.

The scale of the mini landscape varies from a tableau of shrubs and flowers to a close-up of lichens. However, this type of photo changes from a standard close shot to a landscape when you use techniques to add depth and dimension to the image. For example, a close-up of lichens on a rock is just that, lichens on a rock. To get a mini landscape, you need to change your angle so that, along with the lichens, you see more of the scene, including background elements and maybe even sky.

Sky is often missed in mini landscapes because it is harder to deal with in small scenes compared to a big one. Mini landscapes are small and often low to the ground. It is easy to photograph them looking down, but when you point your camera down, the sky is no longer part of the scene. The trick is to get low with your camera so that the small landscape fills the bottom of your image area (maybe even most of the frame), but so that you are still able to get some sky.

You do have to be careful when shooting toward the sky. Make sure it is not a distraction to the rest of your scene, and that you can expose both the mini landscape and sky properly to hold detail where needed. You don't want a mini landscape with a washed-out sky. You can get away with a bright sky if it is just a small part of the composition. If you have only a narrow area along the top of the frame with bright sky, for example, it will simply add depth to the photograph without taking away from your subject. More than that amount of sky, however, and you likely will have a problem.

Ancient Bristlecone National Forest, Big Pine, California.

Acadia National Park, Maine.

Composition and light are always important for landscape photography, but they are especially critical when recording an intimate landscape. For example, even if the light isn't perfect, the Grand Canyon has a scale and drama that can overcome that. But when the landscape is a small scene that few people have seen, it has no inherent characteristics that will draw a viewer's attention. You will want to compose the scene so it is interesting to look at and use the light to its most favorable effect. Distracting light, on the other hand, can be a big problem because there is no place else for the viewer to look if the light isn't attractive.

The mini landscape does a great job of focusing a viewer on details of a location—details that are often missed when big landscapes are photographed. These details can say a lot about a place, giving extra information about the texture and form of the plants and rocks, different sizes of the leaves, how any water is flowing, and other things. All of these facets come together in an intimate landscape to give the viewer a special per-

spective of this location. Because of this, you need to choose carefully what is in your composition. Instead of a line of rocks going into the distance, you may just have one rock. How does that rock relate to the other photo elements, which might include just a few flowers and some other plants? With fewer specific items in the composition, you must be more aware of each of them and how they relate visually to one another.

Again, there are a number of tips that will help you maximize this type of picture.

Use moderate to slight telephoto focal lengths (photo A):
Such focal lengths have a perspective that works quite well with small scenes. Strong telephotos or very wide focal lengths can have their place with all landscapes, including the mini landscape, but they often change perspective so much that you lose some of the feeling of a small, intimate landscape.

Including the sky in small landscapes, like the two images to the left, means you have to get low with your camera. But that sky can transform the image from a close-up to a landscape photo, which can be an important part of such smaller-scale images.

Burned chaparral, Fallbrook, California.

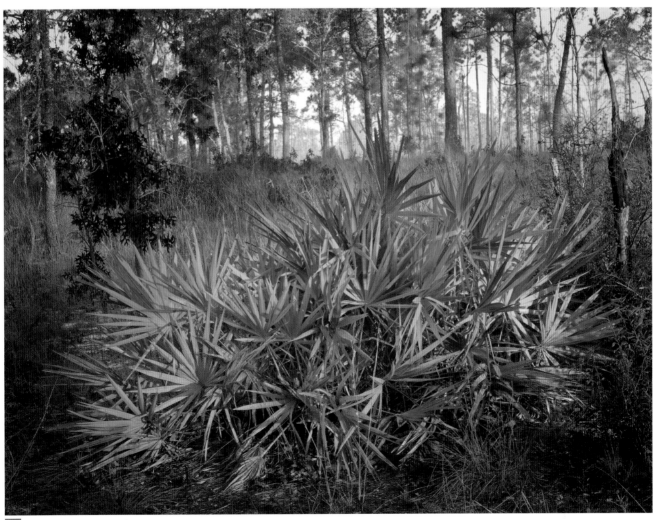

A Apalachicola Bluffs and Ravines Preserve, Florida.

• Shoot at a 45-degree down angle (photo A):
It is rare that I advise shooting down at such a steep angle, but this works quite well for the intimate landscape. You will have to be high enough to see relationships between the scene's elements from front to back, yet not so high as to make this look like an aerial photo.

• Create mystery about scale:
It can be very interesting to create images without a strong feeling of scale because the landscape gains a unique feel or sense. When there is nothing for the viewer that identifies scale, such as a fence post or a common flower, one that people recognize and therefore know its size, you produce an ambiguous, almost mysterious way of looking at the scene.

• Or, look for something to give scale (photo B):
Though this is the opposite of the last tip, it can also be a great way of dealing with this sort of landscape. In this case, by deliberately including something recognizable in the composition, you tell the viewer something about this scene, its size, and how to understand it. It is a concrete, specific way of looking at the scene.

A Olympic National Park, Washington.

B Yosemite National Park, California.

• Avoid harsh sunlight:
The small landscape often looks best in diffused sunlight on cloudy days, or in the shade. I think that is because of the scale—highlight and shadows quickly become very distracting if you are not careful.

• Shoot on cloudy but bright days (photo C):
The light from such days tends to be really good for a mini landscape. It is an open light that fills in the shadows so you have no harsh, problematic contrasts, yet it is not a flat, gray light either. You can often get a soft backlight from these conditions that looks very good on the small landscape.

C Shenandoah National Park, Virginia.

Photographer Profile

*Bill Fortney

Master of the Aerial Landscape

Bill Fortney (www.americafrom500feet2.com) is a master photographer who founded the Great American Photography Workshops program. He has completed three books, including the best-selling *America From 500 Feet*. His aerial work is quite distinctive and something he is well known for. His latest work continues that unique look at the American landscape, *America From 500 Feet II*.

Imperial Sand Dunes National Recreation Area, California. © Bill Fortne

I started doing aerial work for two reasons. The first is that I had wanted to become a pilot since I was a kid, and after establishing my photographic career and family life, this seemed like a good a way to pursue that dream. The second reason is that I also wanted to find a unique way to see the landscape. I had stood (five feet, nine inches) and photographed the country for many years. Over that time I had taught with a number of well-known photographers, and they all emphasized looking for a different angle to the scene. They emphasized getting low or getting high.

I figured 500 feet was a little higher than anyone else was getting!

I, like all photographers, get a rush when I see something that is really different. Flying, for me, is seeing the world through new eyes. I only fly the first and last hour of the day, when the light is outstanding for photography. It is a real joy because the shadows are spectacular, leading to exceptional images.

I don't know how many people will want to try this unique type of landscape photography, but anyone can do it. Either hire good pilots to fly you around in small, slow airplanes, or learn to fly yourself. That's what I did. The great thing about this type of photography is that you don't have to be at a National Park or spectacular location to find worthwhile photographs. I've found interesting things within a mile or two of lots of nondescript airports across America.

There is a lot of camera movement in aerial work. This is especially true when hanging from a powered parachute, which is the type of shooting I have been doing lately. Therefore I need to use a high ISO setting, often at 800 or above, which can produce noise. With film that was a disaster. Today there are several

Baptist Missionary Church, Cades Cove, Tennessee. © Bill Fortney.

D-SLRs with a full 35mm-frame sensor that record with low noise levels when shooting at 800 to 3200 ISO. They make this work much easier.

Today's zoom lenses are also a great benefit of technology. They allow people to have truly broad focal-length ranges with very sharp results, even when shooting with a wide open aperture. Vibration Reduction or Image Stabilization in the lens or camera is also a big help.

I have a lot of places on my wish list to photograph from the air, so we'll see which ones I make it to. I simply enjoy getting up in the air and seeing what I see! One thing is for sure—I have great fun every time I go up!

natural icons

Delicate Arch, Arches National Park, Utah.

How many times have you seen photographs of the Grand Canyon, of Delicate Arch in Arches National Park, or of Half Dome in Yosemite? These icons of the U.S. National Parks have been photographed time and again for many years. The primary challenge for landscape photographers who want to shoot such famous landmarks is how to record them in different ways. While there are photographers who basically "trophy hunt" landscape icons, this is not a very stimulating or creative style of photography.

That said, however, I know that most of us want to get some great shots from the iconic landscapes in our countries. Sometimes your time is limited and you can only capture a traditional, and usually clichéd, image of these famous scenes. That can be fun and add new photos to your collection to share with others, but it isn't going stretch your photographic skills or give you extraordinary photos. Rather, it's more about snapshots or documenting your travels than it is about shooting dramatic photography.

When I get to a new location, I find it is well worth checking with a local visitors' center to learn more about that site; plus these centers will often have postcards or posters of some of the more dramatic and iconic scenes of the area. Such photographs can give you ideas both about what to photograph if a scene looks great, or what not to photograph if the postcard is just too boring or too obvious.

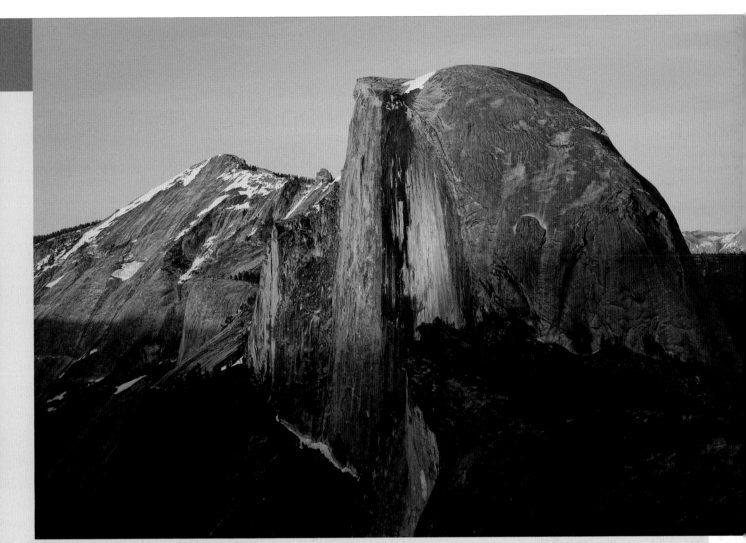

Half Dome, Yosemite National Park, California.

I believe all photographers see the world in unique ways. The challenge is in creating photographs that express that unique point of view. This becomes increasingly difficult when you are dealing with well-known areas that have reached the saturation point for photography.

Consider a renowned location in Arches National Park that overlooks the South Window of the Window Arches. Even if you have never been there, I think you will relate to this story. There is a small knob of rock that can hold just a few photographers. From this rock, you can see through the South Window toward Turret Arch. When the sun rises, it lights up the South Window and Turret Arch quite dramatically.

The problem is that all photographs taken from this spot look the same. Let's be honest—short of a freak storm, these photos are all going to look monotonously similar because you cannot vary your position. And though the world probably has more than enough photographs of the South Window Arch framing Turret Arch, you don't have such a shot and think maybe you should get one, too. This becomes trophy hunting more than photography. The problem is that you might miss a lot of other great shots while concentrating on the standard opportunity. Once you are committed to that rocky knob, you cannot easily move from it to work the subject, finding more interesting and obscure angles.

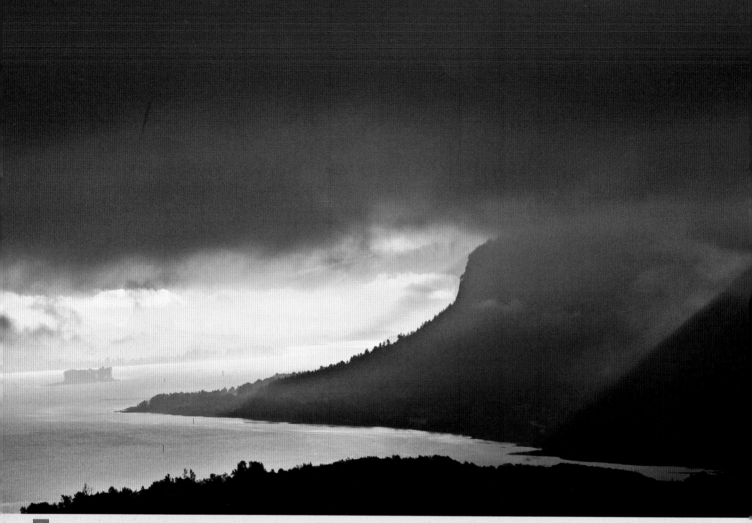

A **Columbia River Gorge, Oregon.**

Yet there are some fantastic possibilities for getting shots beyond this one spot—a spot, by the way, that photographers argue over because the space is so limited. There are, for example, many places on the other side of the arch that allow you to capture a wonderful glow of light from sunrise, a glow that lights up the underside of the arch and reflects light on the rocks behind it. This is dramatic and beautiful, but if you were on the rocky knob, you would never see this, let alone be able to photograph it.

The point is that you should never limit yourself to a specific shot. This will prevent you from finding your unique vision of this location. And it will, I believe, limit your experience of the location as well. Imagine how little you are seeing and experiencing of a beautiful and scenic location if you are stuck to a small piece of rock instead of exploring the area by moving around freely.

So how can you photograph iconic scenes without making images that everyone has already seen? There are several ideas that can help.

● **Shoot during unusual conditons (photo A):** You will notice that iconic scenes are usually photographed at certain times of day or under good weather conditions because those are easiest. Unfortunately, that's when everyone else is there. To record a shot that is out of the ordinary, plan to photograph at a different time of day or in weather conditions that put other photographers back at their camp or hotel. If you pay attention to all the techniques and tips discussed in this book, from light to composition, you will get excellent images in these off-times.

• Photograph during a different season (photo B):
Photograph during a different season. I realize this is
not possible for everyone because you may only be able
to visit this location at a specific time. However, if you
can plan a trip to an iconic location in an off-peak
month, you will find fewer photographers to compete
with and you will find some unequalled possibilities for
photographs that other times of the year do not offer.

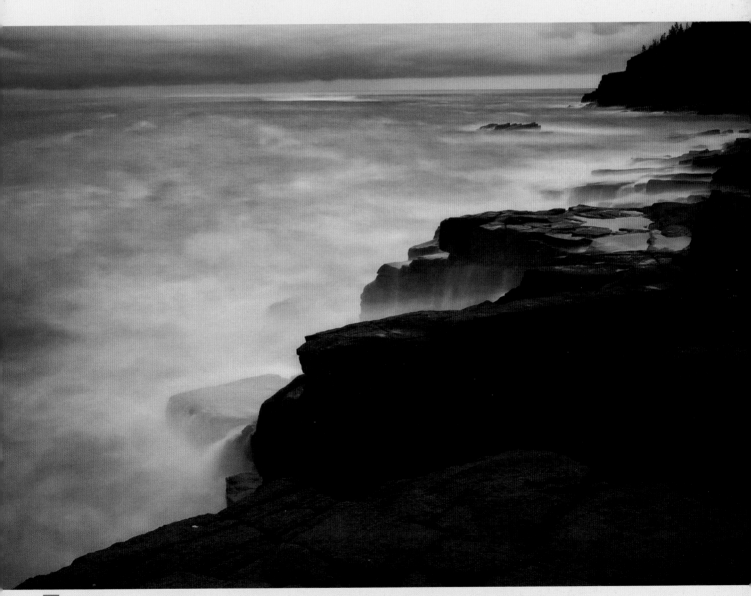

B Acadia National Park, Maine.

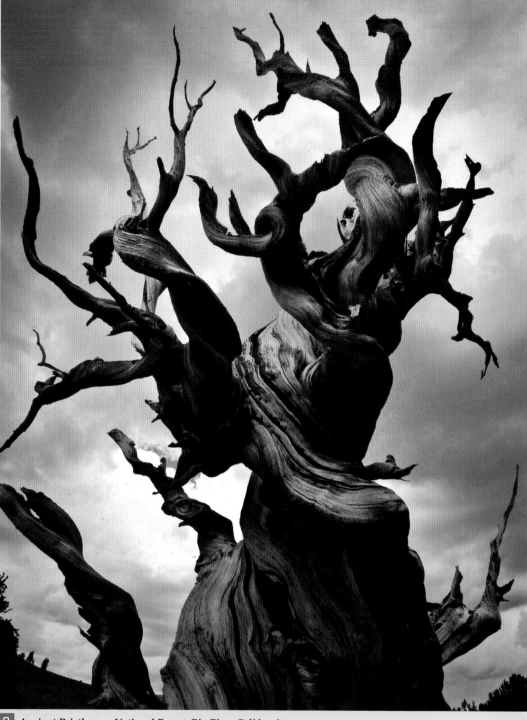

A Ancient Bristlecone National Forest, Big Pine, California.

• Look for unique angles (photo A):

The standard angles are so photographed that you can practically find holes worn into the rock from tripods. Since the positioning for these shots is so common, you will be treading in the same visual footsteps as everyone else. Pause a moment and look around. What angles to the scene are not being exploited? Can you use them?

•Try an extreme focal length (photo B):

If you can get close enough, take pictures of the scene using your wider focal lengths, even a full-frame fisheye if you own one. Or, try a long telephoto if you can back away far enough.

• Include more of the setting (photo C):

Iconic landscapes are often based on classic landscape photo techniques emphasizing a specific detail or form, such as an arch or converging lines; or on vegetation

types, such as the Ancient Bristlecone Pine. Most photographers then direct their attention to just these elements of the scene. Yet, it can be interesting and different photographically if you include more of the environment or setting. This tells your viewer more about the place and how the iconic form fits into that place. Often you will find that your viewers are amazed to discover what the landmark or area really looks like because they never saw it like that before.

• Include the people (see page 114):

Often these iconic scenes are places that attract a lot of people. Why not include them in the scene? That would give a truer representation of what this place is like. But pay attention to composition and how you can incorporate the people into the scene in an interesting way.

B Balanced Rock, Arches National Park, Utah.

C Tunnel View, Yosemite National Park, California.

winter

Summit, Guanella Pass, Colorado.

A winter scene is not a landscape in the same sense that a mountain vista or desert view is a landscape. Winter can be a part of nearly any of the types of landscape scenes we've discussed in the previous chapters. But I am giving winter its own chapter because it represents something distinctive, and I encourage you to take winter pictures if you live where it snows, since many photographers don't take this opportunity.

I grew up in Minnesota. I was acutely aware of winter because the state has 11 months of snow and one month of rough sledding! Well, okay, that's an exaggeration; but it is true that Minnesota has a long winter. The leaves fall from the trees in early October and don't return until May. So if I had put my camera away to hibernate through the winter, I was not going to be shooting outdoors for a long period of each year. That would be a shame because winter offers some rare and stunning landscapes that make exceptional photographs.

There is no denying that conditions in winter make photography a challenge. Low temperatures mean you need layers of clothing. And it becomes difficult to manipulate camera controls with gloves on, or else fingers get cold and stiff quickly from using chilled camera gear. Icy winds add to the chilly discomfort.

Casco Bay, Freeport, Maine.

However, being outside in winter with your camera can also be rewarding. There are things you can do to deal with winter conditions and still be able to get excellent photos. Here are some tips for using your equipment in the cold:

1. Find a pair of gloves that can be used with your camera

Go to a local sporting goods store and look for gloves made for exercising or for hunting in cold conditions. These gloves are often thin and offer finger flexibility. Hunting gloves typically include a special surface on the fingers to aid in gripping objects, which will help when holding and setting your camera.

2. Find a pair of warm gloves or mittens that go over the first pair described above

I don't like gripping my camera with bare hands in cold weather, so the first pair helps with that. However, that pair doesn't keep my hands warm for any length of time, so another pair is necessary. I have also found a special hunter's muff to be helpful. This is an insulated sleeve with a neck strap—you put your hands into this muff to keep them warm when not holding the camera. It works great, especially if you place a hand-warming packet in there, too.

3. Carry at least two fully charged batteries

The camera's battery will get cold and cease to function much more quickly than normal. You can then swap batteries, putting the cold one in a pocket to warm up. Then when the replacement battery gets cold, swap again.

4. Never take a cold camera directly into a warm place (and this includes a warm car)

Condensation can form on your camera, which is not a good thing (yes, the water can get inside you camera). Either keep you camera warm in a zipped camera case, or put it (and the case) into a plastic garbage bag that you can bring inside, letting the camera warm up.

5. When it is snowing, put a zoom on your camera and forget about changing lenses

You don't want to get snow inside your camera body where it will melt and cause problems. Also be careful to notice if any snow has melted on your lens, because it could cause problems if it refreezes there as the temperature drops.

Once you are prepared to shoot in the winter cold, there are a number of proven techniques that can result in interesting landscape photos. For instance, winter is generally less colorful than other seasons (white snow, gray trees, etc.). So, look for color contrasts in other things, such as blue sky, red berries, or sunrise and sunset colors, even as those colors reflect on the snow.

• Get outside when the snow is falling (photo A):

This can be a truly magical time to photograph, and these are photos you don't get a chance to record every day!

A Mt. Baldy, California.

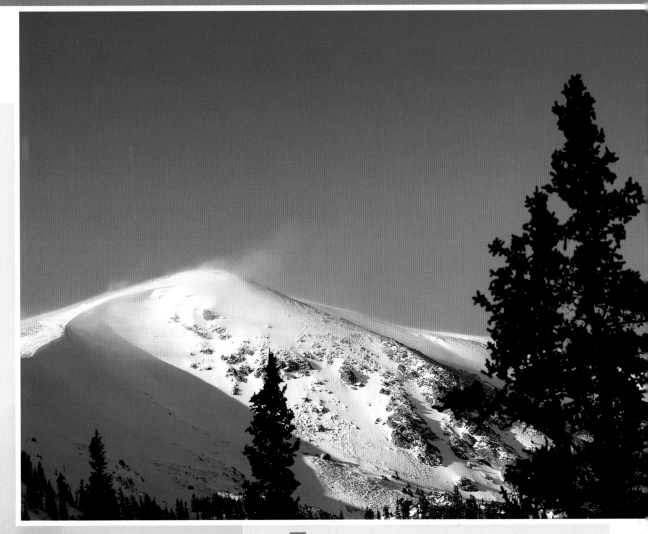

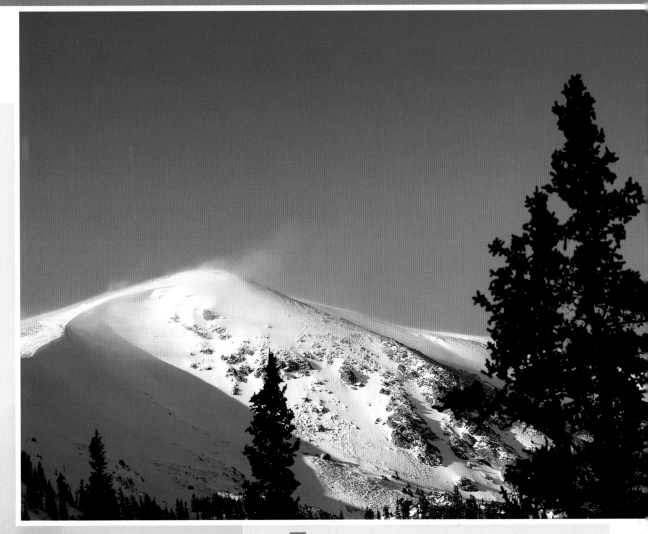

Rocky Mountains, Colorado.

• Use the sun (photo B):

It is generally low through the entire day in winter, which means you can get excellent landscape light at all times of day. A low sun also means the sky is often a rich blue. In fact, you will usually want to avoid polarizing filters because they can make the sky too dark, almost black. Use the rich sky, especially if there are nice, white clouds for contrast.

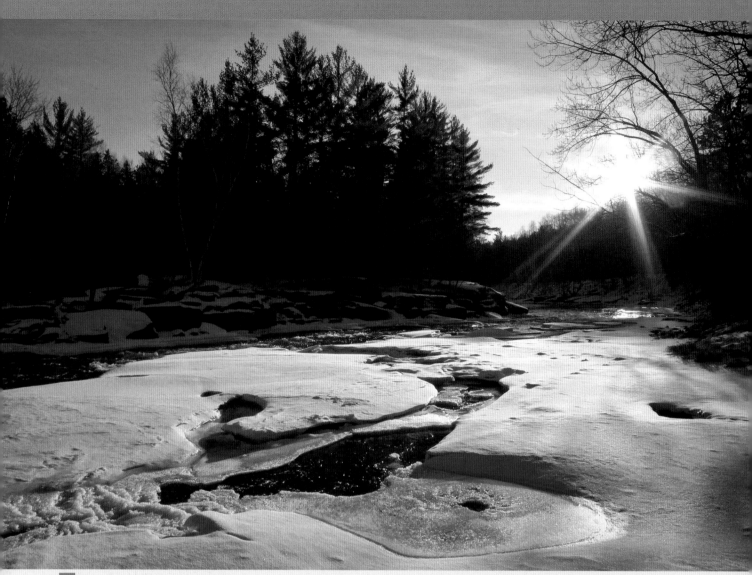

A **Banning State Park, Minnesota**

• Look for shadows (photo A):

A low sun also means long shadows, and these winter shadows are often a fascinating study in form and shape. Combined with the bright tones and textures of the snow, such winter shadows produce a number of neat photo opportunities. Just be aware that metering for shadows can blow detail in the white snow. You may have to underexpose such scenes based on what the meter is telling you.

Additionally, you can often include the sun in your photographs, since it is low to the horizon. Shoot into the sun for dramatic backlight, including great snow forms. Play around with exposure to see what patterns of light you can get around the sun.

• Expose properly for bright snow (photo B):

Just as you must be aware of how shadows affect metering, use care to properly expose the snowy portions of a scene, since they have brighter tones than most exposures. This brightness level will typically cause meters to compensate and underexpose a scene by as much as two stops. Examine your histogram to see if the graph leaves a gap on the right side. You want snow to be exposed so it is bright, but not washed out (the snow should show details—not pure white, blown highlights). Use exposure compensation to increase exposure as needed (typically at least a full stop).

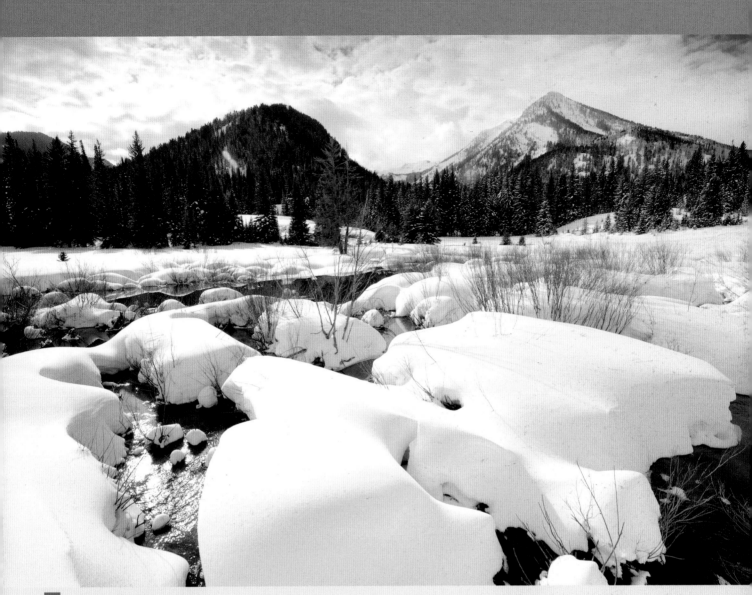

B Wasatch Mountains, Utah.

how landscape photos can change the world

Miriam Stein is a conservation photo editor who has worked with many top nature photographers. She has served as photo editor at Conservation International, Defenders of Wildlife, The Nature Conservancy, and with a number of publications at the National Geographic Society. She's a board advisor for the Imaging Foundation and a founding affiliate of the International League of Conservation Photographers.

Cades Cove, Great Smoky Mountains National Park, Tennessee.

**Essay by
Miriam Stein**

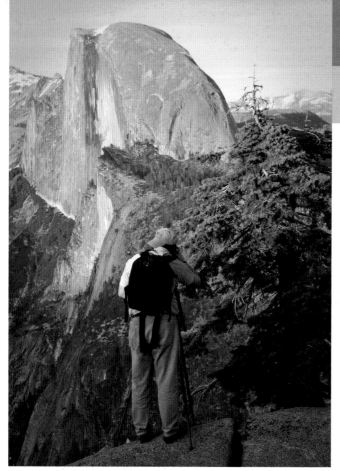

Glacier Point, Yosemite National Park, California.

The vista is in front of me. I know that feeling, the one I get when I envision how the photograph might look. Will look—if I can get everything just right. Now it's a matter of the light. And the pesky technical details.

As the clouds roll into place and the sun weaves its magic, the potential is intoxicating. I think, "This will be the best photo I've ever taken." Click. "It will look amazing on my wall." Click, click. "My friends will be so impressed." Click. "I'll submit it to photo contests and see it on the cover of Outdoor Photographer." Click, click, click.

I get the shot. It's exhilarating. I've actually taken an excellent landscape photograph. You can probably identify with me—you've felt the same excitement as you've also recorded a shot you're proud of. But now what?

There are many motivations for shooting landscape photography. All of the thoughts described above have crossed my mind as I envision a great landscape photo while looking through my viewfinder. But it is usually

reward enough to simply feel that inner peace of satisfaction as I recall the landscape itself in all its natural glory.

I'm sure that inner satisfaction is a common motivation, but further, I am actually embarrassed by the narrow scope of my ambition as a landscape photographer. I secretly feel that it's shallow to let the picture gather dust on my wall, even if I do enjoy looking at it. That's because I know that a good landscape photograph can do so much more.

A good landscape photograph can reach out to people. I know photographers, scientists, and conservationists who can recall the specific photos that first piqued their interest in the subject that turned into a lifelong passion. It's amazing that something so simple as a photograph can have such a lasting effect on one's life, how it can stir a person's actions and influence their travels and even their career moves. The bond a person develops with a landscape that reaches them through a photograph is virtually unbreakable.

A compelling landscape photo not only reaches out to people, but can also draw them into the location—make them feel as if they are part of that moment, surrounded by that light, experiencing that nature. It can burn itself into a viewer's mind and resonate for years—not only the subject of the photo, but also the details within the landscape: the curve of a tree limb; a shaft of light hitting a leaf; the texture of a cloud; a ripple in the water.

Every year, tens of thousands of photographers flock to Yosemite National Park. What inspires them to visit? In many cases, it is the timeless Ansel Adams photos hanging on their walls. It's the countless photos they've seen featuring El Capitan gracing covers of photography magazines and calendars. These tourists have bonded with those photos. The photos inspire them to see the landscapes and experience the awe in person.

Rockhill Preserve, Apalachicola, Florida.

In fact, nature photography is often used as a tool to inspire. It can give a face to a natural area in need of protection. It can bring wildlife to one's living room and make an ecosystem come alive. A collection of landscape photos can provide a window into the beauty of our entire planet. The same collection can also serve as a voice for disappearing landscapes and threatened environments, communicating a need for conserving the natural beauty in our wondrous world.

While photography has always been part of conservation communications, its role and value as a tool has reached an elevated status in recent years. Conservationists have started to notice the power of the photograph to inspire: Inspire donors to support conservation work, inspire individuals to vote for environmental protection, and inspire politicians to promote conservation.

I once worked for a conservation organization that surveyed its membership to assess what type of photo was most appreciated. The options were landscape, wildlife, and people pictures, all relating to conservation. The results showed a strong preference for landscape photography.

The survey demonstrates that a threatened landscape showcased in a dynamic photograph will effectively engage viewers. The sweeping vision will draw them into the scene, creating that unbreakable bond. The beauty within the landscape will inspire conservation because it's seen as a wilderness worth protecting, as piece of the natural world worth investing in.

Many different types of landscapes can be used in what's been coined as "conservation marketing." Knowing an audience and creating a portfolio specifically for their interests can have a profound effect on the success that landscape photography will have on conservation action. For instance, wildlife biologists, outdoor enthusiasts, and avid birdwatchers can all relate to a landscape photo that includes a person holding binoculars. A landscape with someone on horseback can grab the attention of not only equestrian enthusiasts, but also of farmers and ranchers, two groups often neglected and alienated by conservationists. Before-and-after landscapes depicting environmental devastation are most useful in providing government entities hard evidence of an immediate threat.

It is not surprising to learn that professional photographers have been using their talents for decades to bestow a voice for pieces of the natural world in need of protection. During the 1950's and 60's, as the environmental movement blossomed, photographs brought attention to Ohio's Cuyahoga River, so full of chemicals that it actually caught fire. The resulting media attention on such an unnatural event helped spur the enactment of the Environmental Protection Act and the Clean Water Act.

Years later, a series of landscape photographs of old-growth trees in Tongass National Forest juxtaposed against pictures of clear-cutting brought attention to a portion of wilderness under threat. Once again, media and political attention resulted in the most comprehensive timber reform legislation in U.S. history.

Similarly, photos in a book about Alaska's Arctic National Wildlife Refuge inspired U.S. Senator Barbara Boxer to display pictures during a Senate hearing and to sponsor a 2003 anti-drilling bill. Controversy surrounding the photography ensued due to the political sensitivity of drilling at that time. The additional scrutiny supported the conservation cause because it drove more people to look at the beautiful photos of a landscape that was previously thought to be nothing more than an ice field.

In one of the biggest success stories of conservation photography, the late president of Gabon, Omar Bongo, viewed photos taken in his country during a major conservation campaign. He was struck by the natural wonders depicted in the photos, understanding that he had the power to protect these beautiful and important resources in his own backyard. Very quickly, President Bongo signed 13 national parks into creation in 2002. By protecting his country's unique and precious natural resources, President Bongo created an economic revenue stream resulting from ecotourism.

Such tales of how photography has changed the world might well be intimidating to an amateur nature photographer. When I look at my own photos, I like to recall these high-profile success stories of photography aiding conservation efforts. I'm reminded to strive to use my photos for some kind of greater good, especially to bring attention to conservation and environmental causes. However, I'm not so sure my photography will secure me fame or fortune, or even result in conservation legislation being enacted, and you probably feel the same way. So the question you might ask is, "What can I do with my photographs to make a difference?"

Having worked for a variety of conservation organizations, I know that every cause is catalyzed by powerful visual communications. Multimedia presentations communicate the work of conservationists to colleagues and partner organizations. Websites disseminate information, engage the public, and convey important messages. Marketing materials attract new donors and inspire the financial support of new projects. Scientific documents and political packages can make or break local conservation policy.

Every type of conservation medium can benefit from strong photography. And the preference is almost always to show landscape photography because it conveys the broadest perspective of what needs conserving. If the scientists and communications professionals are under deadline and don't have access to good photos, they'll usually settle for not-so-good photos.

Arches National Park, Utah.

Think about all of the pictures you have hanging on your wall or stored on your hard drive. Could your landscape photography do more than sit there? It would be unfortunate if someone in the conservation community, trying to protect a landscape that you had photographed, settled for substandard photography because your pictures are kept a little too close to your heart.

Land trusts are ubiquitous and desperately need visual documentation to support their work. Larger organizations, like The Nature Conservancy, have local offices with small budgets. They always appreciate a photographer interested in developing a free, yet mutually beneficial partnership. The internet is a fantastic resource and helps create instant virtual relationships, so getting your photos into a position where they can make a difference could be as simple as sending a few emails.

The rewards of such partnerships are multifaceted. Local conservation organizations can provide access to otherwise unattainable and often pristine landscapes. You first experience the exhilaration of taking great landscape photos that no other photographers have taken, and then you share your work with your new conservation partner, who uses the photos to encourage conservation action.

I believe the most gratifying satisfaction derived from your landscape efforts is the knowledge that your photos will serve a greater purpose by furthering the mission of conservation. And just maybe, if we continue to think creatively and work collaboratively, our landscape photography will affect one small corner of the world at a time.

A

abstract images 92
angle of view *see relative magnification*
Aperture (Apple software) 129
aperture 33, **34, 50–51**, 68
aperture priority exposure mode 48, 50, 71
APS-C *see sensor, APS-C*
autoexposure bracketing (AEB) 99, 140

B

background 32, 33, 34, **85**, 88, 93, 170, 182, 186, 196
black and white 52, 120, **122–130**
 conversion **127–129**
bracketing *see autoexposure bracketing*
brightness 68, 98, 99, 124, 129, 138, 215

C

Camera Raw 45
camera movement **52**
camera support *see tripod*
center-weighted metering *see metering, center-weighted*
clipping 68, 70, 71, 138
close-up photography 23, 34, 170, 196
clouds 102
color cast 72–74
color saturation 52
composition 11, **76–93**
 dominant visual elements **82**
 framing **88**
 space **83**
 relationships **22**
 rule-of-thirds **80–81**
compression (JPEG) 42
computer monitor *see monitor, computer*
contrast 37, 38, 52, 58, 63, 66, 91, 98, 127, 152
 see also high contrast
conversion from RAW *see RAW conversion*
conversion to black and white *see black and white, conversion*
conversion to grayscale *see black and white, conversion*

D

deserts **160–167**
depth of field 16, 26, **33–34, 50–51**
dynamic range 71, 90, 100, 141
 see also high dynamic range (HDR)

E

edges **89**
electronic viewfinder (EVF) 20, **22**
exposure **48–51**, 66, 68, **70–71**, 140
exposure compensation **71**, 140, 215
exposure modes **48–51**, 52, 71

F

file formats *see recording formats*
filters 67, 74, 120, 127
 graduated **38–39**, 94, 99
 in-camera 125, 126
 infrared **130–132**
 polarizer 36, **37–38**, 100–101, 107, 109, **171**
 software 129
fire **117**
flare **67**
flower landscapes **176–181**
focal length 15, 18, 20, 24, **26–34**, 96, 198, 208
foreground 29, 33–34, **84**, 88, 93, **147**, 166, 176, 179, 182, 192
forests **152–159**
f/stop 35, 49, 50, 67, 68
 see also aperture
full-frame *see sensor, full 35mm-frame*

G

geology **151**
grayscale 127, 129, **130**
 see also black and white

H

histogram 70–71, 180, 214
high contrast 17, 58, 66, 98
high dynamic range (HDR) 17, 66, **99–100**, **138–141**
highlight warning **48**, 66, 71, 180
human influences **110–119**, 216–221

I

image processing
 in-camera 42, 45, **51–52**, 126
 using computer software 45, 71, 74, 99, 100, **127–129**, 140
image stabilization (IS) system **36**, 52, 187, 202
infrared photography 120, **131–132**
internal focus **35**
interpretation 61, 76, 78, 90–93, 94
ISO 15, 68, **69–70**, 202

J

JPEG *see recording formats, JPEG*

L

layers 99–100
LCD display **46–48**, 58, 63, 67, 70, 125
lenses 15, 18, 20, 22, 23, **25–36**, 67, 109, 130
 normal 30
 telephoto 15, 25, **30**, 34, 84, 150, 179
 wide-angle 15, 25, **29**, 34, 100, 150, 166, 179
 zoom 18, 25, 32, 74, 202, 212
light 11, 38, **58–75**, 91, 124, 149, 152, 161–162, 166
 backlight **64–66**
 dramatic **62–63**
 subtle **64–65**
Lightroom 45, 128, **129**, 141

m

man *see human influences*
manual exposure mode 50, 51, 71, 133
megapixels (MP) 9, **12–19**
memory card **39–40**
metering
 center-weighted **69**
 multi-segment **68**
 spot **69**
microclimate **195**
mountains **144–151**
multi-segment metering *see metering, multi-segment*

n

natural icons **204–209**
nature is perfect **76**
Nik software **129**
noise 51
normal lens *see lenses, normal*

O

Oceans **168-173**
overexposure 48, 71, 99, 171, 180

P

panorama 120, **132–137**
perspective 16, 26, **30–32**, 84, 179, 183, 198
Photoshop 94, **128–129**, 132, 133, 140
plug-ins 129, 140
prairies **188–195**
printer 42, 45, 124, 127, 130
printing 16, 34, 42, 46, 47, 52, 120, 127, 130
program exposure mode 48

Q

quality (of image files) **12–19**, 21

R

RAW *see recording formats, RAW*
RAW conversion (software) 45, 51, 74, 127
recording formats **42–46**
 JPEG **42**, 45, 51–52, 66, 72, 125
 RAW **45**, 51, 66, 72, 100, 127
 RAW+JPEG **46**, 126–127
relationships, compositional **82**
relative magnification 18, **26–27**, 29
resolution (pixels) 12, 15, 16, 18, 20, 42, 45
RGB (color mode) 130
rule-of-thirds 80–81

S

sensor 9, **12–19**, 26–27, 42, 45, 68, 71, 99, 130, 138
 Four Thirds 15, 16, 18, 21, 22, 26, 27, 29, 30, 36
 APS-C 15, 16, 18, 21, 26, 27, 29, 30
 full 35mm-frame 12, **15**, 16, 18, 19, 21, 26, 27, 29, 202
shapes 78, 92, 98, 103, 151, 152, 174, 186, 190, 191
sharpness (lens/image) 24, 33–36, 50, 52
shutter priority exposure mode 48, 71
shutter release 46, 54, 140
shutter speed 36, 50, 53, 68, 70, 108–109, 131, 187
sky 11, 29, 38, 64, 81, **94–103**, 105, 106, 127, 149, 162, **164**, **171**, 177, 191, 197, 213
small scale landscapes **196–201**
spot metering *see metering, spot*
stitching photos 119, 120, 132, **133**, 136
stories 82, 84, 85, **96**

T

telephoto lens *see lenses, telephoto*
textures 62, 64, 86, **92**, 97, 124, 152, 166, 168, 174, 176, 190
tonality 45, 84, 127, 133, 140, 168
tripod 11, 15, 18, 19, **36**, **52–54**, 67, 131, 132, 133, 138, 140, 186, 187, 192

V

viewfinder 20, 23, 29, 32, 35, 38, 54, 68, 69, 90, 104, 132, 146

W

wetscapes **182–187**
white balance **72–75**, 133
wide-angle lens *see lenses, wide-angle*
winter **210–215**

Z

zoom lens *see lenses, zoom*